Master Drawings and Watercolors
of the Nineteenth and Twentieth Centuries

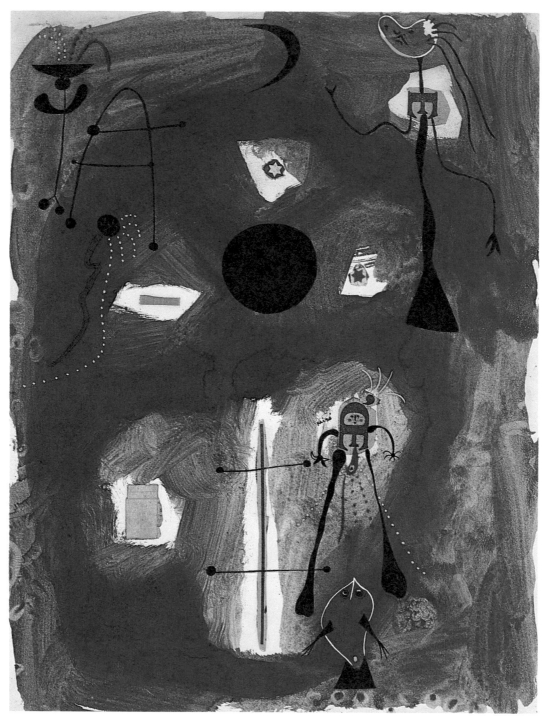

JOAN MIRO
A Night Scene, 1937
(see also cat. no. 62)

Master Drawings and Watercolors
of the Nineteenth and Twentieth Centuries

The Baltimore Museum of Art

Introduction by Victor Carlson
Catalogue Entries by Carol Hynning Smith

An Exhibition Organized by The Baltimore Museum of Art
and The American Federation of Arts

THE BALTIMORE MUSEUM OF ART
Founded in 1914, the museum's collections encompass a number of diverse areas: primitive arts, European art from the Renaissance to the present, including a large collection of prints and drawings; American art of the nineteenth and twentieth centuries; and decorative arts centering on works made in Maryland. The museum's collection of works by Picasso and Matisse, part of the Cone Collection, are among the most extensive holdings in any public collection.

THE AMERICAN FEDERATION OF ARTS
The American Federation of Arts is a national, non-profit, educational organization, founded in 1909, to broaden the knowledge and appreciation of the arts of the past and present. Its primary activities are the organization of exhibitions which travel throughout the United States and abroad, and the fostering of a better understanding among nations by the international exchange of art.

Copyright © 1979
The American Federation of Arts

Published by The American Federation of Arts
41 East 65th Street
New York, New York 10021

LCC 79-88492
ISBN 0-917418-63-8

AFA Exhibition 79-1
Circulated August, 1979-August, 1980

Designed by Pauline DiBlasi
Type set by Finn Typographic Service, Inc., Stamford, Connecticut
Printed by Eastern Press, Inc., New Haven, Connecticut

Cover:
EUGENE DELACROIX
Two Views of a Young Arab, c. 1832 (see also cat. no. 6)

This exhibition and publication are supported by grants from
SCM Corporation and the National Endowment for the Arts.
Their generous support is gratefully acknowledged.

SCM Corporation is pleased to join with the National Endowment
for the Arts in support of this exhibition of master drawings and
watercolors from The Baltimore Museum of Art. Although many
are familiar with the Matisse and Picasso drawings in Baltimore's
renowned Cone Collection, few are aware of the richness of the
museum's holdings in the graphic arts. This great depth includes
not only works by nineteenth century masters such as Delacroix,
Degas and Cézanne but also the works of contemporaries like
Oldenburg, Kelly, Rauschenberg and Johns. This exhibition and
catalogue are the fruit of a joint effort by The American Federation
of Arts and The Baltimore Museum of Art to share this cultural
treasure with a wider audience. We at SCM applaud the effort and
are proud to lend our assistance.

Paul H. Elicker, *President*
SCM Corporation

MUSEUMS PARTICIPATING IN THE TOUR

The Solomon R. Guggenheim Museum, New York

Des Moines Art Center

Art Museum of South Texas, Corpus Christi

The Museum of Fine Arts, Houston

The Denver Art Museum

ACKNOWLEDGEMENTS

For some years The Baltimore Museum of Art has been actively collecting nineteenth and twentieth century drawings, an area which gained immeasurably in stature following the bequest of the Cone Collection in 1950. Although enlightened donors such as Blanche Adler and her sister, Saidie A. May, had presented works on paper by Klee, Modgliani and Miró in the 1930s and the superb Daumier (cat. no. 16), one of three owned by the Maryland Institute College of Art, has been on loan since 1934, the Museum's holdings in this area attained international recognition only with the Cone bequest, ranging in time from Ingres to a William Zorach portrait drawing from 1943. The Francophilic taste of Dr. Claribel and Miss Etta Cone, together with their brother Frederick, was an important determinant in shaping the future character of the collection. In 1963 the bequest from Mrs. Nelson Gutman of her modern European works of art, together with a purchase fund, further strengthened our commitment to develop this aspect of the drawing collection. Concurrently, the Museum has continued to acquire contemporary drawings, predominantly although not exclusively American, frequently as gifts to the Thomas E. Benesch Memorial Collection, founded by Edward M. Benesch and the late Mrs. Benesch, who in 1959 gave the first of a long sequence of works by living artists. That the present exhibition could be realized is due to the generosity of the above collectors, as well as to the donors of individual works of great importance, such as the Eakins and Homer, without which we would be immeasurably the poorer. It is also appropriate to acknowledge the support of my colleagues, who have agreed to the acquisition of a number of major works in this catalogue even though the funds could have been applied to accessions in other areas. It is a pleasure to thank Carol Hynning Smith for her thorough work on the catalogue entries, which she researched with commendable professionalism. Excepting the entries for Ingres, Corot, Eakins, and Homer, the latter two kindly written by Sona Johnston, Associate Curator of Painting and Sculpture, the catalogue was prepared by her. Thanks also must be given to Jay Fisher, Associate Curator of Prints and Drawings, to Theodore Mosher, Preparator, to Carol Murray, Registrar and Kate Miller, Assistant Registrar, for their support and interest during this time-consuming project. It is also a pleasure to acknowledge Katherine Baden Stewart's expertise in the preparation of the drawings for travel.

Victor Carlson
Curator of Prints & Drawings
The Baltimore Museum of Art

The American Federation of Arts has for many years organized exhibitions and published catalogues from the collections of American and foreign museums, to travel both in this country and abroad. For example, the AFA has joined forces with the following museums: the Museo del Oro, Bogotá, for an exhibition of pre-Columbian gold; the National Museums of Zaire; the former Museum of Primitive Art, New York; the Department of American Paintings and Sculpture of The Metropolitan Museum of Art for an exhibition which traveled both in the United States and Australia; the Newark Museum for a show drawn from their extraordinary Tibetan Collection; the American Museum of Natural History for an exhibition on Northwest Coast Indian Art; and, most recently, the Yale University Art Gallery on a show from their exceptional American Silver collection. This program is one of which we are particularly proud in that it has encouraged museums to share their rich and often unique collections with a larger national and international public.

It is, therefore, with great pride that we now join with The Baltimore Museum of Art in organizing this exhibition of nineteenth and twentieth century drawings and watercolors from their famous collection in that media. We are deeply indebted to their Trustees, former Director, Tom Freudenheim and Assistant Director, Brenda Richardson, for their generosity in sharing so many major works from their collection.

Particular thanks are due to Victor Carlson, Curator of Prints and Drawings, who selected the works to be included and who wrote the catalogue introduction. Without his enthusiastic support and knowledge, this project could not have been realized. Credit is also due to Carol Hynning Smith, who wrote the catalogue entries, and to all those members of The Baltimore Museum staff who assisted with this exhibition and publication. To all of them we extend our warm thanks.

I should also like to acknowledge and express my appreciation of the contributions of several AFA Staff members: Jane Tai who was in charge of all aspects of the exhibition; Susanna D'Alton who organized the tour; Melissa Meighan who helped monitor the condition of the drawings while they traveled; Mary Ann Monet and Fran Falkin who proofread the catalogue; Anne Wallace who coordinated the publicity and Walter Poleshuck who helped secure the funding. Our thanks are also due to Pauline DiBlasi who designed this handsome catalogue.

Finally, we are deeply indebted to SCM Corporation and the National Endowment for the Arts for their critical support of the exhibition and publication through generous grants, and to the museums across the country which will present this exhibition.

Wilder Green, *Director*
The American Federation of Arts

INTRODUCTION

"Drawing is the probity of Art."
(Jean-Auguste-Dominique Ingres, 1780-1867)

Ingres' terse dictum is engraved on the monument dedicated to him in the Ecole Nationale des Beaux-Arts in Paris, official recognition of the artist's stature and of the importance of his art in nineteenth century France. From the Renaissance on, drawing has been a basic skill which artists of all periods have mastered. The term "drawing" in its narrowest sense applies to the description of form, rendered on paper using media such as chalk, charcoal, or inks with pen or brush. But on another level the noun "drawing" can refer to the harmonious ordering of compositional elements which comprise any work of art. The latter, more general definition of drawing emphasizes its essential role in the creative process. Certainly Ingres did not insist only on correct description of form, but also would have understood his quotation to apply as well to the organization of a painted composition. "If I had to put a sign over my door, I should inscribe it *School for Drawing*, and I am sure that I should produce painters." (Lorenz Eitner. *Neoclassicism and Romanticism. 1750-1850. Sources and Documents.* Vol. II, Englewood Cliffs, New Jersey: Prentice-Hall, Inc., 1970; p. 136). The clarity of form and composition which Ingres found in classical antiquity and in Raphael were ideals firmly held by the Frenchman, whose position as professor at the Ecole des Beaux-Arts (1829-1851) and Director of the French Academy at Rome (1834-1841) meant that his words reached the highest official circles. As the foremost exponent of French Neo-Classicism, Ingres' example was imitated with varying degrees of success by his pupils, among them Eugène Amaury-Duval, (cat. no. 2), whose pencil portrait of a lady is clearly in debt to the master, although without the latter's revealing intimations of personality.

Since the mid-seventeenth century, when the French Academy at Rome was founded, it had been an article of faith that the most promising young French students should be sent to the capital to study at first hand the examples of ancient, Renaissance and Baroque art which, before the establishment of museums, could best be found in Rome's churches and palaces. An essential facet of the student's training was to copy past masterpieces in order to better understand those works of art; however, among the most delightful studies produced by the *pensionnaires* at the Academy are informal landscapes of the Roman campagna, painted or drawn out-of-doors, such as the sheet by Théodore Caruelle d'Aligny (cat. no. 3) or those of his friend Jean-Baptiste Camille Corot. Not all winners of the Prix de Rome felt there was merit to the Academy's didactic program. In 1791, Anne-Louis Girodet-Trioson urged that students be released from this academic regimen to develop their own courses of study, which need not be confined to Rome and its environs. Gericault also spoke of the tedium of time spent at the Academy, and in 1816 advocated that the students' time there be reduced to one year so that they could get on with the development of their own work.

The unrest with official programs of study and the concurrent emphasis on individuality, noted above, eventually solidified into opposition to what some saw as the cold marmoreal perfection of Neo-Classicism. Ingres himself became an object of derision for Eugène Delacroix, Théodore Chasseriau, Théodore Rousseau and Odilon Redon, although as diverse temperaments as Auguste Renoir and Pablo Picasso carefully studied the Neo-Classicist's work on occasion.

In Eugène Delacroix, those artists disaffected by Ingres' example found a leader. Earlier, Théodore Géricault's *Raft of the Medusa* exhibited at the Paris Salon of 1819, demonstrated the latter's ability to synthesize his study of Michelangelo and a contemporary event, producing a large scale painting which immediately heralded a new direction in nineteenth century French art (cat. no. 5). Géricault chose a contemporary event fraught with life and death tensions and rendered it with dramatic chiaroscuro lighting in keeping with the emotional pitch of the subject. But Géricault's untimely death in 1824 meant that the leadership of French Romanticism eventually passed to Delacroix. The latter's passionate admiration for the great colorists of the past, for example Veronese and Rubens, made him aware of the expressive potentials of working with a heightened palette. Delacroix's 1832 trip to Morocco as part of a diplomatic mission confirmed his addiction to color as revealed in the strong, clear African sunlight (cat. no. 6); the voyage was an indelible experience. As a draughtsman Delacroix's emphasis on spontaneity, even at the expense of correct description of form, was anathema to Ingres. Charles Baudelaire recorded Delacroix's most famous comment on the art of draughtsmanship, that an artist must be able to record the figure of a man in the time it takes him to fall from the fourth floor to the ground. And Baudelaire added: "This enormous hyperbole seems to me to contain the major concern of his whole life, which was, as is well known, to achieve an execution quick and sure enough to prevent the smallest particle of the intensity of action or idea from evaporating." (Eitner, *op. cit*, pp. 131-132). Ingres and Delacroix, so apart both in temperament and esthetic stance, remained life-long enemies as the breach in their artistic philosophies was impossible to reconcile.

Meanwhile, across the Channel in England Romantic landscape painting was being transformed by Joseph Mallord William Turner and John Constable. The former's fascination with natural disasters—fires, avalanches, storms at sea—were often the pretext for boldly applied colors of dramatic impact or ravishing subtlety. Even in his commissioned watercolor of *Grenoble Bridge*, (cat. no. 9) the prismatic reflections on the river's surface anticipate the still more daring breakup of local colors to be found in Turner's later works. But in France, Constable's work was known earlier and more deeply appreciated by contemporaries who saw his *Hay Wain* at the Paris Salon of 1824. Constable's deeply felt, unaffected sympathy with nature anticipates the artists of the Barbizon school in France, whose visions of their own countryside are often painted with comparable gentle gravity.

Around 1850 several artists settled at the village of Barbizon, on the edge of the Forest of Fontainebleau. Foremost among them was Jean-François Millet, whose art does not fit comfortably into the definition of Romanticism, because Millet's study of such Renaissance masters as Raphael and Michelangelo gives a classic aura even

to the poses of the Frenchman's peasants working at grueling labor (cat. no. 12). The strength and immutable presence of Millet's figures are set to paper with a force and certainty which assures him a place among the great figure draughtsmen of his century. Charles Emile Jacque's touchingly sensitive portrait of his daughter (cat. no. 11) surely was executed after he had studied Millet's drawings, as the subtle modeling and sensitive articulation of form creates a striking parallel to Millet's style. Because one does not readily think of Jacque as a portraitist, the Baltimore drawing is all the more unexpected.

Among those landscape artists working at Barbizon, V. N. Diaz de la Peña and Charles Daubigny are represented here. The thick impastos of Diaz' gouache *Sunset* marvelously convey an impression of impending dusk. Working with pigments applied in bold scumbles, the artist's command of his medium is everywhere evident. Unhappily, Diaz' works on paper are among the rarities of Barbizon draughtsmanship. Daubigny's boldly drawn study of a field is a typical example of an aspect of his art which later had unexpected repercussions (cat. no. 14). Certainly it was Barbizon landscape drawings such as the Daubigny under discussion here which were studied by the young Mondrian, around 1905-1908 (cat. no. 50). Such works must have been known to the Hague Impressionists, and in fact the Daubigny drawing in Baltimore once was part of a private collection in the Dutch city. One can easily imagine Mondrian's fascination with the calculated diagonals forming the boundaries of the plots of land surveyed in Daubigny's vista.

In his review of the 1845 Paris Salon, Charles Baudelaire sounded a note which, in a bewildering number of forms, was to become one of the tenets of Modernism. "No one is cocking his ear to tomorrow's wind; and yet the heroism of modern life surrounds and presses upon us. Our true feelings choke us; we know them well enough. We do not lack for subjects or colors with which to make epics. The painter, the true painter for whom we are searching, will be the one who can seize the epic quality of contemporary life and make us see and understand, with brush or with pencil, how great and poetic we are in our cravats and patent-leather boots." (Eitner, *op cit*, p. 155). Although Baudelaire was to find his artist of the future in Constantin Guys, the writer's program actually attained its richest fulfillment in the work of Honoré Daumier (cat. no. 16). His truly stupifying lithographic *oeuvre* of nearly 4,000 subjects has been compared to Balzac's *Comédie Humaine* in the breadth of its comprehension of human circumstances and emotions. Daumier's views of mankind—his pride and avarice, his bourgeois pretensions and follies, his inept control of political issues of great moment—are catalogued in his prints and drawings with a brilliance undimmed by the sheer mass of his work. Daumier himself echoed Baudelaire when the artist exhorted one to be of one's time, but in fact Daumier was quite aware of and sensitive to art of the past. Perhaps some of the assured bravura of Daumier's less finished drawings came from his study of Fragonard's bold, late studies intended to illustrate Ariosto's *Orlando Furioso*, which at the time were in the Walferdin Collection at Paris.

Among the artists loosely associated with Impressionism, Edgar Degas was consummately a draughtsman, one of the greatest in the formidable and continuous French tradition. In spite of his association with some of the most advanced painters of his day, Degas had a deep-seated admiration for Ingres' works, which the younger artist collected. Degas' *Head Of A Roman Girl*, an early work drawn in the Italian capital, has a solidity and clarity of form which Ingres might well have admired (cat. no. 17). If later, and to some extent under the influence of Japanese art and photography, Degas abandoned classical references in the construction of his compositions and the poses of his figures (cat. no. 18), his art nonetheless never entirely shared the spontaneity of the Impressionists' visions. Degas' observation that the artist does not draw what he sees, but what he must make others see, illustrates the subtle quality of his intellect. It was a goal in which Degas magnificently succeeded.

American artists were isolated geographically from both the past traditions of earlier European art and the rich complex of academic and avant-garde work to be experienced on the continent. Nor did most cities in the United States have public galleries where European art of whatever epoch could be studied at first hand. The best known of the American expatriot artists is Mary Cassatt who, through her liaison with the Impressionists, knew Degas. The latter was a decisive influence on her development, as can be seen especially in her drawings, which Degas admired. In the preparatory drawing for her etching *Sombre Figure* (cat. no. 19), the bold masses of the seated woman completely avoid any of the finicky banalities which popular taste would have preferred. One can easily imagine Degas giving a terse nod of approval to Cassatt's assured and direct study.

Both Winslow Homer and Thomas Eakins worked briefly in France, the former in 1866-1867, the latter from 1866-1870. Unlike Mary Cassatt, one cannot trace in their paintings and drawings specific references to their European experiences, although one may assume that at the very least they received there a more thorough academic training (Eakins studied with Jean-Léon Gérôme) than would have then been possible on their native soil. Both artists were masterful watercolorists, a medium in which Homer particularly excelled (cat. no. 20). As Theodore Stebbins observed, Homer's art represents the eclecticism of his period at its best, as the artist was able to apply his talents, sharpened and perfected by study abroad, to subjects derived from his native country.

Thomas Eakins, whose life centered in Philadelphia, taught for a while at the Pennsylvania Academy of Arts, but was forced to resign because he insisted that all his students, women and men, draw after the living model rather than draped figures or plaster casts. In September, 1879, the artist was interviewed by *Scribner's Illustrated Monthly Magazine*, where he defended his teaching practices. He commented: ". . . the outline is not the man; the grand construction is. Once that is got, the details follow naturally." Eakins' insistence that the human figure be seen as a totality and not as the sum of its parts is a surprising anticipation of Matisse's view of how anatomy should be studied, as expressed in the latter's 1908 "Notes Of A Painter." The grand overall design which Eakins urged his students to realize is superbly expressed in his rare watercolor portrait (cat.

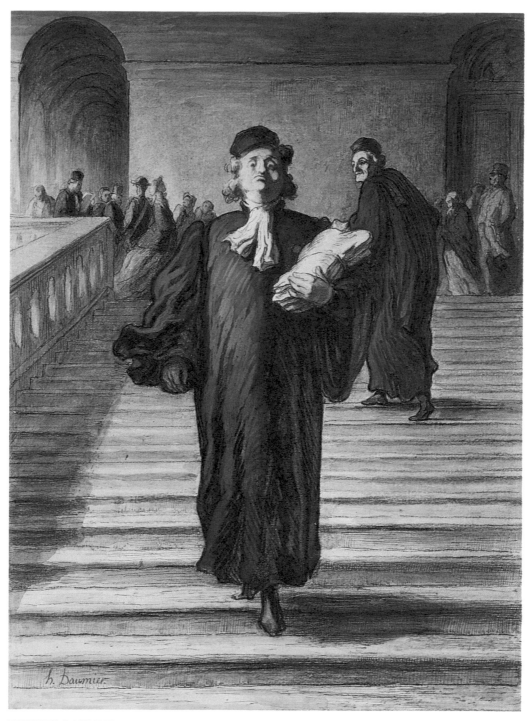

HONORE DAUMIER
The Grand Staircase of the Palace of Justice
(see also cat. no. 16)

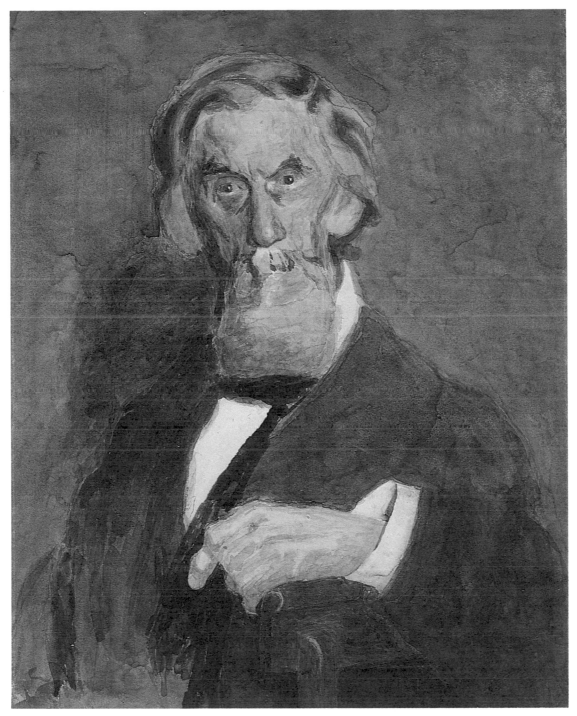

THOMAS EAKINS
Portrait of William H. MacDowell, c. 1891
(see also cat. no. 21)

no. 21), a magistral image. Among the most truly impressionist of all draughtsmen at the time was another expatriot American James A. McNeill Whistler. Especially in his watercolors and brush or pen sketches, Whistler carried economy of means to a startling degree of abbreviation. His small brush sketch surely drawn in Venice (cat. no. 22), conveys the effect of sunlight reflected from architecture and water with a few lines of rare evocative power.

One of the most important results of recent studies of nineteenth century French art is the reawakened interest in painters who do not fit within the avant-garde categories which have dominated much previous writing about the period. Artists such as Eugène Carrière (cat. no. 23) and Henri Fantin-Latour (cat. no. 24) were greatly esteemed by many of the more revolutionary painters of the time, although their art does not represent a clear break with academic conventions. Carrière's friendship with Gauguin brought the former into the synthetist-symbolist group which assembled at Pont-Aven in Brittany, while during the 1890s Matisse and Derain, among others, studied at the Academie Carrière. Fantin-Latour was quite possibly even a more influential figure because he introduced Redon to lithography. There is a striking parallel between the blurred forms of Fantin-Latour's drawings and lithographs and Seurat's conté crayon drawings, each artist manipulating white paper as the source of light for scenes drawn in rich blacks.

During the last two decades of the century a number of artists, disenchanted by what they viewed as Impressionism's excessive preoccupaton with evanescent sensations, sought to develop more personal forms of expression. Vincent van Gogh's early watercolor (cat. no. 25) is within the confines of Hague School Impressionism, especially its delicate palette of grayed, muted colors. Its static composition does not yet hint at the tense calligraphy with which the mature artist expressed his frequently overwrought emotional state. By contrast, Georges Seurat found the future direction of his art in the scientific analysis of the way colors interact. In 1878, the young artist enrolled at the Ecole des Beaux-Arts, where he studied under a pupil of Ingres, Henri Lehmann. The cool perfection of Seurat's early academic figure drawings have in common with his mature conté crayon sheets (cat. no. 26) perfectly modulated light, although his later studies literally use light as the substance for the creation of plastically realized volumes.

Because in his late work Paul Cézanne carried his investigations of forms to a degree of abstraction rarely paralleled by his contemporaries, it has become commonplace to view the artist's historical position as seminal to the creation of twentieth century abstract art. However, to some extent Cézanne arrived at this mature style through the study of earlier works of art. A significant number of his drawings are free copies after other masters, among them the French Baroque sculptor Pierre Puget (cat. no. 27). On a number of occasions the nineteenth century artist turned his relentlessly analytical gaze to the excited pose and strained musculature of Puget's seventeenth century masterpiece, as if to find there some private lesson Cézanne could turn to his own purposes.

The abstract qualities of Cézanne's late works anticipate one of the major directions of twentieth century modernism, while the unreal world revealed especially in Odilon Redon's lithographs and charcoal drawings (cat. no. 28) prefigures this century's fascination with the subconscious. "There is a kind of drawing which the imagination has liberated from any concern with the details of reality in order to allow it to serve freely for the representation of things conceived. . . . No one can deny one the merit of having given the illusion of life to my most unreal creations. My whole originality, therefore, consists in having made improbable beings live humanly according to the law of the probable, by as far as possible putting the logic of the visible at the service of the invisible." (*Artists on Art*, edited by Robert Goldwater and Marco Treves; New York: Pantheon Books, 1947, p. 361.)

The Baltimore Museum of Art's collection of works by Pablo Picasso and Henri Matisse is by far the richest facet of its drawing collection. The group of 46 early Picasso drawings and watercolors, executed between ca. 1899 and 1907 is a particularly significant group by virtue of their exceptional quality. From the artist's early watercolor sketch of his friend Carles Casagemas Coll drawn in Barcelona (cat. no. 31) through the 1906 sheet done in Spain at Gosol in which one sees the first tentative moves towards a more abstract realization of form (cat. no. 34), the collection as a whole is an extraordinary record of a great artist's coming to maturity. Although examples of the artist's mature development of Cubism are most unhappily lacking, there are two strikingly different realistically drawn portraits, each concurrent with Picasso's synthetic Cubism (ca. 1914-1921). The earlier, a portrait of the poet Léopold Zborowski (cat. no. 37), is a tense, emotionally heightened evocation of character, the more surprising because it is contemporary with other portrait drawings by the artist which, in the subtle modeling and cool perfection of line, are indebted to Ingres' example. One of the finest of these works is the magistral *Portrait of Dr. Claribel Cone* (cat. no. 38), a classic study of the power of line to define personality in the most astringent terms. While it is regrettable that the museum's collection does not trace Picasso's later career as a draughtsman with examples of comparable interest, within its limitations the collection would be difficult to duplicate elsewhere.

Again, in the case of Henri Matisse, the museum's holdings are by no means comprehensive, yet, given certain limits, there are an enviable number of outstanding sheets. The selection of drawings executed by the artist in Nice is particularly striking, and includes such masterpieces as the famous version of *The Plumed Hat* (cat. no. 40) as well as the less popular but equally challenging charcoal studies, drawn on finely ribbed paper. Depending on the pressure applied to the stick of charcoal, the artist could create a range of tones varying from the most delicate, transparent grays to rich, dense blacks. Matisse's *Reclining Model with Flowered Robe* (cat. no. 41) exploits the full range of tonal effects which can be achieved in this medium. Concurrent with his charcoal drawings Matisse also executed the unshaded pen studies which are such a popular aspect of his draughtsmanship. Often, as the artist explained, preliminary essays in charcoal might precede his pen drawings because the softer medium permitted the artist to make corrections and revisions as he

explored the possibilities offered by his model. Only when Matisse felt satisfied by his analysis did he turn to pen and ink which, once applied to paper, allow the artist no time to reconsider his intention. Matisse once compared the execution of his pen drawings to an acrobatic performance, which either was a success or a failure. The exacting line and rich calligraphic embellishments of his finest pen studies (cat. no. 42) demonstrate the balance between vision and execution which the artist continually sought.

Picasso's prolix stylistic innovations and Matisse's daring investigations of color and decorative pattern have dominated European art during the first half of this century. The Russian-born American artist Max Weber had been exposed to Cézanne, Picasso and Matisse during his student years in Paris. When Weber returned to New York in 1909 he brought with him first hand experience of the Parisian avant-garde as both Cubism and Futurism deeply touched Weber's early development. Each of these movements called into question the adequacy of our normal field of vision—and thus of art based on it—to describe the state of flux in which objects exist, as indicated by the title of Weber's watercolor *Interior in the Fourth Dimension* (cat. no. 46). Before the Armory Show of 1913, which for the first time introduced the United States to an enormous cross section of recent European art, both Charles Demuth and John Marin had gone to France to find for themselves alternatives to the academic training then dominating an American artist's education. Unlike Weber, each managed to retain a strong sense of personality, in spite of their exposure to movements such as Cubism and Futurism. Demuth's vaudeville performer (cat. no. 48), rendered with attention to the edges of forms created by the controlled spread of liquid pigment across dampened paper, has all the subtlety of a Rodin watercolor without, however, making reference to a specific European source. John Marin's fascination with the pounding tempo of city life or the energy of natural forces may have been spurred by the Futurists, whose work he could have known when he was abroad from 1905-1910. But Marin's forceful personality frustrates any attempt to localize the origins of his style. "The Futurist exaltation of energy, courage, and virility and its scorn of intellectualism are echoed in Marin's writings and objectified in his work." (Phoebe K. Scholl, "A Study of the Styles and Techniques of Some Outstanding Recent American Watercolor Painters," quoted in: Theodore E. Stebbins, Jr., *American Master Drawings and Watercolors*, New York: Harper and Row, 1976; pp. 304-05.)

Concurrently, highly charged emotional content and concern for social injustice are dominant themes in the work of artists active in Northern Europe, whose stylistic innovations stand in sharp contrast to the elegant, more cerebral movements of Fauvism and Cubism. Several Dresden artists banded together, in 1905, to issue a manifesto *Die Brücke (The Bridge)*. As its title implies, the members of the group sought a means to escape from academic convention into a new, progressive art which would concern itself with the problems of contemporary society. Erich Heckel's portrait of his wife (cat. no. 53) expresses a sense of isolation and emotional cynicism through the sharply chiseled planes of her face, which recall the formal severity of Medieval Gothic sculpture. Although Käthe

Kollwitz seldom used the stylistic exaggerations of form which characterize the Brücke artists, her sympathy with those disabused by society makes her spiritually a part of the Expressionist movement (cat. no. 54). Another artist who did not formally align himself with the Expressionists is Lovis Corinth, whose late self portraits in particular are assays of personality which, by virtue of their relentless objectivity, properly may be considered a part of the broad Expressionist movement. In Austria, the headlong emotional tone of German art was tempered by more cynical, sometimes erotic statements of man's fate. Gustave Klimt's elegantly linear studies of the female nude often have overtones of musky sensuality (cat. no. 51), while Egon Schiele's figures are at times openly expressive of the traumas and spiritual disintegration of life in pre-World War I Vienna (cat. no. 52).

Both Dada and Surrealism were movements of the greatest import, not only for European art following the end of World War I but, later, for American art in the late 1930s and the following decade. The subconscious, already breached in Redon's art, quite understandably fascinated Max Ernst, who had studied psychiatry at the University of Bonn. His description of how he discovered frottage (cat. no. 56) points up the basic role of the accidental and irrational in the creation of Surrealist art. These latter qualities were not the exclusive preserve of Surrealism, as Paul Klee's paintings and drawings evidence. Even though his works were in the early Surrealist exhibitions in Paris, he never became an official member of that group. In 1920 Klee began to teach at the Bauhaus, first at Weimer and later at Dessau. The ordered structure of Klee's work is only superficially contradicted by the artist's often anti-rational titles (cat. no. 57). Klee's resolutions of personal fantasy expressed through forms having an inevitable visual logic makes him as much the spiritual heir of Redon as he is a contemporary of the Surrealists.

During the decades of the 1920s and 1930s not all European, and particularly French, art was dominated by theoretical stances which questioned past traditions. Several artists active at this time reveal in their drawings a French love of *la belle matière*, an emotional, sometimes sensual, response to the materials from which art is created. The evanescent modeling of Charles Despiau's nude studies (cat. no. 60) or the refined tonalities of Edouard Vuillard's crayon and brush drawing (cat. no. 61) indicate the firm position of more traditional ideals in France at this period.

The Spanish painter Joan Miró was attracted to the Dadaist-Surrealist groups shortly after his arrival at Paris in 1919. Miró's search for a more intuitive, spontaneous art certainly owed something to such Surreal innovations as automatic writing, which sought to expand the boundaries of psychic experience. The Spanish artist's biomorphic figures—often witty, sometimes cruel— are frequently painted with bright, primary colors (cat. no. 62). Using collage elements, the artist continued to explore the paradox between reality and art first stated in Picasso's Cubist 1912 *Still Life With Caned Chair*.

The unrest in Europe which preceded World War II brought many Surrealists to New York. Sebastian Matta Echaurren's menacing landscape vision, although drawn in Paris (cat. no. 63),

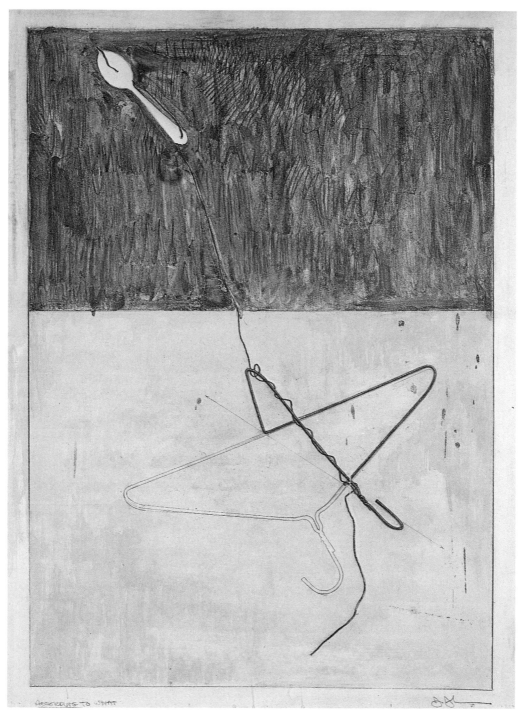

JASPER JOHNS
Study According to What?, 1969
(see also cat. no. 86)

typifies the later stages of Surrealism which certain American artists came to know and admire. Among them was Arshile Gorky, whose 1943 portrait of his wife is indebted to nothing so much as Picasso's 1906 Gosol figures (cat. no. 34). But in Gorky's mature drawing, done three years later (cat. no. 64), the importance of Miró's and Matta's art is quite evident. Gorky was a draughtsman of refined sensibilities, whose work as a whole stands at a pivotal stage of art history where the Surrealists' lessons were subsumed into the specifically American movement of Abstract Expressionism.

Because historical developments are never neatly linear, one must mention at this point several Americans who did not completely abandon a realist tradition, although each personality expanded the expressive potentials of that term. Edwin Dickinson's *sfumato* manner of drawing reveals forms through the play of delicately nuanced shadows which encompass the artist's subject, creating a tenebrous atmosphere of great refinement (cat. no. 66). But Charles Sheeler's precisionist images are the very opposite. The brilliant, clear light preferred by the artist relentlessly exposes structure and texture, qualities especially evident in the artist's rare black and white drawings (cat. no. 67). One is always immediately conscious of Milton Avery's subject matter even though his formal experiments verge towards abstraction. In the artist's watercolors particularly, tensions often emerge between the representational demands of a subject and the creation of a two-dimensional design, as illustrated by the strong horizon line and brilliant yellow sky of his *Bubbly Sea* (cat. no. 68).

Abstraction in American art gathered force after 1945, with the movement centered in New York known as Abstract Expressionism. Painters such as Jackson Pollock, Willem de Kooning and Franz Kline are among the artists first identified with this group. In 1952 the critic Harold Rosenberg used the term "Action Painting" to describe the outsized canvases of the New York school, which often resembled nothing so much as the war scars on a battlefield after a duel between the artist and his materials. Even though Kline's black and white brush drawings are small in format, they are charged with the super-abundant energy which so often is a part of New York painting at this time. An essential of Abstract Expressionism is the artist's gesture, which may appear not only as a mark on a sheet of paper, but also can occur when the artist tears apart his drawings to recombine them into a new image. Such methods have overtones of Cubism's use of collage and Surrealism's fascination with automatic processes producing unanticipated order. Larry Rivers' collage-drawing, in which he explores the theme of a Civil War veteran's death, is disillusioned social commentary expressed through jagged cuttings of paper and abrupt, harsh lines (cat. no. 76).

A number of works by recent American artists reflect the heritage of Surrealism in various ways. Claes Oldenburg's designs for fantastic monuments, each created for a specific, actual setting (cat. no. 78), if executed would loom over their environments in a truly hallucinatory manner. Robert Rauschenberg's use in his drawings of images clipped from magazines or newspapers and transferred to paper are combined with passages of abstract, non-referential brushwork (cat. no. 79). The "reality" of the artist's clippings is negated by his abstract drawing, thus the two elements can coexist only through the artist's sensibility, not by virtue of any rational program or relationship. Many of these philosophic questions surface in Jasper Johns' work, which is ridden with subtle and devious critical nuances. Here, also, Johns' consummate ability as a draughtsman gives visual life to the intellectual concerns expressed by the content of his art, which often has overtones of philological quandary (cat. no. 86). The austere beauty of Eva Hesse's drawings would seem to put her at a remove from the more explicit imagery of Rauschenberg or Johns. However, she admired Johns' target paintings, and her fascination with the repetition of forms, or in her sculpture, the issue of overwhelming scale, can be seen as an adumbration of a Dadaist sense of the absurd (cat. no. 82).

A number of contemporary artists continue to be concerned with the human figure, the *doyen* among them being Philip Pearlstein (cat. no. 91). His lush ink wash drawings or watercolors celebrate the tactile beauty of the body without reference to larger social issues, as the artist has commented. Antonio López García's *verismo* is of a different order; an unworldly light reveals detail with such extraordinary clarity that the viewer—awestruck by the artist's skill—is in danger of accepting as the artist's message the literal rendition of objects, without questioning whether the subject matter may have been selected to express an emotional or philosophic outlook (cat. no. 90).

Taken in all, the 91 drawings and watercolors selected for this exhibition illustrate a number of the major personalities and issues which have shaped the history of European and American art since the early years of the nineteenth century. The entirely exceptional level of formal invention expressed by personalities of astonishingly diverse temperaments makes the study of this period a constantly fascinating, and demanding, exercise. Throughout the history of these years, the art of drawing has played a variety of essential roles, from the conventional ones of preparatory studies or reference notes to the creation of independent works of art, complex and exacting in their formal and intellectual concerns.

Victor Carlson

The following publications of The Baltimore Museum of Art are cited so frequently that they are given in abbreviated forms: *Baltimore Museum of Art News; Cone Collection*, Baltimore: Baltimore Museum of Art, 1955; *Paintings, Sculpture and Drawings in the Cone Collection*, Baltimore: Baltimore Museum of Art, 1967; *Saidie A. May Collection*, Baltimore: Baltimore Museum of Art, 1972; *Thomas Edward Benesch Memorial Collection*, Baltimore: Baltimore Museum of Art, 1970.

JEAN-AUGUSTE-DOMINIQUE INGRES
French, 1780-1867

1. *Portrait of the Architect André-Marie Chatillon*

Pencil on off-white paper

8⁷/₈ x 6¹/₂ ins. (22.5 x 16.4 cms.) sheet

Signed and dated in pencil, lower right: INGRES. del. *vit* Rome. M.D.CCC.X.

Museum Purchase, 1979

PROVENANCE: Mme. de Valpinçon, before 1888 (according to Courboin, 1895); Charles Ledoux, Château Brignac, Maine-et-Loirs; M. de Marguerie, son-in-law of the preceding owner; sold in Paris, 1952, by Dr. Otto Wertheimer to M. Knoedler & Co., New York; purchased by Mrs. Edward F. Hutton, Westbury, Long Island; sold Sotheby's, London, July 8, 1964, no. 82, illus.; purchased by Feilchenfeldt, Zurich; sold by the latter to the Galerie Lorenceau, Paris, in 1968; purchased by an anonymous private collector; purchased by Feilchenfeldt, Zurich, 1978.

EXHIBITIONS: Norton Gallery, West Palm Beach and Lowe Gallery, University of Miami, Florida, "French Painting, David to Cézanne," 1953, no. 3; Paris, Galerie Lorenceau, "Les Maitres du Dessin (1820-1920)," 1968, no. 1.

BIBLIOGRAPHY: François Courboin, *Inventaire des dessins, photographies et graveurs relatifs à l'histoire général de l'art, légués au département des estampes de la Bibliothèque nationale par M. A. Armand*, vol. 1, Lille, 1895, no. 10,100; Hans Naef, "Eighteen Portrait Drawings by Ingres," *Master Drawings*, vol. IV, no. 3, 1966, mentioned p. 258; Hans Naef, *Die Bildniszeichnungen von J.-A.-D. Ingres*. Berne, 1977, vol. I, pp. 203-05 and vol. IV, cat. no. 58, p. 110, repr.

André-Marie Chatillon won the Prix de Rome for architecture, arriving at the Villa Medici in 1809, where Ingres had been in residence since 1806. Born in Paris December 7, 1782, as an architect Chatillon did not make a great impression on his contemporaries, although his scanty biography indicates that he did from time to time receive official appointments for work to be undertaken in Paris or the provinces; it is unclear whether the architect died in 1854 or 1859.

Portraits in strict profile are infrequent in Ingres' work, whether drawn or painted. A number of the artist's earliest surviving drawings ca. 1792-1797 are graphite portrait studies, each circular in format, which look back to earlier examples by Charles-Nicolas Cochin (1715-1790), for example (cf. Naef, 1977, vol. IV, cat. nos. 3-6, 10-14). As Naef has observed, Ingres later executed a number of profile views of sitters, usually friends or fellow artists, from ca. 1810 to 1814. The same authority has suggested that the artist's interest in the expressive potential of this pose may have been prompted by the profile figures in several major paintings which Ingres was at work on in precisely these years (*Jupiter and Thetis*, 1811; *Romulus Victorious Over Acron*, 1812; *Virgil Reading the Aeneid*, 1812; Georges Wildenstein, *Ingres*, Phaidon, New York, 1954, cat. nos. 72, 82, 83).

Given Ingres' intense admiration of classical art, he must have studied with admiration–and perhaps envy–antique cameos and carved gems. The refined and nuanced modeling of the Chatillon portrait, the surface of which is happily of exceptional freshness, suggests that the artist knew these sources. Chatillon's head is set against a ground of much heavier hatchings, thus emphasizing the bas-relief quality of the modeling. This has led Naef to raise the question whether Ingres might not have intended that the Chatillon portrait serve as the model for a medallion. The year before, in 1809, Ingres came to know the medalist Edouard Gatteaux, a faithful friend whose notable collection of Ingres drawings is today in the Louvre. Could the draughtsman have intended these profile portraits, otherwise such an exception in Ingres' work, for the use of his friend?

Victor Carlson

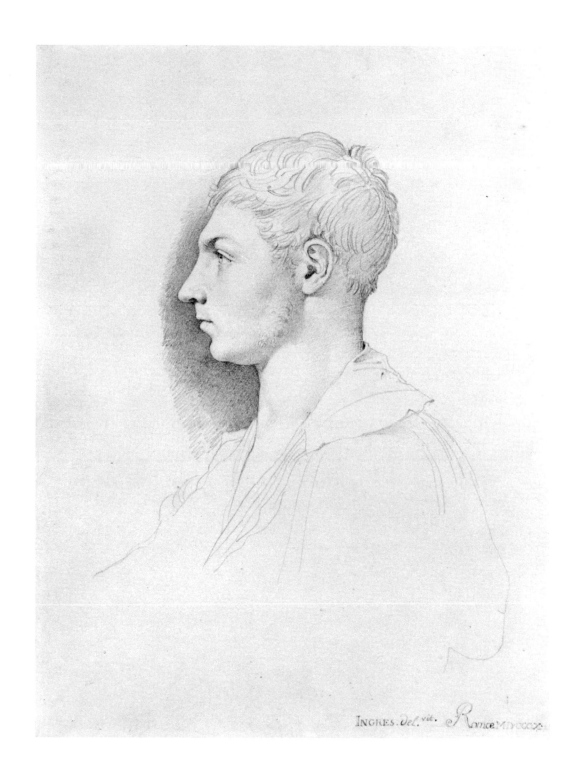

INGRES. del.^{vit.} Romæ MDCCCX.

17

EUGENE AMAURY-DUVAL
French, 1808-1885

2. *Portrait of a Lady (Portrait de Femme)*　circa 1850s

Pencil with brush and gold ink on lightweight off-white wove paper

11⁵/₁₆ x 10⁹/₁₆ ins. (28.8 x 26.8 cms.) sheet

Signed and dated in faint pencil at lower right: *Amaury-Duval/ 185*, last digit illegible

Purchase, Women's Committee Fund, 76.68

PROVENANCE: Albert Cavé, Paris; Gaston Leroy, Paris; Cavé-Leroy Sale, Hotel Drouot, Paris, May 19-20, 1926, no. 19; Stefanie Maison and Hazlitt, Gooden & Fox, London; purchased from Shepherd Gallery, New York, in 1976.

EXHIBITIONS: London, Stefanie Maison and Hazlitt, Gooden & Fox, *Nineteenth Century French Drawings*, May 20-June 18, 1976, no. 21, repr. pl. 2 (attributed here to Lehmann); New York, Shepherd Gallery, *The Non-Dissenters Fifth Exhibition*, November 1-December 31, 1976, no. 2, repr.

Although signed in faint pencil at the lower right, Eugène Amaury-Duval's *Portrait of a Lady* was for some time incorrectly attributed to the German-born Henri Lehmann (1814-1882). A mat cut with a circular opening had covered the signature, and inscriptions on the backing material identified the artist as Lehmann. Both painters, fellow students of Ingres, emulated the master's style in drawings and oils. The stylistic homogeneity found in the art by Ingres' followers as well as the fact that their work remains little studied contributed to the misattribution.

Compositionally similar to Ingres' numerous pencil portraits, Amaury-Duval portrays a centrally placed seated figure. Primary attention is focused on the sitter's face, as she confronts the viewer and on her hands, somewhat nervously clasped on her lap. Her simple jewelry is indicated by accents of gold paint.

Some of Amaury-Duval's portraits more clearly imitate Ingres (for instance, see portraits of a man and a woman, repr. in *Allen Memorial Art Museum Bulletin* XXIV, 3, Spring 1967 as catalogue for the exhibition, *Ingres and his Circle*, nos, 8 and 9). In the present drawing, however, the artist describes a lady with soft modeling and gentle draughtsmanship, which is less dependent upon Ingres' example.

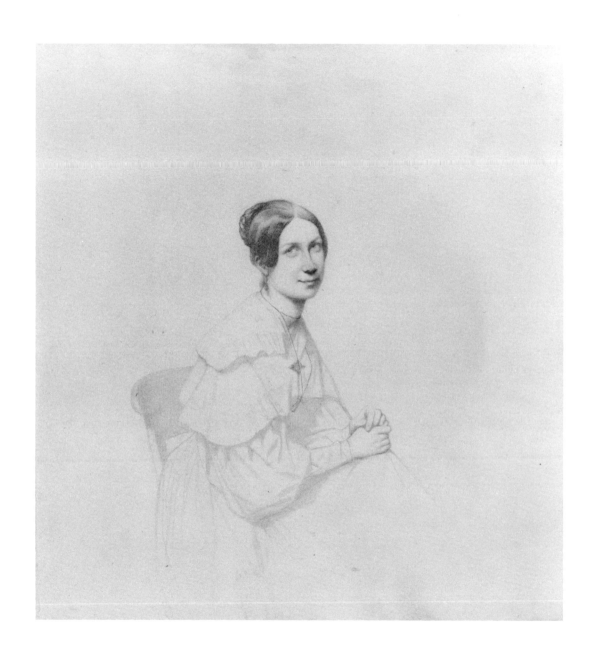

THEODORE CARUELLE d'ALIGNY
French, 1798-1871

3. *Landscape at Olevano*

Pencil on off-white wove paper

10¹¹/₁₆ x 17⁵/₈ ins. (27.2 x 44.8 cms.) sheet

Inscribed in pencil at lower left: *à Olèvano*
Studio stamp in red at lower left: *THre ALIGNY* (Lugt 6)

Purchase, Blanche Adler Fund, 76.29

PROVENANCE: Purchased from Colnaghi, London, in 1976.

Théodore d'Aligny became friends with Camille Corot while both were young students in Rome during the 1820s. Like Corot, Aligny drew his landscapes directly after nature in the countryside near the Italian capital. The town of Olevano, seen in the distance in the present drawing, lies to the east of Rome. Aligny chose a rock formation in a bright airy spot as the central motif. The carefully delineated structure of natural forms reflects the artist's keen observation of details and the clarity of his organization of data. Upon his return to France, Aligny was one of the first painters to live and paint in the Forest of Fontainebleau around Barbizon, the later domicile of Jean-François Millet and Charles Jacque.

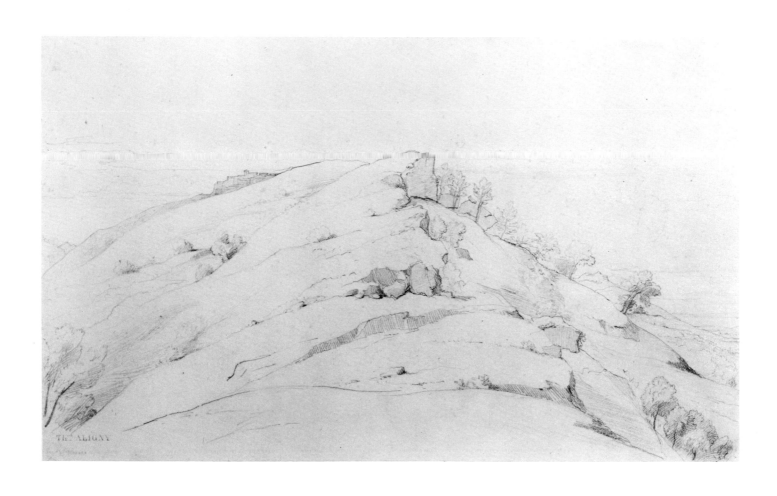

JEAN BAPTISTE CAMILLE COROT
French, 1796-1875

4. *Two Studies of Young Boys*

Pencil on white laid paper

7¹³/₁₆ x 9⁷/₈ ins. (20 x 25.2 cms.)

Purchase, Nelson and Juanita Greif Gutman Fund, 67.18

PROVENANCE: Purchased from Hans Calmann, London, in 1967.

BIBLIOGRAPHY: *Art Quarterly* (Spring, 1967), p. 172; *Gazette des Beaux-Arts*, suppl. 1189 (Feb. 1968) p. 79; BMA *News*, vol. xxx, nos. 1-2, 1968, p. 27.

The two studies of young boys wearing smocks, one staring wide-eyed at the viewer and the other asleep, cannot be found among the staffage used by Corot for his paintings. However, similar if not identical figure studies do occur in Corot's early painted works (see Alfred Robaut, *L'Oeuvre de Corot*. Paris, H. Floury, 1905, vol. 2, nos. 56-57, ca. 1823-1826). Unfortunately the artist's drawings have never been adequately surveyed, consequently it has not been possible to find among Corot's early documented sheets as exact parallel to the style of the Baltimore study.

Nonetheless, the attribution to Corot, which has been questioned verbally, can be defended. Although the crystalline play of light over the figures, modeled with exactly defined shadows created by areas of parallel pencil lines, is a style of draughtsmanship widely practiced during the 1820s, the work under consideration here demonstrates certain inflections which point to Corot's authorship. The stolid pose of the young boy in the upper left or the dozing youngster at the lower right, his slumping figure drained of all energy, are sympathetically observed types which recall the staffage of several Corot oils ca. 1830-1833 (Robaut 222, 224 bis, 244), as well as the earlier oil sketches of figures mentioned above.

Moreover, the artist's method of drawing the *Two Studies of Young Boys* corresponds exactly to Corot's practice. A slight preliminary sketch established the poses of each figure, serving as well to determine the placement of shadows, which were added next. Finally, over this ground, details of costume and facial expression completed the studies, the artist at this stage working with a finely pointed pencil and heavier pressure. Even in a somewhat later drawing *Young Woman Seated With Her Arms Crossed*, ca. 1840 (Paris, Louvre) Corot's working methods are the same, although the style of the latter work is looser than the presumably earlier Baltimore drawing (for an excellent reproduction of the Louvre drawing, see *French Drawings From Prud'hon to Daumier*, introduction by Maurice Serullaz, Greenwich, Conn., New York Graphic Society, 1966, pl. 76). Although the absence of the familiar Corot estate sale stamp (Vente Atelier Corot-Lugt 461) may be momentarily disconcerting, it should be noted that a number of perfectly authentic Corot figure drawings lack this verification (Paris, Orangerie des Tuileries, *Hommage à Corot*, June 6-September 29, 1975; cat. nos. 141, 142, 150, 152, 156).

Victor Carlson

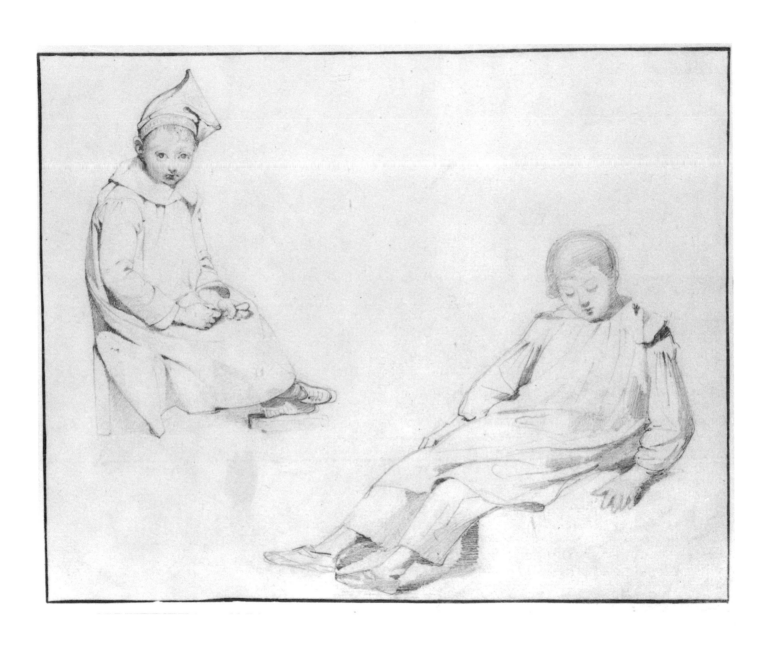

THEODORE GERICAULT
French, 1797-1824

5. *Sketches for the Heads of Sailors in the Scene of the "Mutiny" (Study for the "Raft of the Medusa")* circa 1818

Pen and brown ink over pencil on brown wove paper

8¼ x 10⁵/₁₆ ins. (20.9 x 26.1 cms.) sheet

Signed in pencil at lower left corner: Géricault

Purchase, Fanny B. Thalheimer Bequest Fund, 77.44

PROVENANCE: César de Hauke, Paris, 1953; Galerie Brame, Paris; purchased from Hazlitt, Gooden & Fox, Ltd., London, in 1977.

EXHIBITIONS: Winterthur, Kunstverein, *Théodore Géricault*, August 30-November 8, 1953, no. 145, not repr.; Paris, Bernheim-Jeune & Cie, *Gros, Géricault, Delacroix*, January 1954, no. 47, not repr.; London, Hazlitt, Gooden & Fox, *19th Century French Drawings*, May 19-June 17, 1977, no. 13, repr. pl. 14.

BIBLIOGRAPHY: Lorenz Eitner, *Géricault's Raft of the Medusa*, New York & London: Phaidon, 1972, no. 31, not repr.

REMARKS: Previously called *Trois têtes de soldats*.

Sketches for the Heads of Sailors is a sheet of studies for figures which appear in a detailed pen and ink drawing, *Mutiny on the Raft* (Stedelijk Museum, Amsterdam; repr. in Eitner, pl. 6). "The Mutiny" along with "The Rescue" and "Outbreak of Cannibalism" were episodes from an eyewitness account by Corréard and Savigny of the shipwrecked Medusa and the plight of those left abandoned in the high seas on a makeshift raft. Géricault explored several incidents in depth before choosing the moment of the first sighting of Argus, the rescue ship, as the subject of his oil *The Raft of the Medusa* (Louvre), which he exhibited at the Salon of 1819. (For a detailed history of the painting's development, see Lorenz Eitner, *Géricault's Raft of the Medusa*, New York and London; Phaidon, 1972).

As Eitner has noted in private correspondence, the three faces in the Baltimore drawing bear a striking resemblance to Géricault's *Self Portrait* (Frances S. Jowell Collection, Toronto; repr. in the 1971 Los Angeles catalogue, *Gericault*, pl. 70), where the model wears a similar cap. One wonders if the artist purposefully included his own image to empathize with the stricken sailors, or whether he was just his most convenient subject. The anguished faces, composed in rapid pen strokes, display various emotional responses to the horrifying event: despair, fear, shock.

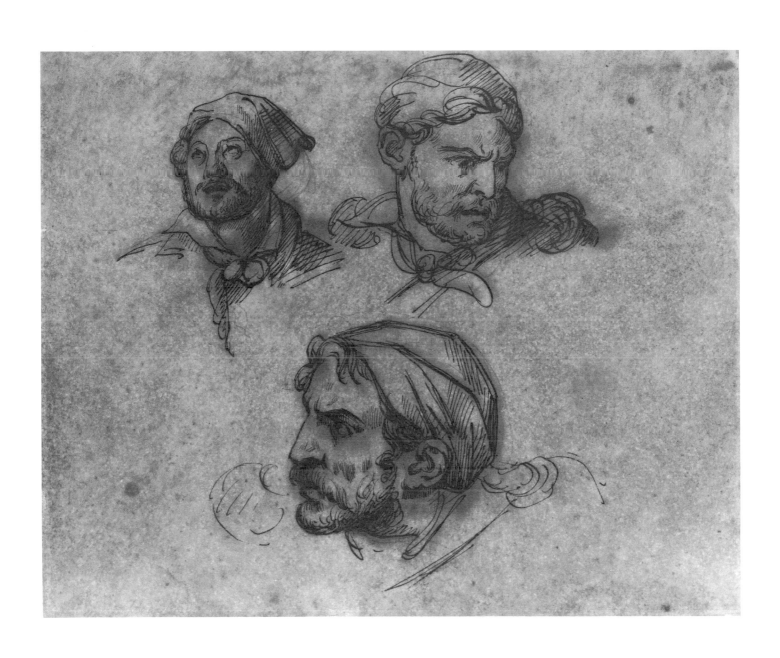

EUGENE DELACROIX
French, 1798-1863

6. *Two Views of a Young Arab*
 (Jeune Arabe, vue de face et debout) circa 1832

Brush and watercolor over pencil on off-white wove paper

11¹¹⁄₁₆ x 13⁹⁄₁₆ ins. (29.7 x 34.5 cms.) sheet

Studio stamp in red at lower left: *E.D* (Lugt 838)

Purchase, Nelson and Juanita Greif Gutman Fund, 76.27

PROVENANCE: Vente Delacroix, Paris, February 17-29, 1864, no. 531; sold to M. Gariel (information from Robaut); Sale, Palais Galliera, Paris, March 16, 1972, no. 6, repr.; purchased from Stefanie Maison and Hazlitt, Gooden & Fox, London in 1976.

EXHIBITIONS: London, Stefanie Maison and Hazlitt, Gooden, & Fox, *Nineteenth Century French Drawings*, May 20-June 18, 1976, no. 6, repr. pl. 10.

BIBLIOGRAPHY: Alfred Robaut and Ernest Chesneu, *L'oeuvre complet d'Eugène Delacroix*, Paris: Charavey Frères, 1885, no. 1590.

In 1832, two years after the French conquest of Morocco's neighbor Algeria, Eugène Delacroix accompanied the Comte de Mornay on a diplomatic mission to Morocco. René Huyghe has aptly described this journey as "the most overwhelming experience of his life." (*Delacroix*, New York: Harry N. Abrams, 1963, p. 265). There under strong sunlight which creates glistening reflections, the Romantic painter delightedly observed and recorded episodes full of local color. In a letter to Armand Bertin, Delacroix wrote: "The picturesque is here in abundance. At every step one sees ready-made pictures, which would bring fame and fortune to twenty generations of painters." (from *Eugène Delacroix, Selected Letters*, London: Eyre and Spottiswoode, 1971, p. 192). He found the Moroccan people fascinating:

Imagine, my friend, what it is to see lying in the sun, strolling in the street, or repairing old shoes, men of the consular type, Catoes, Brutuses-even possessed of the disdainful air that the masters of the world ought to have; these people own only a single garment, in which they walk, sleep, and are buried, and yet they appear as satisfied as Cicero would be in his curule chair. I tell you that you will never believe what I shall bring back because it will be so far from the truth and the nobility of these natures. The antique has nothing more beautiful.

(From letter to Pierret, as quoted in Frank Anderson Trapp, *The Attainment of Delacroix*, Baltimore and London: Johns Hopkins Press, 1971, p. 114)

Delacroix filled sketchbooks with pencil and watercolor drawings, often annotating them with vivid descriptions. Seven sketchbooks remain intact (one in the collection of Musée Condé, Chantilly, has been reproduced in facsimile); others have been broken up and the individual sheets sold. *Two Views of a Young Arab* no doubt comes from one of these dispersed volumes.

These detailed studies of arabs, their costumes, arms and armor, and architectural or landscape settings provided Delacroix with a visual dictionary he would consult throughout his life. Some of his most famous oils painted during the decade following his trip, including *The Jewish Wedding* and *Women of Algiers*, closely follow watercolor sketches made in North Africa. Other motifs—pure landscapes, groups of riders or single figures such as represented in the present drawing—exist only in sketch form. Whether drawn as documentation for future paintings or independent records of what he saw, Delacroix's Moroccan watercolors are some of the most beautiful works in his œuvre.

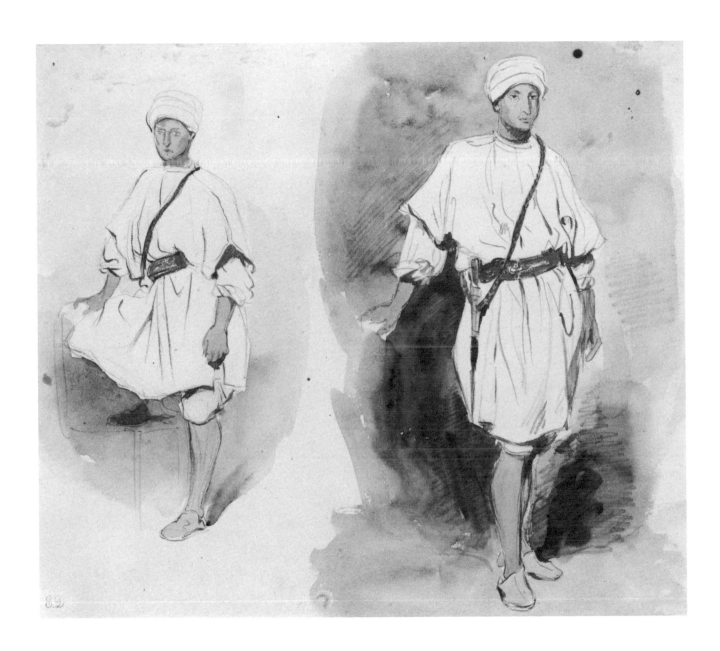

ANTOINE LOUIS BARYE
French, 1796-1875

7. *Tiger Stalking Prey (Tigre guettant une proie)*

Pen and black ink over brush and watercolor on off-white wove paper

7³⁄₈ x 10¹¹⁄₁₆ ins. (18.6 x 27.2 cms.) sheet

Signed in brush and blue watercolor at lower right: *BARYE*

George A. Lucas Collection on Indefinite Loan to The Baltimore Museum of Art from the Maryland Institute College of Art, L.34.48.610

PROVENANCE: Dutilleux Sale, Hotel Drouot, March 26, 1874, no. 37; Robaut; George A. Lucas.

EXHIBITIONS: Paris, Galerie Durand-Ruel, *Rétrospective de tableaux et dessins de maîtres modernes*, 1878, no. 8; Paris, Ecole des Beaux-Arts, *Barye*, 1889, no. 686; Baltimore, Maryland Institute, *Lucas Collection*, 1911, no. 610; Baltimore, Baltimore Museum of Art, *George A. Lucas Collection*, October 12-November 21, 1965, no. 303, not repr.

BIBLIOGRAPHY: Charles Otto Zieseniss, *Les Aquarelles de Barye, Etude critique et catalogue raisonné*, Paris: Editions Charles Massen, n.d. (c. 1954), no. B 44, p. 68, repr. pl. 16.

Famous as the great "animalier" sculptor of nineteenth century France, Antoine Louis Barye executed over 200 watercolors. With brush and watercolor, the artist represented the same motifs he created in bronze–lions, tigers, serpents, etc.–but placed the animals within a landscape setting. As in the present case, his watercolors are usually not directly related to any individual sculpture. Barye first exhibited watercolors at the 1831 Salon and participated in numerous watercolor shows. As neither his oils nor his watercolors are dated and were not precisely documented when exhibited, a chronology is difficult to establish.

Barye, frequently accompanied by his friend Eugène Delacroix between 1828 and 1833, visited the Jardin des Plantes in Paris to observe and sketch the animals in the zoo. Throughout his life, Barye continued to make such excursions to the menagerie, which was enriched with many Bengal tigers, elephants, and other exotic creatures during the Second Empire. Anecdotes tell of the sculptor's Baltimore patron William T. Walters calling on Barye in Paris during the 1860s only to be told that the artist had gone off to see a new tiger just arrived at the zoo (Stuart Pivar, *The Barye Bronzes*, [Woodbridge]. Antique Collectors' Club, 1974, p. 5).

More than a dozen watercolors portray single tigers (Zieseniss, nos. B 31-44). Some represent the tiger calmly strolling, rolling on the ground, or at rest surrounded by the countryside. The present work, in contrast, is the most dramatic, featuring a snarling beast with tail rigidly extended silhouetted against an expansive blue sky.

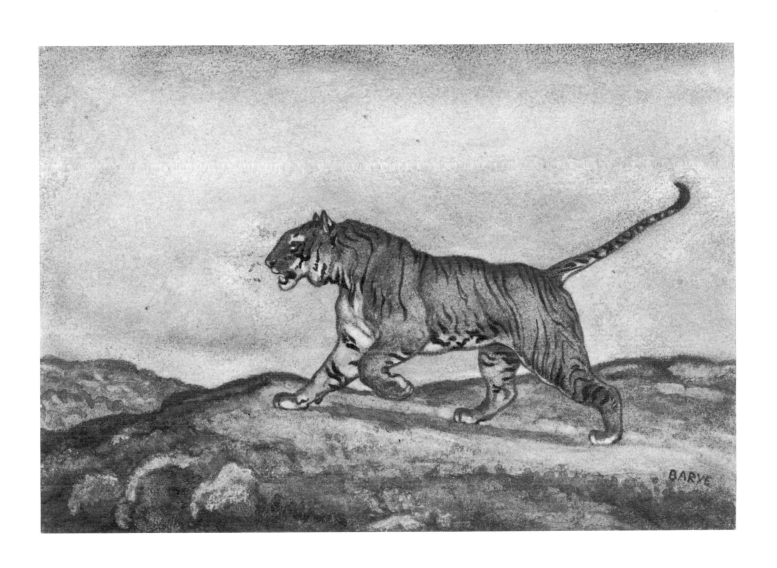

ALFRED DE DREUX
French, 1810-1860

8. *Cavaliers* 1833

Pencil on off-white wove paper

4³/₄ x 6³/₈ ins. (12 x 16.3 cms.) sheet

Signed and dated in pencil at lower right: *Alfred. D.D./1833*

Purchase, Lillian L. Cox Fund, 76.28

PROVENANCE: Purchased from Hector Brame-Jean Lorenceau, Paris, in 1976.

Alfred De Dreux, son of the architect Pierre-Anne Dedreux, specialized in equestrian subjects, such as represented in the present drawing. The horse was a favored theme of the Romantic painters including Eugène Delacroix and Théodore Géricault, the latter a friend of De Dreux.

The steep hillside landscape setting serves as a device to place the horse in an energetic pose with forelegs stretched out and body muscles bulging. De Dreux carefully describes the animal's anatomy and the figure's contemporary riding habit.

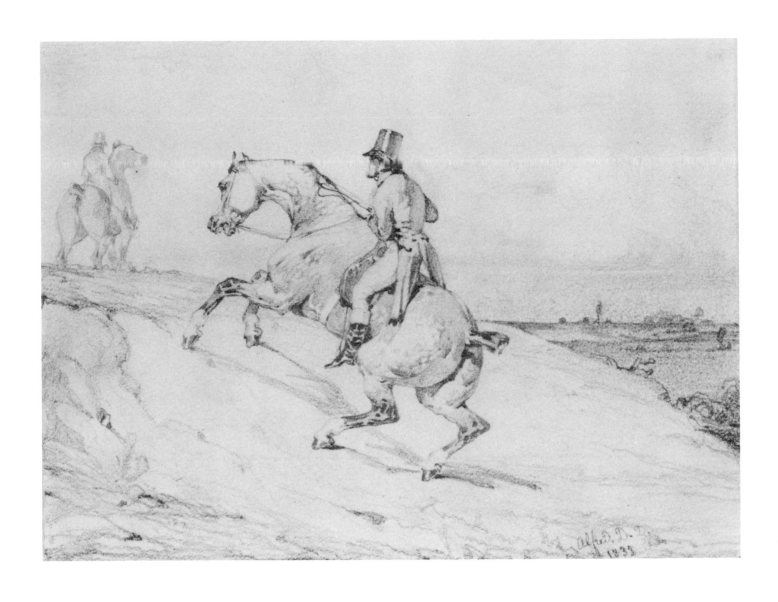

J. M. W. TURNER
English, 1775-1851

9. *Grenoble Bridge* circa 1824

Pen and black ink, brush and watercolor and gouache, with heightening in brush and white ink on off-white wove paper

20⅞ x 28¼ ins. (53 x 71.7 cms.) uneven sheet

Signed in white ink at lower right: *JMW Turner*

Purchase, Nelson and Juanita Greif Gutman Fund, 68.28

PROVENANCE: Painted for Charles Holford of Hampstead in 1824 (information from Christie's 1872 Sale catalogue); Holford Sale, Christie's, June 24, 1861, no. 28; purchased by Francis Broderip; Sale, Christie's, February 6, 1872, no. 626; purchased by Thomas Agnew & Sons, London; Thomas Greenwood of Sandfield Lodge, Hampstead; Sale, Christie's March 12, 1875, no. 282; Thomas Agnew & Sons, London; Earl of Dudley; Sir Donald Currie; Lady Mirrielees (Currie's daughter); Mrs. M. Craven (Lady Mirrielees' daughter); purchased from Thomas Agnew & Sons, London, in 1968.

EXHIBITIONS: London, Royal Academy, *Old Masters*, 1907, no. 224; London, Thomas Agnew & Sons, *Centenary Loan Exhibition of Water-colour Drawings by J. M. W. Turner, R.A.*, February-March 1951, no. 22, not repr.; Chapel Hill, William Hayes Ackland Memorial Art Center, University of North Carolina, *English Watercolors and Drawings: 1700-1900*, September 21-October 26, 1975, no. 64, repr. pl. 4.

BIBLIOGRAPHY: Sir Walter Armstrong, *Turner*, London: Thomas M. Agnew & Sons, 1902, p. 256, not repr.; *Gazette des Beaux-Arts* supp. February 1969, no. 304, repr. p. 72; Diana F. Johnson, "*Grenoble Bridge* by J. M. W. Turner," *Annual III*, Baltimore Museum of Art, 1968, pp. 39-41, repr. p. 38, fig. 1.

Related in style to J. M. W. Turner's elaborate watercolors executed for transposition into engraving or mezzotint, *Grenoble Bridge* reflects the popularity of picturesque views. This watercolor was commissioned in 1824 by Charles Holford, probably as a souvenir of his travels.

Turner frequently referred to earlier sketches as sources for his watercolor compositions, as in the present case. Two chalk drawings from the 1802 "Grenoble Sketchbook" (124 loose sheets) executed during the artist's first visit to the Continent, served as topographical guides for *Grenoble Bridge*. One drawing was catalogued by A. J. Finberg (*A Complete Inventory of the Drawings of the Turner Bequest*, London: National Gallery, 1909, Vol. I, LXXIV, no. 547a), while the second, one of 27 sheets not listed in Finberg's inventory, is reproduced in the Baltimore Museum's *Annual III* (p. 41). A comparison of the latter with the Baltimore watercolor indicates that Turner followed the basic composition of his earlier drawing. In the watercolor he made alterations to background architecture, such as raising the height of both the bridge's tower and another square tower near the right edge, as well as more fully delineating architectural details such as windows and roof tiles. The major change is the introduction of various genre figures to give picturesque interest to the view. Such figures are only implied in a very rudimentary manner in the early sketch.

Also connected with *Grenoble Bridge* are three watercolors of approximately the same dimensions as the present work, listed by Finberg under the heading "1820-1830 Colour Beginnings" (CCCLVIII, nos. 346, 367, and 368). Number 368, the least descriptive of these watercolors, establishes the general massing of color with pale blue in the center and distance while golden orange is used for the architecture and sunlit foreground water. Number 346, providing a more detailed rendering of buildings and bridge towers, also includes brief indications of the boat at the left and figures on the right bank which appear in the Baltimore version. However, the overall coloration of the former is dominated by a brilliant peacock blue not found in the present example. Number 367 most closely anticipates the finished version in its greater detailing of figures, boats, and laundry in the foreground as well as in the use of densely applied reddish orange heightening for elements such as the roof tiles.

Somewhat surprisingly, no pencil underdrawing is readily apparent in *Grenoble Bridge*. One wonders if the artist's reliance on the Grenoble Sketchbook drawing and his experiments with various hues in the three "color beginnings" allowed Turner to apply watercolor without a skeletal framework. In an earlier example, however, he did sketch the entire composition in pencil before applying watercolor as seen in his unfinished 1819 *View from Naples* (repr. in 1975 British Museum exhibition catalogue, *Turner in the British Museum*, no. 72), where the lower half of the sheet remains bare save for the linear structure.

Turner designed picturesque scenes throughout his career. As early as 1811 W. B. Cooke commissioned him to illustrate *Picturesque Views of the Southern Coast of England*. Another series, *The Rivers of England*, was published just a year before Turner painted *Grenoble Bridge*. The composition of one of the illustrations for that series, *Newcastle-on-Tyne*, bears striking resemblance to the Baltimore river scene (see watercolor study, *Newcastle-on-Tyne*, repr. in *Turner in the British Museum*, no. 85). In the years following *Grenoble Bridge*, Turner executed topographical watercolors of towns along the Seine and Loire, later translated into engraving and published as three volumes of *Turner's Annual Tour* in 1833, 1834, and 1835.

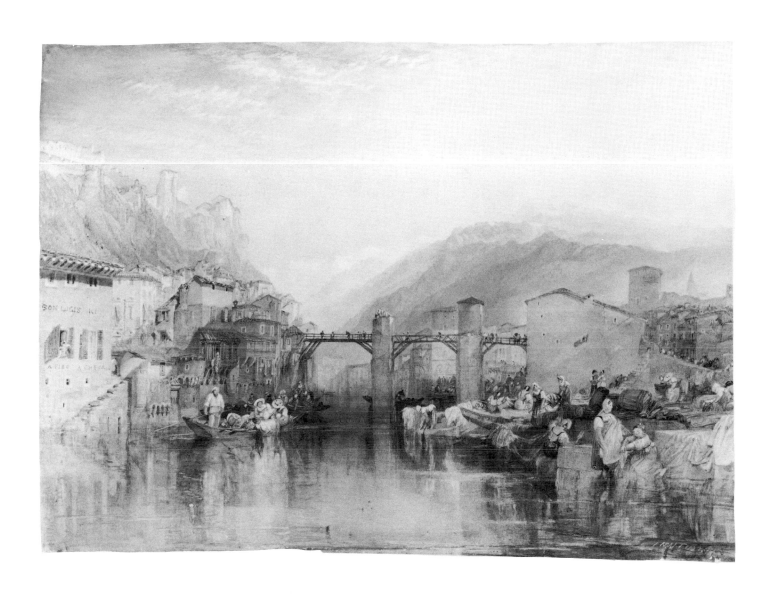

EUGENE ISABEY
French, 1804-1886

10. *A Shore Encampment* circa 1830

Brush and watercolor over pencil on off-white wove paper

5⅜ x 11¾ ins. (13.7 x 29.9 cms.) sheet

Initialed in faint pencil at lower right: *EI*

Inscribed in pencil on verso: *Mont bleu*----(illegible)

Purchase, W. Claggett Emory Fund, 63.258

PROVENANCE: Joubin; Paccil; Gilbert David (Lugt 757a) (information from dealer, no collector's marks on drawing); Helene Seiferheld, New York, 1963.

EXHIBITIONS: Ann Arbor, University of Michigan Museum of Art, *French Watercolors, 1760-1860*, September 29-October 24, 1965, no. 55, not repr.; Cambridge, Fogg Art Museum, *Eugène Isabey, Paintings, Watercolors, Drawings, Lithographs*, November 22-December 29, 1967, no. 26, repr.; College Park, University of Maryland Art Gallery, October 26-December 4, 1977, Louisville, J. B. Speed Art Museum, January 9-February 18, 1978, and Ann Arbor, University of Michigan Museum of Art, April 1-May 14, 1978, *From Delacroix to Cezanne: French Watercolor Landscapes of the 19th Century*, no. 94, repr. p. 37.

In 1830, Eugène Isabey accompanied the French Expedition to Africa, as its official painter. Not as deeply moved by the strong light, exotic people and picturesque environs as would be his compatriot Eugène Delacroix two years later (see cat. no. 6), Isabey apparently was not greatly attracted to North African subjects. No known paintings and only a handful of lithographs, published in Baron Denniée's *Précis historique et administratif de la Campagne d'Afrique*, remain as evidence of his impressions during the African sojourn.

The present watercolor is thought to have been painted during this voyage as the brilliant sunlight shimmering across the sandy beach and the rich blue sea suggest a North African setting. Five years earlier Isabey had journeyed to England, where both he and Delacroix studied drawings by English watercolorists, whose examples influenced the French artists' technique. In *A Shore Encampment* Isabey uses watercolor in its pure form, allowing areas of bare white paper to function as sparkling sunlight on the sand or as glistening reflections across the clear blue water. At the same time, the transparency and fluidity of the medium are readily apparent; color variations of sand are subtly indicated by overlapping washes of different hues of tan. The low slung pup tent and casually placed objects in the middle ground are chosen for their picturesque shapes and local color. This intimate landscape, rendered with great immediacy, does not appear to be a study for Isabey's panoramic African views executed in lithography (see Atherton Custis, *Catalogue de l'oeuvre lithographie de Eugène Isabey*, Paris: Paul Prouté, 1939, nos. 24-28).

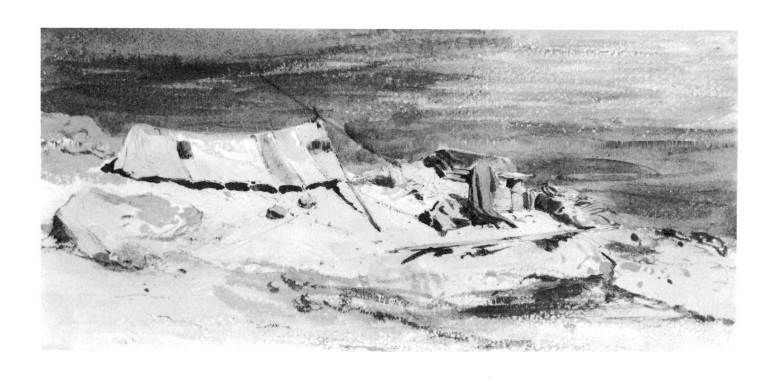

CHARLES EMILE JACQUE
French, 1813-1894

11. *Portrait of the Artist's Daughter* 1854

Black and white chalk on tan laid paper

6³/₁₆ x 5¹/₄ ins. (15.8 x 13.3 cms.) sheet

Signed and dated in black chalk at lower right: *Cb Jacque/1854*

Purchase, Blanche Adler Fund, 75.6

PROVENANCE: Purchased from Shepherd Gallery, New York, in 1975.

EXHIBITIONS: New York, Shepherd Gallery, *Ingres and Delacroix through Degas and Puvis de Chavannes: The Figure in French Art*, May-June 1975, no. 66, repr. p. 162.

Charles Jacque executed the present, somewhat pensive chalk portrait of his daughter in 1854. Four years earlier his etching portrayed her as a young curly-haired child holding a doll (see no. 155 in J. J. Guiffrey, *L'oeuvre de Ch. Jacque*, Paris: Mlle Lemaire, 1866). Flowing lines indicate her waving hair, while emphatic reinforced dark lines define the young girl's right profile and nose. Jacque's vigorous, seemingly spontaneous draughtsmanship recalls the drawings of his friend and neighbor, Jean-François Millet. The two artists had moved their families to Barbizon in the Forest of Fontainebleau in 1849, and lived in close communication for the following few years. There, they painted the rustic countryside and hard working peasants. With their friends, Théodore Rousseau and Diaz de la Peña, Jacque and Millet are considered the central painters of the Barbizon School. Jacque most typically represented farm scenes of sheep, cows, or hens. Portraiture is thus an unfamiliar, although attractive, facet of Jacque's work.

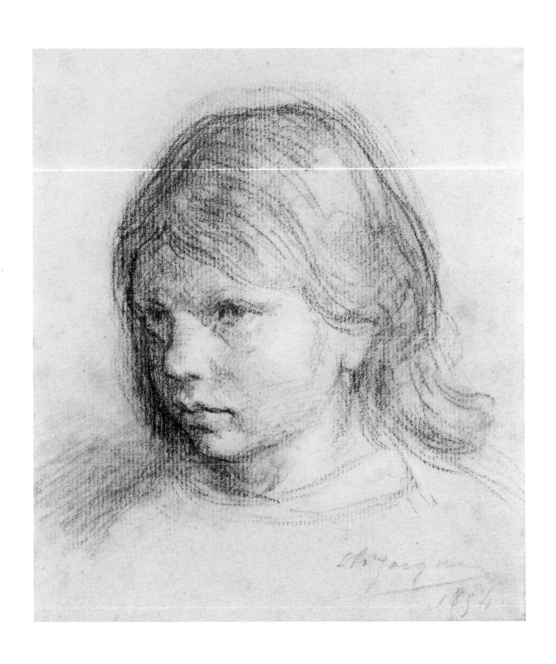

37

JEAN-FRANCOIS MILLET
French, 1814-1875

12. *The Gleaners* circa 1855-56

Black crayon on off-white China paper

7¹³/₁₆ x 11⁷/₁₆ ins. (19.8 x 29.1 cms.) sheet

Millet estate stamp at lower left: *J.F.M.* (Lugt 1460) and Millet Sale stamp on verso: *Vente/Millet* in oval (Lugt sup. 1816a)

George A. Lucas Collection on Indefinite Loan to The Baltimore Museum of Art from the Maryland Institute College of Art, L.33.53.5

PROVENANCE: Probably no. 180, Millet Sale, Paris, 1875; possibly purchased from Millet Sale by George A. Lucas (he attended sale and owned copy of catalogue; however his diary makes no mention of purchase from sale); George A. Lucas.

EXHIBITIONS: Baltimore, Maryland Institute, *Lucas Collection*, 1911, no. 210, not repr.; Baltimore, Baltimore Museum of Art, *A Century of Baltimore Collecting, 1840-1940*, June 6-September 1, 1941, p. 113, not repr.; Baltimore, Baltimore Museum of Art, *From Ingres to Gauguin*, 1951, no. 51, not repr.; Minneapolis, University of Minnesota, March 26-April 23, 1962 and New York, Solomon R. Guggenheim Museum, May 15-July 1, 1962, *The Nineteenth Century: 125 Master Drawings*, no. 82, not repr.; Baltimore, Baltimore Museum of Art, *George A. Lucas Collection*, October 12-November 21, 1965, no. 336, not repr.; New York, Shepherd Gallery, *The Forest of Fontainebleau, Refuge of Reality*, April 21-June 10, 1972, no. 50, repr.; Paris, Grand Palais, October 17, 1975-January 5, 1976, and London, Hayward Gallery, January 20-March 7, 1976, *Jean-François Millet*, no. 106, repr. p. 149 in French cat. and p. 87 in English cat.; Minneapolis, Institute of Arts, *Millet's "Gleaners*," April 2-June 4, 1978, no. 18, p. 18, repr. fig. 20.

BIBLIOGRAPHY: Gregory Hedberg, "J-F. Millet's *The Gleaners*," *Nineteenth Century* IV (Summer 1978), repr. no. 7, p. 80.

Jean-François Millet's interest in the subject of gleaners, those who gathered the scattered remainder of wheat left by reapers, spanned almost a decade, as Robert Herbert has documented in "Le dossier des *Glaneuses*" from the 1975-76 Paris *Millet* exhibition catalogue and more recently in his essay for the 1978 exhibition *Millet's "Gleaners*" shown at the Institute of Arts in Minneapolis. The earliest oil, a small vertical *Summer* (Collection Mr. and Mrs. John D. Rockefeller, 3rd; repr. in Paris cat., p. 147) was commissioned by Alfred Feydeau; Herbert thus dates it to 1852-53. That work estab-

lished the basic poses for the three monumental figures with a haystack and cart behind them. Millet later incorporated these figures, using an expanded horizontal format, in an etching (Delteil 12) and in his famous Salon painting of 1857 (Louvre; repr. in color in Jean Bouret, *The Barbizon School and 19th Century French Landscape Painting*, Greenwich: New York Graphic Society, 1973, p. 185).

As Herbert has suggested, the Lucas drawing is the principal study for the etching. Several factors support this positon. First, the drawing and etching are almost identical in size (drawing: 19.8 x 29.1 cms. sheet; etching: 19 x 25.2 cms.). Second, and more significantly, the important role of line in the Baltimore drawing for defining forms and details may be interpreted as anticipation by the artist of his need to reconstruct the composition in linear terms for use in etching. In contrast, other crayon studies related to the initial painting are drawn more loosely with foreground landscape only summarily suggested (see drawings in Musée Grobet-Labadié, Marseilles, repr. in Paris cat., p. 146; and in Louvre, repr. in Bouret, p. 184).

In addition, several details link the Lucas drawing to the small oil and etching, and distinguish it from the Salon painting. In the large oil for instance, the women's clothing has been modified: at the left, the woman's scarf has an added flap hanging down her neck and she no longer wears a vest; the center figure wears a pink scarf wrapped around her outstretched right arm; and the skirt of the figure at the right has been lengthened. Other changes made in the Louvre painting include placing the birds higher and farther away from the haystacks and moving the man on horseback at the right background farther to the right.

This comparison of related drawings, paintings, and etching enables us to place the Lucas drawing within the chronology of Millet's development of the "Gleaners" theme. The firm drawing of the three foreground women in the Baltimore study reflects an already established composition derived from the small 1852 oil. However, the expanded background landscape and small figures, which were not included in the latter, are very sketchily handled. In the etching, on the other hand, these background elements are clearly defined. Alterations made in the 1857 Salon painting providing accents of bright color imply a further development of the theme in the oil medium. Thus, the Lucas drawing, slightly predating the etching, comes midway in the 1850s, after the small oil and before the Salon painting.

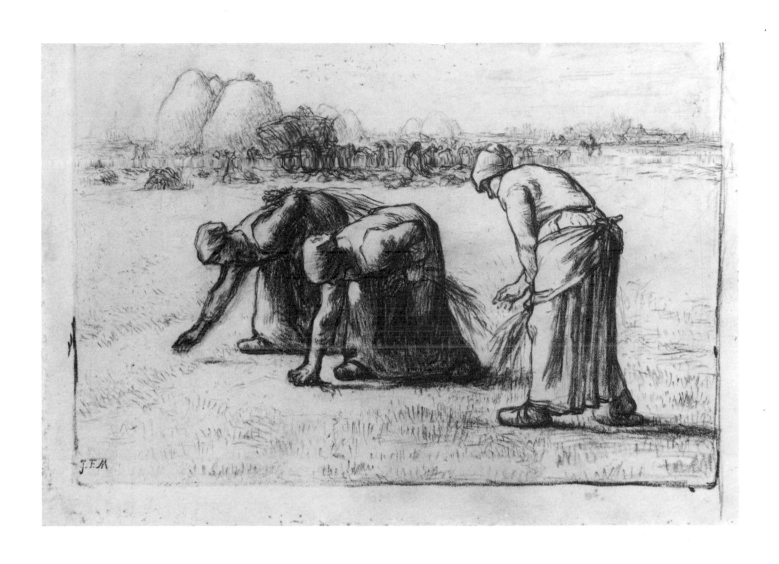

NARCISSE DIAZ DE LA PENA
French, 1807-1876

13. *Sunset*

Brush and gouache over black chalk on off-white wove paper

5³/₄ x 9¹/₈ ins. (14.7 x 23.2 cms.) sheet

Signed in pen and black ink at lower right: *N. Diaz.*

Purchase, Friends of Art Fund, 65.15

PROVENANCE: Purchased from the Drawing Shop, New York, in 1965.

EXHIBITIONS: New York, Shepherd Gallery, *The Non-Dissenters: David through Puvis de Chavannes*, May-June 1968, no. 84, not repr.; New York, Shepherd Gallery, *The Forest of Fontainebleau: Refuge of Reality*, April 21-June 10, 1972, no. 23, repr.; College Park, University of Maryland Art Gallery, October 26-December 4, 1977, Louisville, J. B. Speed Art Museum, January 9-February 19, 1978, and Ann Arbor, University of Michigan Museum of Art, April 1-May 14, 1978, *From Delacroix to Cézanne: French Watercolor Landscapes of the 19th Century*, no. 44, repr. p. 111.

Narcisse Diaz de la Peña, a French artist of Spanish descent, characteristically selected landscape motifs which allowed him to dramatize the momentary effects of light. *Sunset*, a theme here exploited for its dramatic impact, is full of movement and vivid color. The vibrant sky, consisting of thin layers of yellow, blue, gray and tan illuminates the darkened expansive field below, with small spots of bright red along the horizon line near the center of the sheet. As in the present example, Diaz emphasized the climatic flux or ever-changing aspects of nature in his paintings and watercolors of the rural French countryside near Barbizon, where he lived.

Sunset, by virtue of its color and texture, approximates oils of the same subject, which Diaz exhibited at the Salon in 1837 and onwards. The dense application of opaque gouache emulates the scumbled effect the artist achieved in his thickly applied oils.

CHARLES-FRANCOIS DAUBIGNY
French, 1846-1886

14. *Landscape*

Charcoal and crayon on tan laid paper

17½ x 24¾ ins. (44.6 x 62.9 cms.) sheet

Studio stamp in red at lower right: 🔴 (Lugt 518)

Purchase, Fanny B. Thalheimer Fund, 74,28

PROVENANCE: Mesdag Collection, The Hague; purchased from Sale, Sotheby-Park Bernet, London, July 4, 1974 by Shepherd Gallery, New York; purchased from Shepherd Gallery by the museum in 1974.

BIBLIOGRAPHY: *Gazette des Beaux-Arts*, supp., March 1976, no. 194, repr. p. 47.

Vigorous draughtsmanship characterizes Charles-François Daubigny's *Landscape*. Using a type of short hand, the artist plots the topography of the locale, distinguishing uphill from downhill from distant fields by heavy emphatic black lines. Within these demarcated areas more freely drawn hatchings further differentiate in an almost schematic fashion one tract of land from its neighbor. The silhouette of a large tree dominates the landscape, standing out against a broad sky. Like the adjoining shrubbery, the tree is created of curving rhythms which counterbalance the more angular geometry of the farmland.

Not directly related to any of Daubigny's etchings, nor a study for a known painting, the present drawing is somewhat unusual for the absence of small figures, animals, or birds that ordinarily appear in Daubigny's works. Previously in the Mesdag Collection in The Hague, Daubigny's drawing exemplifies the Barbizon naturalism that the young Dutch painter, Piet Mondrian probably knew first hand (see cat. no. 50).

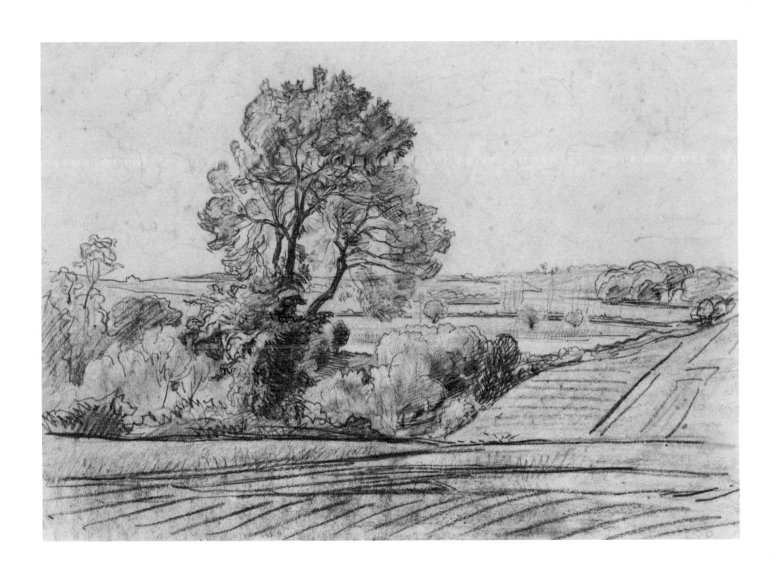

THOMAS COUTURE
French, 1815-1879

15. *Nude with Crossed Arms (Study for the Mural "Mater Salvatoris," in St. Eustache, Paris)*
circa 1851-56

Black crayon and pencil heightened with white crayon on tan laid paper

18¹/₈ x 13¹/₄ ins. (46.1 x 33.7 cms.) sheet

Initialed in black crayon at lower left: *T.C.* Inscribed in pencil on verso at lower right: *D1972* and at lower left: *RGTS*

Purchase, Nelson and Juanita Greif Gutman Fund, 74.44

PROVENANCE: Purchased from Shickman Gallery, New York, in 1974.

Nude with Crossed Arms is a preparatory study for a figure in Thomas Couture's mural, *Mater Salvatoris*. In 1851 the artist received a commission to execute three large oil paintings for the Chapel of the Holy Virgin in the Church of Saint-Eustache in Paris. The only major commission which Couture completed, the chapel was opened to the public in 1856. The central mural behind the altar, inscribed "Mater Salvatoris Ore Pro Nobis," depicts the enthroned Savior's Mother flanked by thirteen angels (repr. in University of Maryland 1973 exhibition catalogue, *Thomas Couture: Paintings and Drawings in American Collections*, fig. 13). The pose of the model in the present drawing corresponds to that of the angel at the middle left edge in the painting, who, turning her head away from the viewer and up towards the Virgin, crosses her hands over her breast in reverence to Mary.

The majority of known studies for the Saint-Eustache murals (see Shepherd Gallery, New York, 1971 exhibition catalogue, *Thomas Couture Drawings*, nos. 17-26) are primarily line drawings with loosely drawn hatchings. In contrast, the very plastic nude in the more highly finished Baltimore example is subtly and consistently modeled by close parallel lines which have been blurred or smudged. The artist also added white chalk highlights to define swelling muscles or protruding bones. Couture placed his monogram at the bottom of the sheet indicating that he considered the drawing a completed work.

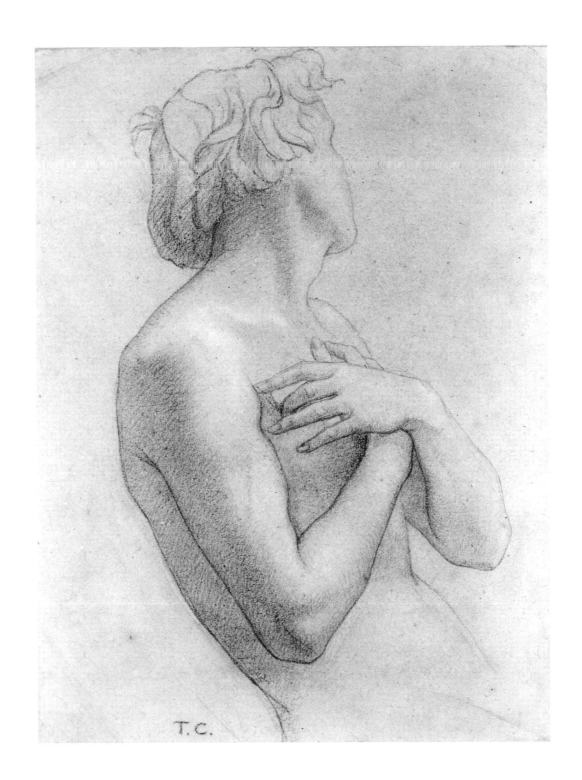

HONORE DAUMIER
French, 1808-1879

16. *The Grand Staircase of the Palace of Justice (Le Grand Escalier du Palais de Justice)*

Pen and black ink, brush and watercolor over black crayon, heightened with gouache on white laid paper

$14^{1}/_{8}$ x $10^{7}/_{16}$ ins. (35.8 x 26.6 cms.) sheet

Signed in black ink at lower left: *h. Daumier.*

George A. Lucas Collection on Indefinite Loan to The Baltimore Museum of Art from the Maryland Institute College of Art, L.33.53.2

PROVENANCE: George A. Lucas.

EXHIBITIONS: Paris, Ecole Nationale des Beaux-Arts, *Dessins de l'école moderne*, February 1884, no. 119, not repr.; Paris, Galerie L. & P. Rosenberg Fils, *Exposition H. Daumier*, April 15-May 6, 1907, no. 9, repr. as frontispiece and on announcement card; Baltimore, Maryland Institute, *Lucas Collection*, 1911, no. 79, not repr.; Buffalo, Albright Art Gallery, *Master Drawings*, January 1935, no. 102, repr.; Philadelphia, Pennsylvania Museum of Art, *Daumier*, 1937, no. 40, repr,; Baltimore, Baltimore Museum of Art, *A Century of Baltimore Collecting 1840-1940*, June 6-September 1, 1941, p. 113, not repr.; Baltimore, Baltimore Museum of Art, *From Ingres to Gauguin*, 1951, no. 70, repr. p. 27; Rotterdam, Museum Boymans-van Beuningen, August 2-September 28, 1958, Paris, Musée de l'Orangerie, October 2, 1958-January 2, 1959, and New York, Metropolitan Museum of Art, February 3-March 15, 1959, *French Drawings from American Collections: Clouet to Matisse*, no. 105, repr. pl. 126 (in French ed., pl. 138); London, Tate Gallery under the auspices of the Arts Council of Great Britain, *Daumier Paintings and Drawings*, 1961, no. 202, repr. pl. 30a; Minneapolis, University of Minnesota, March 26-April 23, 1962 and New York, Solomon R. Guggenheim Museum, May 15-July 1, 1962, *The Nineteenth Century: 125 Master Drawings*, no. 24, not repr.; Baltimore, Baltimore Museum of Art, *George A. Lucas Collection*, October 12-November 21, 1965, no. 325, not repr.; New York, Wildenstein, *Romantics and Realists*, April 7-May 7, 1966, no. 41, repr.; New York, Shepherd Gallery, *Ingres and Delacroix through Degas and Puvis de Chavannes, The Figure in French Art 1800-1870*, Spring 1975, no. 57, repr. p. 138.

BIBLIOGRAPHY: Erich Klossowski, *Honoré Daumier*, Munich: R. Piper & Co., 1923, no. 127, not repr.; Eduard Fuchs, *Der Maler Daumier*, Munich: Albert Langen, 1930, no. 183, repr. from wood engraving by Prunaire, p. 183; Baltimore Museum of Art, *A Picture Book*, 1955, repr. p. 51; Metropolitan Museum of Art, *Miniatures Daumier*, Series MW, 1955, repr. in color; Michel Laclotte (ed.), *French Art from 1350 to 1850*, New York: Franklin Watts, Inc., 1965, repr. p. 39; Robert Rey, *Honoré Daumier*, New York: Harry N. Abrams, 1966, repr. fig. 40, p. 32; K. E. Maison, *Honoré Daumier: Catalogue raisonné of the paintings, watercolors and drawings*, Vol. II, London: Thames and Hudson, 1968, no. 601, repr. pl. 223; George Boas, "The Aesthetics of French Romantic Painting," *Annual IV*, Baltimore Museum of Art, 1972, repr. p. 54, fig. 1.

According to verbal tradition, it was thought that George A. Lucas purchased Honoré Daumier's *Grand Staircase at the Palace of Justice* in 1864 at the time he commissioned the artist to paint three watercolors for the Baltimore collector, William Walters. However, no documentation for this assertion can be found in the Lucas diary, recently published under the editorship of Lilian M. C. Randall (Princeton University Press, 1979). Lucas did visit Daumier's studio several times during 1864 and 1866, but made no notation of purchasing drawings other than the three ordered for Mr. Walters. Nearly twenty years later, after the artist's death, Lucas' December 3, 1881 diary entry documents a Daumier purchase:

Saturday. At Somers & Bought lot of Eaux fortes & Lithographs & also Drawing of Daumier.

Lucas' ledger (Collection, Walters Art Gallery) indicates that he paid 220 francs for that one drawing. Lilian Randall has suggested that this drawing may be the *Palace of Justice*, or one of the two other Daumier watercolors in the Lucas Collection. As his diary further documents, in 1902, he loaned the present watercolor to "Prunaire, 2 rue Nicolas Charlet" to be reproduced in woodcut.

Daumier's highly finished watercolors such as the present one were intended for sale. He frequently incorporated motifs from earlier oils or lithographs. Since Daumier seldom dated drawings or paintings, and repeated similar subjects over many years, establishing a firm chronology for his œuvre is problematic. Without documentation for the purchase or commission of this watercolor, 1864 can no longer be cited as the actual date of *Grand Staircase at the Palace of Justice*, as has been published in the past.

The artist first characterized the lawyers at the Palace of Justice in his biting lithography series, *Les Gens de Justice*, published in *Charivari* between March 1845 and October 1848. K. E. Maison also places several oil paintings of lawyers within the same time period. Although the present watercolor is frequently compared to the oil, *The Triumphant Lawyer* (Boston, Museum of Fine Arts, Maison II-38), the compositon seems rather to be based on the lithograph, *Grand Escalier du Palais de Justice* (Delteil 1372). The movement of the second advocate in the drawing recalls the smaller hunched figure climbing the stairs in the background of the lithograph. In the latter, however, two very solemn lawyers stiffly descend the staircase, both staring straight ahead. The chief protagonist of the Lucas watercolor, on the other hand, is haughty; one senses his more carefree attitude by the movement of his flowing robes and billowing cravat. The actual figures of the curly-haired advocate carrying his papers proudly on his left arm and the large-nosed acquaintance observing him are derived from the oil *The Two Advocates* (Collection Viscountess Hampton, London, Maison I-19). The smaller background figures of the present watercolor, while not directly transferred from other works, do refer to Daumier's repertoire of characters, among them the down-trodden emigrants on the right and the self-assured fashionably dressed lady on the left.

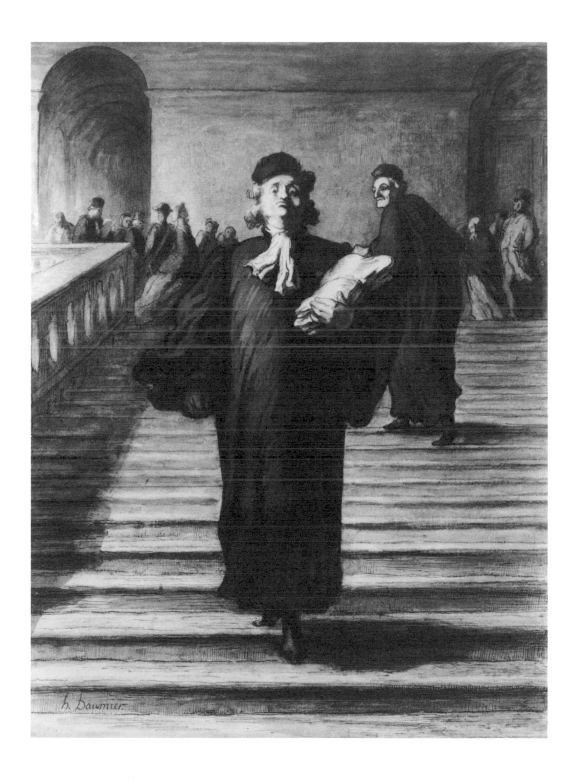

EDGAR DEGAS
French, 1834-1917

17. *Head of a Roman Girl* circa 1856

Black crayon, charcoal, and estompe on off-white wove paper

14³/₄ x 10¹/₄ ins. (37.8 x 25.8 cms.) uneven sheet

Inscribed at lower right in soft pencil: *Rome*

Cone Collection, 50.12.457

PROVENANCE: René de Gas, Paris; Gustave Pellet, Paris: Maurice Exsteens (Pellet's son-in-law), Paris; acquired by Thannhauser Galleries in 1929 from "Editions Pellet"; Thannhauser Gallery, New York.

EXHIBITIONS: Buenos Aires, *Edgar Degas, en Conmemoracion de su centenario*, 1934, no. 23; Kansas City, William Rockhill Nelson Gallery, *Summer Exhibition, Objects lent from the Collection of Mr. and Mrs. Justin K. Thannhauser*, 1955, not repr.; Baltimore, Baltimore Museum of Art, *Manet, Degas, Berthe Morisot and Mary Cassatt*, April 18-June 3, 1962, no. 55, not repr.; St. Louis, City Art Museum of St. Louis, January 20-February 26,1967, Philadelphia Museum of Art, March 10-April 30, 1967, and Minneapolis Society of Fine Arts, May 18-June 25, 1967, *Drawings by Degas*, no. 5, repr. p. 28.

BIBLIOGRAPHY: G. Jedlicka, *Galerie und Sammler*, Zurich, 1935, p. 473; *Cone Collection*, 1967, no. 176, not repr.

Head of a Roman Girl, executed early in Edgar Degas' career, dates from the artist's 1856 sojourn in Rome. As in a similar large drawing in the Art Institute of Chicago (repr. in the 1967 St. Louis exhibition catalogue, *Drawings by Degas*, no. 6), Degas inscribed "Rome" at the lower right corner. In the present work, a long-nosed girl with classic Italianate features is described by delicate lines and soft modeling of her cheeks and neck. The artist analyzes her face with considerable detail while only summarily indicating her scarf and blouse. During this period, as seen in the present example, Degas works with a combination of refined subtle line and stumping to create plasticity of form. In this nearly life-size portrait he captures the robust model in a fleeting moment as she turns and glances to the left.

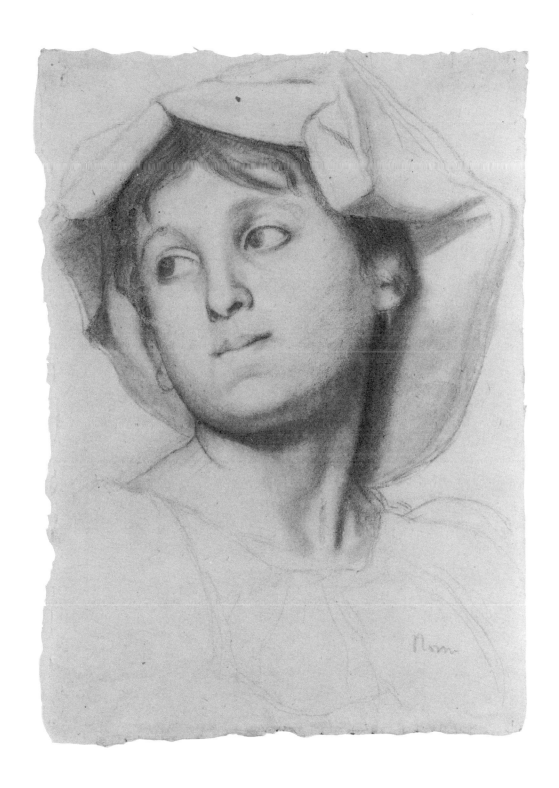

18. *Ballet Dancer Standing (Danseuse debout)*
circa 1886-1890

Black crayon heightened with white and pink chalk on gray-brown wove paper

11 15/16 x 9 1/2 ins. (30.4 x 24 cms.) uneven sheet

Degas studio sale stamp in red at lower left: *Degas* (Lugt 658)

Cone Collection, 50.12.659

PROVENANCE: Second Degas Atelier Sale, Galerie Georges Petit, Paris, December 11-13, 1918, no. 218, repr. p. 121; Etta and Claribel Cone.

EXHIBITIONS: Baltimore, Baltimore Museum of Art, *From Ingres to Gauguin*, 1951, no. 105, repr. p. 4; Baltimore, Baltimore Museum of Art, *Manet, Degas, Berthe Morisot and Mary Cassatt*, April 18-June 3, 1962, no. 63, not repr.

BIBLIOGRAPHY: Etta Cone, *The Cone Collection of Baltimore*, 1934, repr. pl. 79; Lillian Browse, *Degas Dancers*, Boston: Boston Book and Art Shop, (c.1949), no. 193, repr.; *Cone Collection*, 1955, repr. p. 51; *Cone Collection*, 1967, no. 177, repr. p. 61.

Standing Ballet Dancer portrays a dancer during an unguarded moment as she somewhat awkwardly adjusts the bodice of her costume. This drawing, together with three similar crayon sketches (some heightened with pastel) of single figures have traditionally been considered preparatory studies for the oil *Danseuses Montant un Escalier* (see drawings in the Rhode Island School of Design, repr. in Lillian Browse, *Degas Dancers*, Boston: Boston Book and Art Shop, c. 1949, no. 194; Art Institute of Chicago, repr. in Browse, no. 191; and unknown collection, repr. in Browse, no. 192, and oil in Louvre, repr. in P. A. Lemoisne, *Degas et son oeuvre*, Paris; P. Brame et C. M. de Hauke, c. 1947, no. 894). The four drawings as a group are closely related in both subject and style, although only the pastel in the Rhode Island School of Design is unquestionably a study for the Louvre painting because the dancer portrayed stands in an identical pose to the figure appearing in the middle ground of the oil. The Cone work and an almost identical drawing from an unknown collection (Browse, no. 192), on the other hand, describe a dancer who tilts her head to her right, rather than to her left, as with the Rhode Island example. Thus, the present work is directly connected with a pastel sketch (repr. in Lemoisne, no. 999 bis) in which the artist represents three dancers adjusting their costumes. This pastel, in turn, is a preliminary study for two other pastels (repr. in Lemoisne, nos. 997 and 998) and an oil (Lemoisne 996) depicting dancers exercising in a foyer, of which the more detailed pastel (Lemoisne 998) is probably the definitive version.

Degas painted ballet subjects from around 1872 until his death. Often, as depicted here, he captured the dancers unawares—at practice, exercising, or at rest. From the 1880s onwards his drawing style became bolder and freer, representing figures in more generalized, sculptural terms. These formal qualities are reinforced by his increased use of broad drawing media, such as pastel.

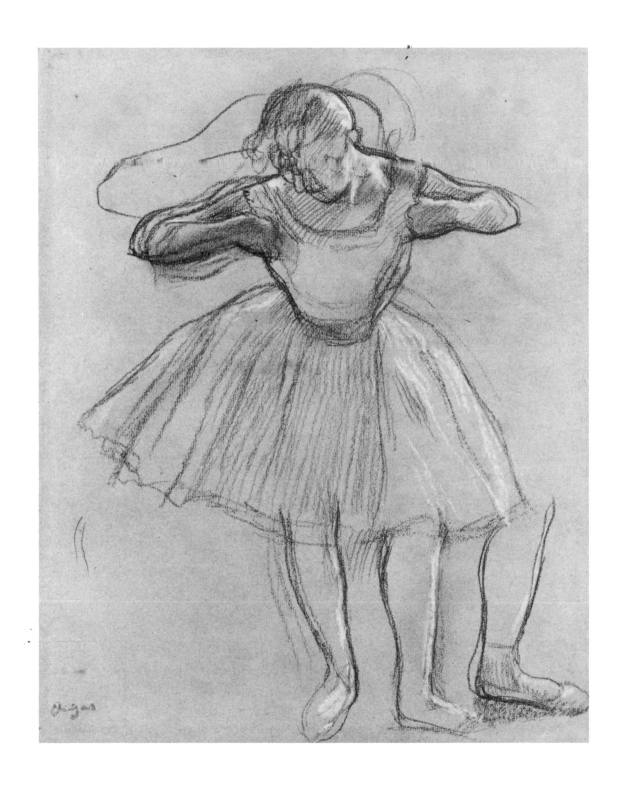

MARY CASSATT
American, 1845-1926

19. *Drawing for the Etching "Sombre Figure"*
circa 1881

Pencil over black crayon on off-white wove paper

10⁷/₁₆ x 7¹/₂ ins. (26.5 x 19 cms.) sheet

Verso: Design left by ground from soft ground etching transfer process

Signed in pencil at lower right: *Mary Cassatt*

Wilmer Hoffman Bequest, 55.30.2

PROVENANCE: Sale, Galerie Guy Stein, April 27-May 25, 1940, no. 12 (unconfirmed); Wilmer Hoffman, Baltimore.

EXHIBITIONS: Baltimore, Baltimore Museum of Art, *Manet, Degas, Berthe Morisot and Mary Cassatt*, April 18-June 3, 1962, no. 119, not repr.

BIBLIOGRAPHY: Adelyn Dohme Breeskin, *Mary Cassatt, A Catalogue Raisonné of the Oils, Pastels, Watercolors, and Drawings*, Washington, D.C.: Smithsonian Institution Press, 1970, no. 739, repr. p. 255.

Mary Cassatt utilized this drawing as an aid in creating her soft ground etching *Sombre Figure* (Adelyn D. Breeskin, *The Graphic Work of Mary Cassatt, a Catalogue Raisonné*, New York: H. Bittner & Co., 1948, no. B.32). Because of the limited areas to which the etching ground adhered to the reverse side of the drawing, it appears that Cassatt first drew the image in crayon. Then she placed the drawing paper on top of the etching plate and selectively traced the sketch in the harder pencil medium. One notices shiny graphite on top of crayon, especially along the hard contours of the figure, where Cassatt applied added pressure to heavily reinforce the outlines. The pressure resulting from drawing these pencil lines caused the etching ground to pull away from the plate and adhere to the reverse side of the drawing. The linear sketch thus transferred from the drawing formed only a skeletal framework for the etching. There, additions made by the liberal use of aquatint resulted in rich blacks and dense tonal gradations, especially prominant in the black dress and the dark negative space encompassing the seated woman.

Beyond technical variations, the drawing evokes a different feeling from the etching. The woman, although pensive, is not nearly as sad or "sombre" as the etched figure. This lighter mood is due in part to the openness of the white areas of the bare page in contrast to the dense mesh of black surrounding, and almost imprisoning, the figure in the etching. The drawing, existing on its own merit, should not be considered merely a step in the soft ground etching process. This initial statement balances delicate linear and decorative qualities with a strong characterization of an individual.

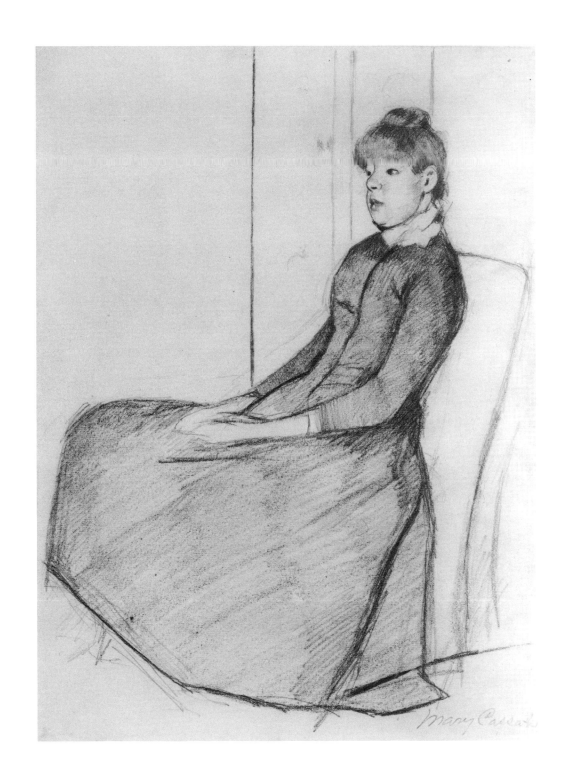

WINSLOW HOMER
American, 1836-1910

20. *The Mussel Gatherers* circa 1881 or 1882

Brush and watercolor over pencil on heavy white wove paper

14⁹/16 x 21⅝ ins. (37 x 55 cms.) uneven sheet

Unsigned

Fanny B. Thalheimer Memorial Collection, Gift of Dr. and Mrs. Alvin Thalheimer, 56.226

PROVENANCE: James W. Elsworth, Chicago, who purchased the watercolor directly from the artist before 1890; Mr. and Mrs. Charles R. Henschel, New York, 1941; purchased by Dr. and Mrs. Alvin Thalheimer from M. Knoedler & Co., New York in 1956.

EXHIBITIONS: Chicago, Art Institute of Chicago, *James W. Elsworth Collection*, 1890; Boston, Institute of Modern Art, June 21-July 15, 1941, and San Francisco, California Palace of the Legion of Honor, August 9-September 10, 1941, *Watercolors and Drawings by Winslow Homer*, no. 1, not repr.; Washington, D.C., National Gallery of Art, November 23, 1958-January 4, 1959, and New York, Metropolitan Museum of Art, January 29-March 8, 1959, *Winslow Homer, A Retrospective*, no. 110, repr. p. 56; Milwaukee, Milwaukee Art Center, *Men at Work, Daumier to Shahn*, October 20-December 4, 1960; Tucson, University Art Gallery, University of Arizona, *Yankee Painter, A Retrospective Exhibition of Oils, Watercolors, and Graphics by Winslow Homer*, October 11-December 1, 1963, no. 11, repr. p. 76.

BIBLIOGRAPHY: *The Collector*, New York, September 1, 1890, p. 146; Theodore Bolton, "Water Colors by Homer. Critique and Catalogue," *The Fine Arts*, April 1932, p. 50, not repr.; *Sunday Sun*, August 4, 1957, Object of the Week, repr.; *BMA News*, June 1958, repr. on cover; "A Tribute to Adelyn D. Breeskin," *BMA News Quarterly*, Summer 1962, no. 4, repr. p. 23; Kent Roberts Greenfield, "The Museum. Its First Half Century," *Annual I*, Baltimore Museum of Art, 1966, repr. p. 23.

In 1875, Homer gave up a successful career as an illustrator for *Harper's Weekly* and *Ballou's Pictorial* to devote himself exclusively to the pursuit of painting. Although his watercolors of the 1870s reflect steady development as he explored the possibilities inherent in the medium, they exhibit a number of characteristics which are reminiscent of his earlier wood engravings. The carefully defined contours, passages of color applied in flat, even washes, and minimal regard for the depth and volume of form are aspects of his style which are clearly related to the requirements of the woodblock technique.

In the Spring of 1881, possibly seeking a fresh and sympathetic environment in which to expand his art, Homer embarked on his second trip abroad, to England, settling in the small fishing village of Cullercoats near Tynemouth on the rugged Northumberland coast. With the possible exception of a brief return visit to America during the following winter, he remained there until November, 1882.

The effects of the journey on Homer's production were profound. The idyllic world of carefree children at play and refined young ladies fashionably attired which had attracted him in the past was abandoned. Fishermen engaged in their endless struggle against the great force of the sea and heroic women maintaining their vigil on the rocky, barren shore became dominant themes. These women with their monumental proportions in such marked contrast to Homer's earlier female representations are particularly impressive, and it has been suggested that they were inspired by the works of the Pre-Raphaelites and possibly the Elgin marbles both of which would have been known to the artist in England (see: John Wilmerding, *Winslow Homer*, New York, 1972, pp. 132-34).

In *The Mussel Gatherers*, the changes which occurred in Homer's style during his Tynemouth experience are readily evident. A cool, moisture-laden atmosphere prevails throughout. Although the figures and the general rock formations of the shoreline have been defined with pencil, the watercolor is composed essentially of layers of wash applied with a diversity of brushwork. In addition to a wide range of dark, somewhat somber tonalities, Homer has employed touches of plum, orange and a fresh, clear green to produce a work which is both subtle yet extraordinarily rich.

Sona Johnston

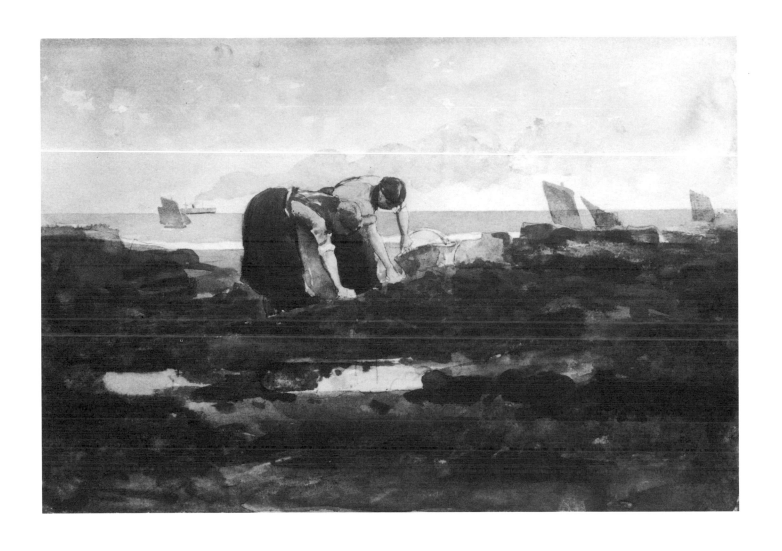

THOMAS EAKINS
American, 1844-1916

21. *Portrait of William H. MacDowell* circa 1891

Brush and watercolor on heavy off-white watercolor paper

27 x 21⅜ ins. (68.6 x 54.4 cms.) sheet

Unsigned

Given in Memory of Joseph Katz by his Children, 64.52.1

PROVENANCE: Mrs. Eakins, 1933; Eakins Estate, 1939; Babcock Galleries, New York, 1942; Joseph Katz Collection; Leslie Katz, Ruth Katz Strouse, and Richard Katz, 1964.

EXHIBITIONS: New York, Whitney Museum of American Art, *History of American Watercolor Painting*, January 27-February 25, 1942, no. 117, not repr.; New York, M. Knoedler & Co., *Thomas Eakins Centennial Exhibition*, June-July 1944, repr. pl. 48; Pittsburgh, Carnegie Institute, *Thomas Eakins Centennial Exhibition*, April 26-June 1, 1945, no. 96, not repr.; Baltimore, Baltimore Museum of Art, *Man and his Years*, October 19-November 21, 1954, no. 65, not repr.; Baltimore, Baltimore Museum of Art, *Modern Art for Baltimore*, February 23-March 17, 1957.

BIBLIOGRAPHY: Lloyd Goodrich, *Thomas Eakins, His Life and Work*, New York: Whitney Museum of American Art, 1933, no. 262; Roland McKinney, *Thomas Eakins*, New York: Crown, 1942, repr. p. 103; *BMA News*, December 1955, repr. p. 11; Fairfield Porter, *Thomas Eakins*, New York: G. Braziller, 1959, repr. pl. 46; *Art Quarterly*, 1965, nos. 1-2, p. 106, repr. p. 120; *Gazette des Beaux-Arts* suppl. February 1966, p. 103, not repr.; Diana F. Johnson, "Portraits by Eakins and Bellows," *Burlington Magazine*, September 1966, pp. 479-80, repr. p. 481; Donelson F. Hoopes, *Eakins Watercolors*, New York: Watson-Guptill, 1971, p. 84, repr. in color, pl. 32.

In January 1884, Eakins married Susan Hannah MacDowell, one of his students at The Pennsylvania Academy of the Fine Arts where he had taught since 1876. Eakins developed a special fondness for his wife's father, William Hance MacDowell, an engraver by profession who subsequently became the model for numerous photographic studies and at least six painted portraits executed by the artist between 1890 and 1904.

Eakins began to work in watercolor in the early 1870s shortly after his return to Philadelphia from three and one-half years of study in Paris at the Ecole des Beaux-Arts under Gérôme, Bonnat and the sculptor, Augustin Alexander Dumont. Although his known production in the medium is limited to less than thirty items, these paintings demonstrate an interest in a wide range of subject matter which, as in his oils, is invariably concerned with some aspect of human activity. In general, they are carefully composed, highly finished works of art. Contrary to the usual procedure, many derive from preliminary oil studies which, although more substantial and richer in color, lack the nuances of light and tone intrinsic to the more delicate medium. Eakins painted the majority of his watercolors in the 1870s and early 1880s; however after a hiatus of some six years, he returned to the medium and produced two additional works, *Cowboy Singing*, c. 1890 (collection: The Metropolitan Museum of Art, Fletcher Fund, 1925) and the *Portrait of William H. MacDowell*.

The Museum's likeness, Eakins' only known attempt at formal portraiture in watercolor, is based on an oil study also painted c. 1891 (Collection: Randolph-Macon Woman's College, Lynchburg, Virginia). Its dimensions are very close to those of the preparatory sketch and it is therefore somewhat larger than his other watercolors. Although both works are nearly identical in format and equally loosely painted, they exhibit certain differences. In the Museum's version, the figure appears closer to the picture plane and, accordingly, the image is larger. Further, there are stronger contrasts of light and shadow, and most significantly, MacDowell's gaze is far more intense and penetrating. Although generally considered to be unfinished, the resulting characterization is remarkably candid and forceful.

Of the six portraits of MacDowell painted by Eakins, three preceded the Museum's version, the only watercolor, and two followed, one dated c. 1898 in which the subject wears a hat and a final likeness, probably executed in 1904, two years before his death.

Sona Johnston

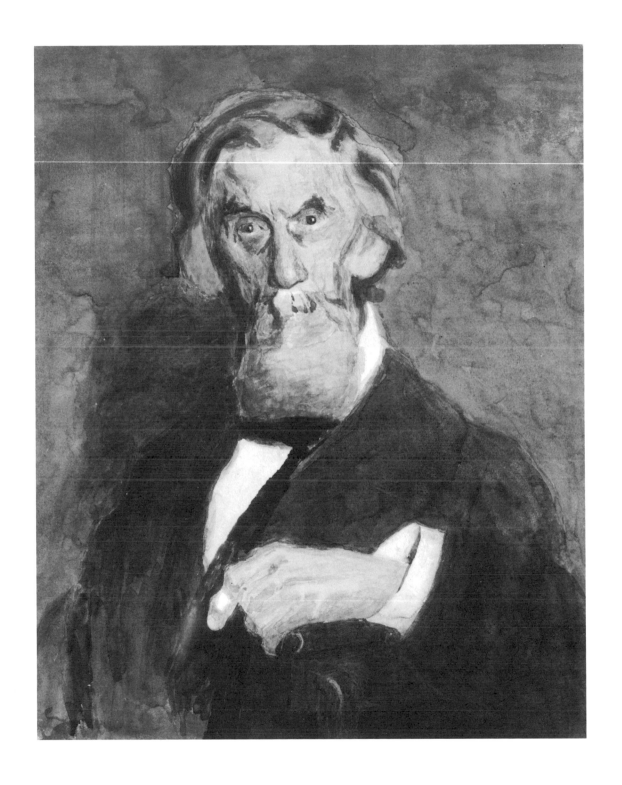

JAMES A. McNEILL WHISTLER
American, 1834-1903

22. *Venice* circa September 1879-November 1880

Brush and brown ink on white laid paper

3¼ x 6¼ ins. (8.2 x 15.9 cms.) sheet

Unsigned

Unidentified embossed stamp at lower left: (FF) (not in Lugt)

Purchase, Garrett Fund, 67.27

PROVENANCE: Bernie Phillips; Colnaghi's, London; purchased from R. M. Light, Boston, in 1967.

EXHIBITIONS: Chapel Hill, William Hayes Ackland Memorial Art Center, University of North Carolina, *English Watercolors and Drawings, 1700-1900*, September 21-October 26, 1975, no. 73, not repr.; Ann Arbor, University of Michigan Museum of Art, *Whistler: The Later Years*, August 27-October 8, 1978, no. 15, repr. in both checklist and catalogue.

BIBLIOGRAPHY: *BMA News*, 1968, nos. 1-2, repr. p. 30.

In financial difficulty following his notorious libel suit against John Ruskin over the latter's criticism of the American-born painter's *Falling Rocket*, James Abbott McNeill Whistler traveled to Venice to fulfill a commission from the Fine Arts Society, London, for 12 etchings. He produced 40 prints, 12 of which were exhibited upon his return to London. *Venice* no doubt dates from this sojourn in the island city from September 1879 until November 1880.

The central domed building may be Sta. Maria della Salute, although the artist has not described the small cupola which tops the dome. His more specific and detailed etchings of this site clearly delineate the church's crowning cupola (see *Salute: Dawn*, no. 215, *Little Salute*, no. 220, and *Nocturne: Salute*, no. 226 in Edward G. Kennedy, *The Etched Work of Whistler*, New York: Grolier Club of New York, 1910). However, other etchings such as *Islands* (Kennedy, no. 222) or *Long Lagoon* (Kennedy, no. 203) represent more generalized Italian architecture viewed from afar, similar to that portrayed in the Baltimore drawing. In fact, the domed structure on the right-hand side of *Islands* appears almost identical to the edifice depicted in *Venice*. In both, a few horizontal and vertical lines indicate the shoreline and its fluctuating reflections upon sunlit waters. Much of the paper remains bare in the present drawing with staccato rhythms created by short parallel lines obscuring to a degree the picturesque charm of the Baroque architecture. Akin to his Nocturnes, *Venice* is first and foremost an "arrangement" of lines and light rather than a portrait of a specific locale. Thus, the exact site remains an enigma.

From an American visiting Venice at that time, the artist Otto Bacher, come descriptions of Whistler's sketching procedure. Sometimes aboard a gondola, Whistler would seize upon a motif which caught his fancy, and would draw it on paper, or often etch it directly on copper plates. After selecting a main focal point, such as the distant buildings in *Venice*, Whistler paid heed to his initial vision, working in an abbreviated style to record his impression of the motif.

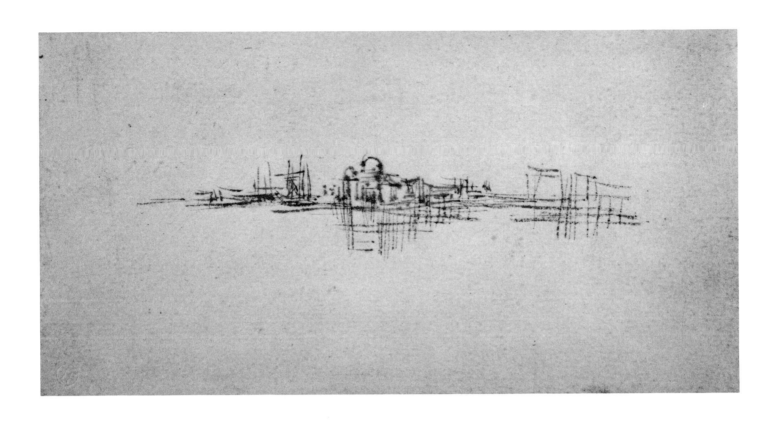

EUGÈNE CARRIÈRE
French, 1849-1906

23. *Studies of Heads: Woman and Child* circa 1878-1888

Brush and gouache, heightened with white impasto on gray-tan wove paper

16¼ x 16⅜ ins. (41.3 x 41.5 cms.) sheet

Studio sale stamp in brown ink at lower right: *Eugène Carrière* (Lugt supplement 434a)

Purchase, Anonymous Donor and Print Department Fund, 65.3

PROVENANCE: Second Sale, Atelier d'Eugène Carrière, 1920, no. 169; purchased from Lucien Goldschmidt, New York, in 1965.

EXHIBITIONS: Washington, D.C., National Gallery of Art, *19th and 20th Century European Drawings*, circulated by The American Federation of Arts, July 1965-July 1966, no. 9, repr.

BIBLIOGRAPHY: *Catalogue des Tableux, Dessins, Lithographies provenant de l'Atelier d'Eugène Carrière*, Paris: Galerie Manzi, Joyant & Cie., February 2-3, 1920, repr. no. 169; *Art Quarterly* XXVIII, nos. 1-2, 1965, repr. p. 118; *BMA News*, 1967, nos. 1-2, p. 49, not repr.

In *Studies of Heads: Woman and Child*, Eugène Carrière used his favorite models, his young wife Sophie and one of their five children born between 1878 and 1888. A sketch from life characterizing facial expressions of his family, the Baltimore drawing is not a study for a specific oil. Sophie, accompanied by one or more children, frequently appears in Carrière's paintings as an idealized representation of Motherhood. In the present drawing, however, the two faces shown frontally do not interact or touch as do the figures of his many *Maternités*, where mothers cradle, nurse, or play with their offspring.

Carrière's monochromatic paintings combine soft brown tones with silvery white highlights. The present gouache, as the description *dessin à la peinture* in the 1920 Studio Sale catalogue implies, emulates to some degree the artist's oil technique. For instance, brush lines are apparent. Unusually, rather large areas of white impasto are added to indicate flickering lights across the faces. This misty atmosphere surrounding his figures results in the *claire-obscure* style distinctive of Carrière.

HENRI FANTIN-LATOUR
French, 1836-1904

24. *Homage to Victor Hugo (Hommage à Victor Hugo)* circa 1885

Conté crayon and white chalk on off-white laid paper

17³/₈ x 11⁷/₈ ins. (30 x 43.9 cms.) uneven sheet

Signed in conté crayon at lower left: *h. Fantin*. Inscribed in white chalk at center near top: *VICTOR HUGO*

Purchase, Joseph Katz Fund, 72.4

PROVENANCE: Vente Danasse, 1909 (according to Mme. Fantin's catalogue); purchased from Stephen Spector in 1972.

BIBLIOGRAPHY: *Le Mondé Illustre*, May 30, 1885, repr.; Alcide Bonneau, "Le Centenaire de Victor Hugo," *Revue Universelle*, 1902, repr. p. 155; Mme Fantin-Latour, *Catalogue de l'oeuvre complet de Mme. Fantin-Latour*, Paris: Henri Floury, 1911, no. 1237, not repr.

Homage to Victor Hugo, drawn shortly after the novelist's death in 1885, depicts two semi-nude allegorical figures: the mourning muse of poetry at the left with her lyre by her side and a triumphant figure at the right holding laurel and a trumpet symbolizing the permanence of Hugo's art. This latter figure reappears in oil four years later in Fantin's painting entitled *Immortality* (National Museum of Wales, Cardiff, repr. in Edward Lucie-Smith, *Henri Fantin-Latour*, New York: Rizzoli, 1977, p. 91).

The somewhat blurred forms and rich blacks of the drawing recall Fantin's extensive work in lithography, which he practiced with great frequency after 1873. He often drew his initial image as a lithograph, later reworking the subject in oil or pastel. The Balti-more drawing, however, predates the lithograph of the identical subject by four years. According to Mme. Fantin, the drawing was executed for reproduction in the May 30, 1885 issue of *Le Mondé Illustre*, while the lithograph (Germain Hédiard, *Fantin-Latour étude suivie du catalogue de son oeuvre*, Paris: Edmond Sagot, 1892, no. 92), exhibited in the 1889 Salon, was later reproduced on the cover of the 1902 centenary festival honoring Hugo at the Sorbonne.

As a painter, Fantin-Latour is best known for his naturalistic portraits of Manet and other contemporary artists and numerous still lifes. He was friendly with the realist and Early Impressionist painters during the 1860s, but drew away from these avant garde artists after 1870, rejecting Impressionism's subject matter and technique. In contrast, Fantin chose imaginary subjects, often based on literary or musical sources, which he painted in the studio. This greater interest in allegory and sentiment is characteristic of his later work as exemplified by the present drawing as well as other homages to composers such as Wagner and Berlioz. Fantin's commitment to honor great artists is a recurring theme throughout his career. In the early *Homage to Delacroix* (Louvre), painted in 1864 the year following the artist's death, the event is portrayed as it might actually have occurred with painters dressed in contemporary street costume flanking a portrait of the deceased master. However, as seen in a preparatory drawing, *Study for the Homage to Delacroix* (Collection unknown, repr. in Lucie-Smith, pl. 22), Fantin even in the mid-1860s considered including the allegorical seated mourning figure.

VINCENT VAN GOGH
Dutch, 1853-1890

25. *Beach at Scheveningen*
circa September/October 1882

Brush and watercolor heightened with gouache on off-white wove paper

13½ x 20¼ ins. (34.5 x 51.2 cms.) uneven sheet

Unsigned

Cone Collection, 50.301

PROVENANCE: Galerie Oldenzeel, Rotterdam; P. Versteeven, The Hague; Sale, A. Mak, Amsterdam, October 27, 1925, no. 121; Galerie Goudstikker, Amsterdam; Thannhauser Gallery, New York; Claribel and Etta Cone, Baltimore.

EXHIBITIONS: Rotterdam, Kunstzalen Oldenzeel, *Vincent van Gogh,* November 10-December 15, 1904, no. 50; Baltimore, Baltimore Museum of Art, *A Century of Baltimore Collecting, 1840-1940,* June 6-September 1, 1941, p. 114, not repr.; Baltimore, Baltimore Museum of Art, *From Ingres to Gauguin,* 1951, no. 158, repr. p. 45; Richmond, Virginia Museum of Fine Arts, *Cone Collection,* October-November 1953; New York, M. Knoedler & Co., *Cone Collection,* January-February 1955; Pittsburgh, Carnegie Institute, *The Seashore, Paintings of the 19th and 20th Centuries,* October 22-December 5, 1965, no. 29, repr.; Frankfurt-am-Main, Frankfurter Kunstverein, *Van Gogh Ziechnungen und Aquarelle,* April 30-June 21, 1970, no. 13, repr. pl. 13.

BIBLIOGRAPHY: J-B de la Faille, *L'oeuvre de Vincent Van Gogh, Catalogue Raisonné,* Paris & Brussels: Van Oest, 1928, no. 1038, repr. pl. LIII; Walter Vanbeselaere, *De hollandsche periode in het werk van Vincent van Gogh,* Antwerp: De Sikkel, 1937, pp. 87, 165, 409; *BMA News,* October 1949, no. 18; *Cone Collection,* 1955, no. 120, not repr.; *Cone Collection,* 1967, no. 25, not repr.; K. R. Greenfield, "The Museum: Its First Half Century," *Annual I,* Baltimore Museum of Art, 1966, repr. p. 65; J-B de la Faille (rev. ed.), *The Works of Vincent Van Gogh,* Amsterdam: Meulenhoff International, 1970, no. F1038, repr. p. 384.

Beach at Scheveningen, one of Vincent van Gogh's earliest watercolors, was painted during the fall of 1882. While he lived in The Hague, Van Gogh made frequent excursions to sketch and paint at the attractive seacoast at Scheveningen. He took his brother Theo there during a summer visit in 1882. Many times in his correspondence with Theo, he mentioned the soothing scenery and the drawings it inspired. Two letters in particular, written in September and October 1882 (Letters 231 and 236 in *Complete Letters of Vincent Van Gogh,* Vol. I, Greenwich: New York Graphic Society, 1958) include brief comments which probably refer to the Cone watercolor, or its pencil study:

Letter 231: Recently I made a study of ladies and gentlemen on the beach, a bustling crowd of people.

Letter 236: Enclosed you will find a little sketch of a larger water color (not BMA's). I also started another one with many more figures, the last summer guests on the beach—an evening effect.

During the Hague/Scheveningen period Van Gogh emphasized mastery of draughtsmanship and had only just begun to employ color, in either watercolor or oil. His letters speak of the importance of drawing as the structural foundation for painting. The Baltimore watercolor was first worked out in pencil; a detailed study (Kröller-Müller Museum, Otterlo; J.-B. de la Faille, *The Works of Vincent Van Gogh,* Amsterdam: Meulenhoff International, 1970, no. F980) depicts many of the same figures including the woman with plaid shawl in the foreground and top-hatted gentleman at the left.

Most Scheveningen subjects in watercolor, and especially those in oil, are less populated views of the rustic shore where fishermen or vacationers play subsidiary roles. In another watercolor also called *Beach at Scheveningen* (F982), which is closest in subject to the Cone drawing, the strolling summer visitors are scattered along the beach in front of picturesque moored sailboats. In contrast, the immobile figures of the present watercolor form a compact central cluster dominating the composition, almost to the exclusion of references to the seascape background. Similarly, in a watercolor of a Hague subject, *The State Lottery Office* (F970) a mass of anonymous figures overshadows their urban setting. In both these works Van Gogh focused his attention on the representation of a group of people rather than emphasizing their picturesque surroundings. In Letter 231, partially quoted above, he described problems involved in portraying crowd scenes such as these two watercolors:

This week I have been working on sketches for water colors . . .

You can see from the enclosed sketch what I want to make—groups of people who are in action some way or another.

But how difficult it is to bring life and movement into it and to put the figures in their places, yet separate from each other. It is that great problem, moutonner: *groups of figures from one whole. . . . As to composition, all possible scenes with figures—either a market or the arrival of a boat, a group of people in line at the soup kitchen, in the waiting room of the station, the hospital, the pawnshop . . . groups talking in the street or walking around—are based on that same principle of the flock of sheep, from which the word* moutonner *is surely derived . . .*

GEORGES SEURAT
French, 1859-1891

26. *Two Men Walking in a Field*
 (Deux hommes marchant dans un champ)
 circa 1882-84

Black conté crayon on white laid paper

12½ x 9⁹⁄₁₆ ins. (31.8 x 24.3 cms.) uneven sheet

Unsigned

Inscribed in pencil on verso by Felix Feneon: *de Seurat/F*

Cone Collection, 50.12.664

EXHIBITIONS: Baltimore, Baltimore Museum of Art, *A Century of Baltimore Collecting 1840-1940*, June 6-September 1, 1941, p. 113, not repr.; Baltimore, Baltimore Museum of Art, *From Ingres to Gauguin*, 1951, no. 163, repr. p. 43.

BIBLIOGRAPHY: *A Picture Book*, Baltimore Museum of Art, 1955, repr. p. 56; *Cone Collection*, 1955, repr. p. 50; C. M. de Hauke, *Seurat et son oeuvre*, Vol. 2, Paris: Paul Brame et C. M. de Hauke, 1961, no. 524, repr. p. 119; John Russell, *Seurat*, New York & Washington: Frederick A. Praeger, 1965, p. 102, repr. fig. 97; *Cone Collection*, 1967, no. 329, repr. p. 60.

Georges Seurat executed many drawings such as *Two Men Walking in a Field* by rubbing conté crayon across heavy textured paper. By varying the pressure with which he applied the crayon, the artist could create a wide variety of tones. In those areas he worked with heavy pressure, his innovative drawing method produced dense, luminous shadows, while in other areas, Seurat's crayon lightly grazes the paper's surface. Thus, the valleys or ribs of the paper function as sources of light illuminating the scene. Figural shapes are not delineated by contour lines and stand out as areas of varied tones set against the artist's background design. Seurat further exploited black/white contrast by use of what he called "irradiation."

That is, a dense grayish-black appears darker if placed next to a significantly lighter tone, and correspondingly, the light tone appears whiter than it actually is. In the present example, a radiating white glow surrounds the upper part of the foreground figure wearing a dark jacket. The black of his head and upper torso juxtaposed to the relatively light sky is thus blacker than the lower portion of his jacket which is set against a medium-dark background.

In the present drawing two men, seemingly unrelated to each other and at some distance apart, walk or stand in an empty space. However, their attire and casual pose resemble Seurat's representations of city-dwellers. The short coat and rounded shape of the small background figure, for example, echoes the form of Seurat's *Boy Standing near a Lamppost* (Robert Lebel Collection, repr. in C. M. de Hauke, *Seurat et son oeuvre*, Vol. 2, Paris: Paul Brame et C. M. de Hauke, 1961, no. 449). In addition, the man in the Cone drawing rests his hand on a cane or umbrella in a fashion recalling mannerisms of the artist's urban figures (see especially *Man Waiting on a Sidewalk* and *Woman Strolling*, both Collection Charles Garibaldi, Marseilles, repr. in Robert L. Herbert, *Seurat's Drawings*, New York: Shorewood Publishers, 1962, figs. 63 and 91). The foreground gentleman, dressed in bright white pants, walks directly toward the viewer with his back erect and hands stuffed nonchalantly in his pockets. Not dressed in peasant attire, this large figure brings to mind similar rigidly frontal models in Seurat's later paintings of Parisian subjects, *La Grande Jatte*, *Les Poseuses*, and *La Parade*. Stylistically similar to several conté crayon works (see *Plowing*, de Hauke no. 525 and *Rain*, de Hauke no. 519) which Herbert distinguishes as Seurat's "Early Mature Drawings," *Two Men Strolling in a Field* was probably executed between 1882 and 1884.

PAUL CEZANNE
French, 1839-1906

27. *Sketch after Puget's Milo of Croton* circa 1890

Pencil on white laid paper

18¾ x 12⅜ ins. (47.8 x 31.5 cms.) uneven sheet

Unsigned

Frederic W. Cone Bequest, 50.12.657

PROVENANCE: Bernheim-Jeune, Paris; Galerie Thannhauser, Lucerne; Galerie Rosengart, Lucerne; Frederic W. Cone.

EXHIBITIONS: Baltimore, Baltimore Museum of Art, *From Ingres to Gauguin*, November-December 1951, no. 148, repr. p. 41; Minneapolis, University of Minnesota, March 26-April 23, 1962 and New York, Solomon R. Guggenheim Museum, May 10-June 30, 1962, *The Nineteenth Century: 125 Master Drawings*, no. 13, not repr.; Washington, D.C., Phillips Collection, February 27-March 28, 1971, Chicago Art Institute, April 17-May 16, 1971, and Boston, Museum of Fine Arts, June 1-July 3, 1971, *Cezanne*, no. 82, repr. p. 109.

BIBLIOGRAPHY: J. Gasquet, *Cézanne*, Paris: Bernheim-Jeune, 1921, repr. p. 114 (rev. ed. 1926, p. 190); J. Meier-Graefe, *Cézanne und Sein Kreis*, Munich: R. Piper, 1922, repr. p. 142; Robert Rey, *La Renaissance du Sentiment Classique*, Paris: Les Beaux-Arts, n.d. (c. 1931), repr. pl. 1, p. 84; Lionello Venturi, *Cézanne, Son Art—Son Oeuvre*, Paris: Paul Rosenberg, 1936, no. 1446, repr. pl. 372; Editore G. G. Görlich, *Cézanne, 76 Disegni*, Milan: Görlich, 1944, no. 23, repr.; Paul J. Sachs, *Modern Prints and Drawings*, New York: Alfred A. Knopf, 1954, repr. pl. 30; *Cone Collection*, 1955, repr. p. 19; Gertrude Berthold, *Cézanne und die alten meister*, Stuttgart: W. Kohlhammer, 1958, p. 90, no. 98, repr.; *Cone Collection*, 1967, no. 175, repr. p. 60; Adrien Chappuis, *The Drawings of Paul Cézanne*, Greenwich: New York Graphic Society, 1975, no. 976, repr.

Sketch after Puget's Milo of Croton is one of 12 pencil copies Cézanne made after the Baroque sculptor's famous statue in the Louvre (see Adrien Chappuis, *The Drawings of Paul Cézanne*, Greenwich: New York Graphic Society, 1975, nos. 207, 502-06, 976-78, 1131, 1200-01). Milo, a famous Greek athlete of towering strength, was devoured by wild beasts (usually described as wolves) when he was trapped in the woods. As dated by Chappuis, Cézanne's copies of *Milo of Croton* span his career, the earliest circa 1866-69 and the latest circa 1897-1900. Seven, including the present drawing (c 976) depict the statue from an identical viewpoint, facing Milo's right

side. As Lorenz Eitner noted in *The Nineteenth Century: 125 Master Drawings* catalogue (exhibition held at the University of Minnesota and the Guggenheim Museum in 1962), it seems unlikely that all seven drawings with their varying dates (c 207, c. 1866-69; c 502, c. 1877-80; c 503-06, c. 1880-85; c 976, c. 1890) were executed in the Louvre. Most probably some of the drawings have a two-dimensional source, either a photograph or one of Cézanne's own previous sketches.

The placement of the Cone drawing within Cézanne's treatment of the Milo theme is somewhat problematic. The majority of his drawings are undated; thus, it is difficult to formulate an exact chronology of his development as a draughtsman. The dates assigned his drawings are often based on stylistic analysis, whereby it is reasonably inferred that as the years progressed the artist's drawing style became looser in a manner paralleling changes in his painting style. Interestingly, Cézanne's other copies of Puget's statue which depict Milo from the same viewpoint used in the Cone example all predate the present work by almost a decade or more. However, the style of the Cone drawing concurs with the artist's subsequent copies of the statue from different viewpoints, with either Milo's torso or back facing the viewer. These copies, as dated by Chappuis, are either contemporary with the Baltimore work or post-date it. Further, the Cone drawing is exceptional in that it depicts the entire sculptural composition, including the base of drapery and the saucer placed casually between Milo's legs. Curiously, ths saucer does not appear in any other existing drawings, and thus, one wonders if Cézanne may have drawn this version directly from the statue.

Cézanne's two earliest interpretations of the Milo of Croton subject (c 207 and c 502) most closely follow the musculature of the sculpture. The lines are primarily descriptive, either forming a continuous contour or indicating the plasticity of the original model by shading. The four drawings from the early 1880s (c 503-06) appear as linear variations on a theme. The muscles swell, bulge and form exaggerated curving shapes. The free, active lines and broken contours are as much expressive as descriptive of Milo's agonized death. The present work, although more highly finished, displays similar exaggerations of the curving forms, such as the double hump of the abdomen, the jutting calf muscle and especially the ambiguous rolling contour of Milo's right arm combined with the lion's foreleg behind it.

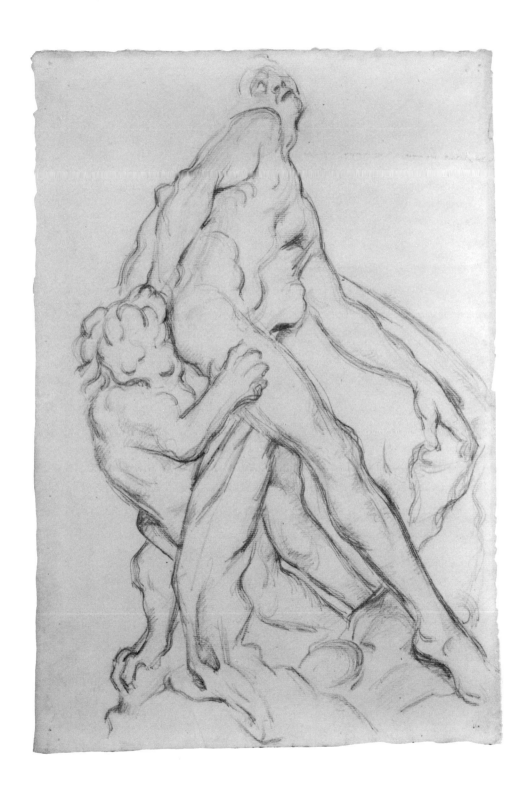

ODILON REDON
French, 1840-1916

28. *The Eye* circa 1880-85

Charcoal and estompe on tan wove paper

16⁵/₈ x 14⁷/₁₆ ins. (42 x 36.7 cms.) sheet

Signed in charcoal at lower right: *Odilon Redon*

Purchase, Nelson and Juanita Greif Gutman Fund, 66.29

PROVENANCE: Ambrose Vollard; purchased from Paul Rosenberg and Co., New York, in 1966.

EXHIBITIONS: New York, Solomon R. Guggenheim Museum, *Rousseau, Redon and Fantasy*, May-September 1968. not repr.

BIBLIOGRAPHY: *Gazette des Beaux-Arts*, supp., February 1967, no. 366, repr. p. 103; *BMA News*, 1967, nos. 1-2, repr. p. 52; Max Kozloff, *Jasper Johns*, New York: Harry N. Abrams, 1967, repr. pl. 108.

A solitary eye, disconnected from its human body, was a frequent subject in Odilon Redon's prints. The titles he gave these works, from portfolios dedicated to authors such as Edgar Allan Poe or Gustave Flaubert, suggest the artist's metaphorical intent. The "eye" can be construed as a physical equivalent for man's visionary powers, poetic genesis, or more generally, a soul or spiritual being. The cosmic setting–expansive skies, clouds, and seas–of these images further reinforce a symbolic iconography.

Several lithographs of floating eyes, published in albums between 1879 and 1888, bear iconographic comparison with the present drawing. *Vision* (repr. in reprint edition of André Mellerio, *Odilon Redon*, New York: Da Capo Press, 1968, no. 34) from *Dans le Rêve* (1879) and *L'oeil, comme un ballon bizarre se dirige vers l'infini* (Mellerio 38) from *A Edgar Poe* (1882), two of Redon's earliest representations of detached eyes, portray the bulbous form of an eyeball topped with feathery lashes. A second lithograph from *A Edgar Poe, A l'horizon, l'ange des certitudes, et, dans le ciel sombre, un regard interrogateur* (Mellerio 41), on the other hand, includes a circular detail from a face showing one eye staring out at the viewer. This interpretation most closely resembles the present drawing, except that here the artist added a mantle of black hair. Perhaps the present drawing was an earlier image which Redon later incorporated into the more complex subject of the lithograph.

Other representations of the "eye" in Redon's prints include lithographs from the 1883 series, *Les Origines*, where he portrayed a cyclops (Mellerio 47), a mythical being which was perhaps the source for his fascination for solitary eyes. Another lithograph from the same portfolio used the eye as part of an imaginary plant (Mellerio 46), while in one of the prints from the 1888 edition of *Tentation de Saint Antoine*, the eye forms part of fantastic mollusks or shell fish (Mellerio 146). In most of these examples, however, an enormous bulging eye exists in a fanciful, dream-like world. The Baltimore *Eye*, in contrast, describes a detail of the human face set in an unspecific ambiance.

Redon executed over 600 charcoal drawings, which was his favorite medium during the 1870s and 1880s. Probably dating from the early to mid-1880s and contemporary with the lithographs cited above, the exquisite Baltimore drawing exemplifies the rich blacks and velvet textures Redon exploited from charcoal.

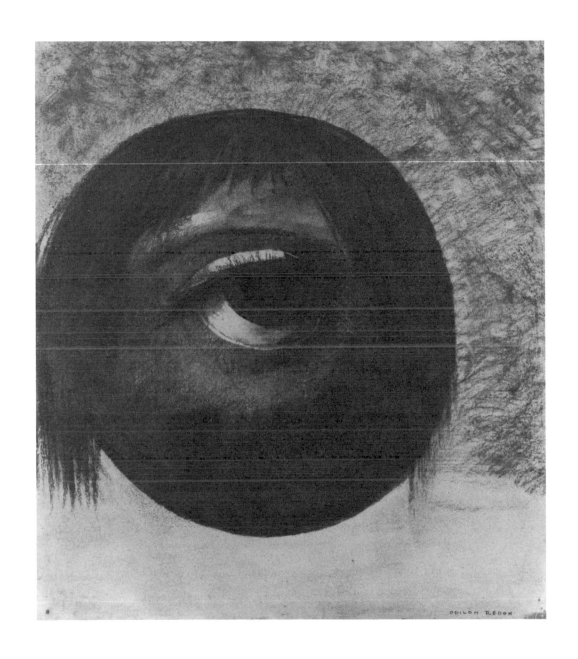

GEORGES LACOMBE
French, 1868-1916

29. *Sheet with Two Studies for the "Chestnut Gatherers":*
Woman's Hand, Woman's Head circa 1892-94

Black crayon on blue-gray wove paper

13⅝ x 10⅛ ins. (34.7 x 25.7 cms.) sheet

Inscribed in pencil at upper right: *14 30/VII*
Estate monogram at lower right: *L* (not in Lugt)

Verso: *Studies of arms*, black crayon. Two stamps at lower right: *SG* (for Shepherd Gallery) followed by *14* in blue ink; *Atelier/Georges Lacombe*

Purchase, Women's Committee Fund, 74.29

PROVENANCE: Estate of the artist; purchased from Shepherd Gallery, New York, in 1974.

EXHIBITIONS: New York, Shepherd Gallery, *Georges Lacombe Drawings*, Spring 1974, no. 14, repr. pl. v.

The drawings of Georges Lacombe, the "Nabi sculptor" had received little attention prior to an exhibition at the Shepherd Gallery several years ago (see Joseph Downing, *Georges Lacombe Drawings*, Spring 1974). Shown there with other sheets from Lacombe's sketchbooks in the artist's estate, the present drawing is inscribed at the upper right corner with three numbers: *14 30/VII*. These inscriptions document that the drawing, number 14 in the Shepherd show, was page 30 from the seventh sketchbook. According to Downing, the model is Marthe Wenger, who married Lacombe in 1897.

A preparatory drawing for his oil, *Autumn* or *Chestnut Gatherers* (Petit Palais, Geneva, repr. in *L'Aube du XXe Siècle, de Renoir à Chagall*, Vol. 1, Geneva: n.d., no. 141), the present work is a study for the head of the woman at the left of the painting and for the left hand of the central figure, who in the oil carries a basket of nuts. The drawing as well as the painting evidences Lacombe's kinship with both Paul Gauguin and the Nabis, the group of artists with whom Lacombe exhibited during the last decade of the nineteenth century. In 1892 he met Paul Serusier, the founder of the Nabis, who a few years earlier had introduced Gauguin's "new" art to Maurice Denis, Pierre Bonnard, and other students at the Académie Julian;

Lacombe immediately became Serusier's disciple. The following year he met Gauguin himself, recently back from the South Seas, and the two artists worked together in Brittany during 1893-94. The pious woman in Lacombe's drawing, represented with her eyes closed and head bent forward as if in prayer, recalls humble Breton peasants at worship in Gauguin's paintings such as *Vision after the Sermon* (National Gallery of Scotland) and more particularly, the woman kneeling in front of a stone pietà in *Calvery* (Musée Royaux des Beaux-Arts, Brussels). Although *Chestnut Gatherers* portrays three foreground figures at work, collecting or carrying autumn nuts, the women move as if in a religious procession with their eyes shut and their heads slightly bent. But unlike Gauguin's Breton figures, Lacombe's peasant women (see in addition to *Chestnut Gatherers* the painting, *The Ages of Life*, also in the Petit Palais in Geneva, repr. in *L'Aube du XXe Siècle*, no. 142) wear less specific Breton costumes. In the present example, the bare-headed model with long flowing hair resembles two characters from the artist's sculptural repertoire: the wooden *Mary Madeline* (repr. in Agnes Humbert, "Georges Lacombe, Nabi Inconnu," in *Les Nabis et leur époque*, Geneva: Pierre Cailler, 1954, no. 16) and the primeval mother image in the carved panel of *Birth* (repr. in Charles Chassé, *The Nabis and their Period*, New York and Washington: Frederick A. Praeger, 1969, no. 46).

Lacombe's figural Breton subjects, whether representing peasant labors–wheat harvesting, nut gathering, rose picking–or more straightforward symbolic themes as in *The Ages of Life* and in the carved bed *Lit* whose three panels portray birth, copulation, and death, exist as metaphors for the eternal cycle of human life or nature's seasons. The static, almost frozen poses of his figures set within symmetrical hieratic compositions bear comparison with Gauguin's Tahitian masterpiece, *From Whence We Come?* (Boston, Museum of Fine Arts).

Lacombe also painted landscapes in the Neo-Impressionist technique of divided color applied in small patches, both during the 1890s, but more consistently after 1904 when he became friends with Theo Van Rysselbergh.

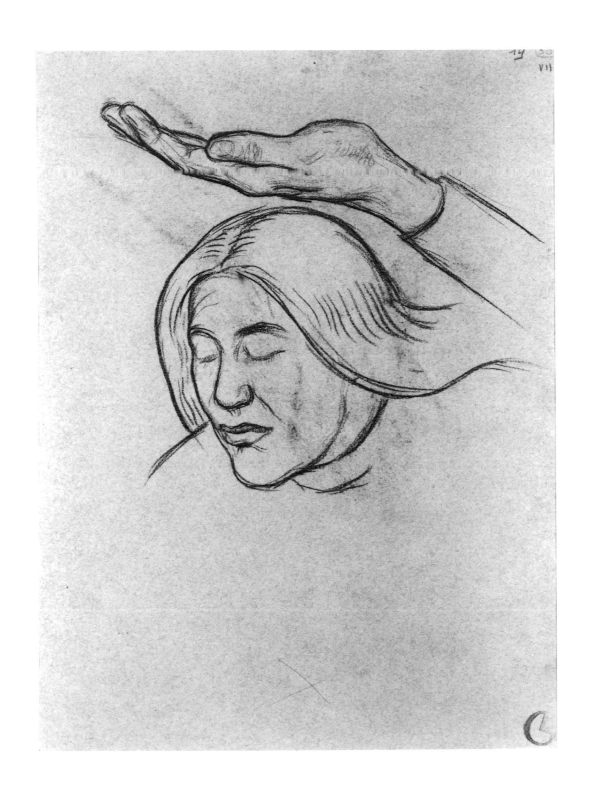

73

JESSIE M. KING
Scottish, 1876-1948

30. *Book Illustration: Where I Made One–*
Turn Down an Empty Glass circa 1903-05

Pen and black ink on vellum

8½ x 7¼ ins. (21.6 x 18.4 cms.) uneven sheet

Monogram in pen and black ink in oval at lower right: *JMK*
Inscribed in pen and black ink at bottom: *WHERE·I·MADE·ONE–*
TURN·DOWN·AN·EMPTY·GLASS·
Inscribed in pencil at lower border: *VERSE LXXV*

Purchase, Nelson and Juanita Grief Gutman Fund, 73.12

PROVENANCE: Purchased from Piccadilly Gallery, London.

EXHIBITIONS: Chapel Hill, William Hayes Ackland Memorial Art
Center, University of North Carolina, *English Drawings and
Watercolors: 1700-1900*, no. 35, not repr.

Jessie M. King's *Where I Made One–Turn Down an Empty Glass* has
yet to be identified with published illustrations from numerous
books designed by the Scottish artist. As Diana Johnson of the
Rhode Island School of Design noted in conversation, Jessie King is
known to have done individual works to illustrate lines supplied by
contemporary poets, rather than fulfilling a publisher's commission;
this might be true of the present drawings.

The finely delineated representation of a solitary slender maid
dressed in flowing garments and surrounded by swirling patterns of
flowers and leaves is close in style and theme to King's illustrations
for Sebastian Evans' *The High History of the Holy Graal* (published
1903) and *Defence of Guenevere and Other Poems by William Morris*
(published 1904). These images, also in black and white, portray
similar lonely romantic females from Arthurian myth or other
legends.

Perhaps too frequently compared with Aubrey Beardsley, the
most famous Art Nouveau illustrator of the late nineteenth century,
King portrays graceful ladies described by delicate linear ara-
besques in constrast to Beardsley's more cynical characterizations
of *femmes fatales* such as Salome. Indeed King's lithe figures more
closely resemble Botticelli's lyrical ideal models. The young Jessie
King was enchanted with the Italian master's pen and ink drawings
she viewed at the Uffizi while traveling in Florence on a student
scholarship. Her drawings reflect influence from both the Renais-
sance painter and contemporary Scottish draughtsmen such as
C. R. Mackintosh under whom she studied at the Glasgow School
of Art.

Illustrator of more than a hundred volumes, Jessie King also
designed bookplates, jewelry, and fabric patterns, some manufac-
tured by Liberty's of London. Not well known, her work merits
greater attention. A recent auction at Sotheby's made the largest
body of her work available to the public (see Peter Nahum, [ed.]
Jessie M. King and E. A. Taylor, Illustrator and Designer, London:
Sotheby's Belgravia, 1977).

WHERE·I·MADE·ONE — TURN·DOWN·AN·EMPTY·GLASS·

PABLO PICASSO
Spanish, 1881-1973

31. *Man on the Beach (Carles Casagemas Coll)*
circa 1899

Brush and watercolor on off-white wove paper

8⅛ x 7⅛ ins. (20.7 x 18.1 cms.) uneven sheet

Signed in brush and black ink at lower left: *P. Ruiz Picasso*

Cone Collection, 50.267

EXHIBITIONS: Baltimore, Baltimore Museum of Art, *From Ingres to Gauguin*, 1951, no. 174, not repr.; New York, Wildenstein & Co., *Cone Collection*, March 29-May 4, 1974.

BIBLIOGRAPHY: *Cone Collection*, 1955, no. 82, not repr.; *Cone Collection*, 1967, no. 78, not repr.; Victor Carlson, *Picasso Drawings and Watercolors, 1899-1907*, Baltimore: Baltimore Museum of Art, 1976, no. 1, repr. in color p. viii, and p. 3.

Near the turn of the century, the young Pablo Picasso and his close friend, the painter Carles Casagemas Coll frequented the Barcelona bistro Els Quatre Gats, where a group of Spanish writers and artists congregated, held exhibitions, and published journals. (For further information on the artists associated with Els Quatre Gats, see the 1978 Princeton Art Museum catalogue, *Els Quatre Gats, Art in Barcelona around 1900*.) Picasso drew portrait heads of his friends, some of which may have been exhibited at his one-man show in February 1900. The following month Casagemas also had a one-man show at the tavern. In October of that year, the two young artists went to Paris, where they viewed the Exposition Universelle, and Casagemas fell in love with a woman named Germaine. Following this unhappy love affair, both artists returned to their homeland. However, soon after, Casagemas journeyed again to Paris, where he committed suicide in 1901. His tragic death provided inspiration for Picasso's canvases, *The Mourners* (Zervos I.52) and *Evocation* (Zervos I.55).

As Victor Carlson has pointed out, the present portrayal of Casagemas with its surrounding dark border approximates the portrait head recorded at Els Quatre Gats (Zervos XXI.116), where Casagemas wears the same hat with upturned brim. Other full-length depictions of Casagemas (Zervos VI.132 and VI.219) also emphasize his strong profile with an unusually long pointed nose.

Like other paintings or drawings executed early in his career, either in Spain or during his first year in Paris, *Man on the Beach* is signed with Picasso's full family names, using surnames of both his mother and father as is the Spanish custom.

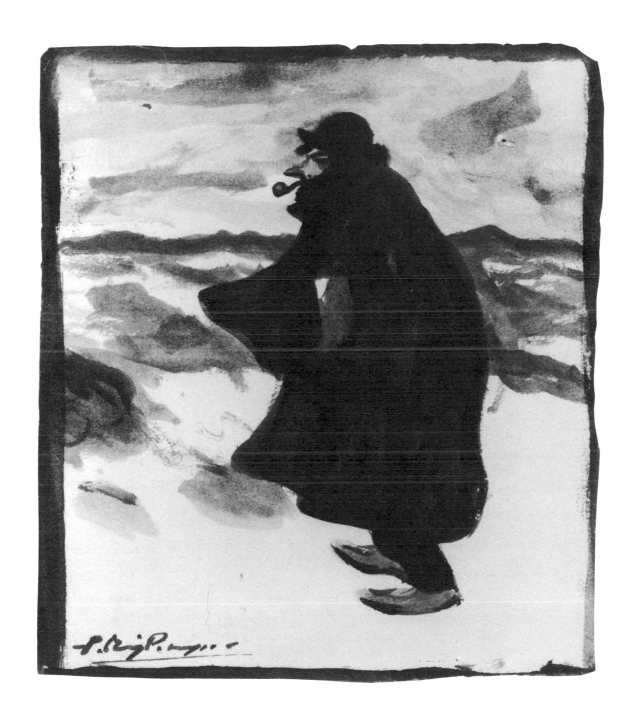

32. *Study for the Painting "La Coiffure"*
circa 1906

Pen and black ink, brush and gray wash on thin tan wove paper

12³/₁₆ x 9³/₈ ins. (30.9 x 23.9 cms.) sheet

Signed in pen and black ink at lower left: *Picasso*

Cone Collection, 50.12.477

EXHIBITIONS: Baltimore, Baltimore Museum of Art, *Modern French Art*, 1925, no. 97, repr. on cover; New York, Wildenstein & Co., *Cone Collection*, March 29-May 4, 1974.

BIBLIOGRAPHY: Etta Cone, *Cone Collection*, 1934, repr. pl. 105; A. D. Breeskin, "Early Picasso Drawings in the Cone Collection," *Magazine of Art*, March 1952, p. 108, repr.; *Cone Collection*, 1967, no. 305, not repr.; Pierre Daix and Georges Boudaille, *Picasso, The Blue and Rose Periods*, Greenwich: New York Graphic Society, 1967, repr. no. XIV.17; Christian Zervos, *Pablo Picasso*, Vol. XXII, Paris: Cahiers d'Art, 1970, repr. no. XXII.421; Denys Sutton and Paolo Lecaldano, *Complete Paintings of Picasso: Blue and Rose Periods*, London: Weidenfeld & Nicolson, 1971, repr. no. 244a; Victor Carlson, *Picasso Drawings and Watercolors, 1899-1907*, Baltimore: Baltimore Museum of Art, 1976, no. 31, repr. on end sheets and on p. 60.

In several canvases painted in Paris or Gosol during 1906, Picasso represents a model grooming her hair attended by a second figure. The present drawing, omitting the attendant save for her fingers at work combing the sitter's locks, is a preliminary study for *The Coiffure* (Metropolitan Museum of Art, Zervos, I.313), where the seated figure turns more to her left and holds up a mirror to view her reflection.

Defined with exquisite draughtsmanship, the slender figure of the Cone drawing is carefully positioned on the sheet to create a stable composition, in spite of the omission of the stool on which she sits. Her delicate profile bears closer resemblance to the elegant models in another painting of a similar subject, *The Toilette* (Albright Knox Gallery, Zervos I.325) and the refined classical features of the models in its related studies (see especially Daix-Boudaille, XV.29, 30, and 32). Interestingly, one of the studies for *The Toilette* (Daix-Boudaille, XV.29) also presents a single figure strategically placed on the page, and by including only a partial description of the mirror she holds, achieves a monumentality similar to that attained in the beautiful Cone drawing.

Picasso

33. *Boy Leading a Horse (Study for the Painting, "Chevaux au Bain")* circa 1905-06

Brush and rose-red watercolor on thin tan wove paper

19¾ x 12¹⁵/₁₆ ins. (50.1 x 32.8 cms.) sheet

Signed in pen and black ink at lower right: *Picasso*

Cone Collection, 50.12.491

PROVENANCE: Collection of Michael and Sarah Stein.

EXHIBITIONS: Baltimore, Baltimore Museum of Art, *Modern French Art*, 1925, no. 88(?); New York, Museum of Modern Art, *Four Americans in Paris: The Collections of Gertrude Stein and Her Family*, December 18, 1970-March 1, 1971, p. 167, not repr. (also included in modified versions of this exhibition shown at Baltimore Museum of Art, April 4-June 13, 1971, and San Francisco Museum of Art, September 15-October 31, 1971).

BIBLIOGRAPHY: Waldemar George, *Picasso Dessins*, Paris. Editions des Quatre Chemins, 1926, repr. pl. 3; Etta Cone, *Cone Collection*, 1934, repr. pl. 109 bottom; A. D. Breeskin, "Picasso's 'Saltimbanques' in the Cone Collection," *BMA News*, Vol. XIII, no. 3 (December 1949) p. 4; A. D. Breeskin, "Early Picasso Drawings in the Cone Collection," *Magazine of Art*, Vol. XLV, no. 3 (March 1952) repr. p. 107; *Cone Collection*, 1967, no. 295, repr. p. 56; Pierre Daix and Georges Boudaille, *Picasso, the Blue and Rose Periods. A Catalogue Raisonné, 1900-1906*, London. Evelyn, Adams and Mackay, 1967, repr. no. XIV.6; Christian Zervos, *Pablo Picasso*, Vol. XXII, Paris. Cahiers d'Art, 1970, repr. no. XXII.270; Denys Sutton and Paolo Lecaldano, *The Complete Paintings of Picasso. Blue and Rose Periods*, London. Weidenfeld and Nicolson, Ltd., 1971, no. 234, repr.; William Rubin, *Picasso in the Collection of The Museum of Modern Art*, New York. The Museum of Modern Art, 1972, p. 34, repr. p. 192; Victor I. Carlson, *Picasso, Drawings and Watercolors, 1899-1907*, Baltimore. Baltimore Museum of Art, 1976, no. 23, repr. p. 45.

The brush drawing is a study for the monumental painting of the same title in the collection of Mr. and Mrs. William S. Paley, New York (Christian Zervos, *Pablo Picasso*, Vol. I, Paris: Cahiers d'Art, 1932, no. 1.264; Daix-Boudaille, no. XIV.7). A watercolor in the Cone Collection (Carlson, no. 24) is similar to the composition of the painting. Two other watercolors (Zervos, 1.269 and 1.270; Daix-Boudaille, XIV.3 and XIV.4) show the boy wearing a costume identical to that seen in the artist's 1905 *Blue Boy* (Private Collection, New York; Zervos, 1.271; Diax-Boudaille, XIII.21).

The boy and horse form the central part of a multi-figure composition *The Watering Place*, known from three sketches (Zervos, 1.265, XXII.266, and XXII.267; Daix-Boudaille, XIV.14-XIV.16) as well as a drypoint (Bernard Geiser, *Picasso: Peintre-Graveur*, Vol. I, Berne: Chez l'auteur, 1933, no. 10). It is generally agreed that Picasso intended to paint a large version of the subject which would have rivaled the *Family of Saltimbanques*, in the National Gallery of Art, Washington, D.C., as his most ambitious painting prior to *Les Demoiselles d'Avignon*. For whatever reasons, *The Watering Place* was never carried further. Only the Paley canvas survives to suggest the grandeur that the composition would have had if executed on the scale of life-size figures.

Victor Carlson

34. *Woman Carrying a Jar (Jeune femme portant une cruche)* circa Summer 1906

Black chalk on thin tan wove paper

9⁹/₁₆ x 7¹/₂ ins. (24.3 x 19.1 cms.) sheet

Signed in pencil at upper left: *Picasso*

Cone Collection, 50.12.487

EXHIBITIONS: New York, Wildenstein & Co., *Cone Collection*, March 29-May 4, 1974.

BIBLIOGRAPHY: Etta Cone, *Cone Collection*, 1934, repr. pl. 107; *Cone Collection*, 1967, no. 312, not repr.; Pierre Daix and Georges Boudaille, *Picasso, The Blue and Rose Periods*, Greenwich: New York Graphic Society, 1967, repr. no. D.XV.32; Christian Zervos, *Pablo Picasso*, Vol. XXII, Paris: Cahiers d'Art, 1970, repr. no. XXII.385; Victor I. Carlson, *Picasso Drawings and Watercolors*, Baltimore: Baltimore Museum of Art, 1976, no. 34, repr. p. 67.

During the summer of 1906 Picasso spent several months in the Catalan village of Gosol. There he was attracted to the Spanish women who performed their daily chores with calm dignity. He executed numerous sketches in a notebook which was later published as *Carnet Catalan* (see Zervos, XXII.359-363).

Here a peasant balances a jar on her head with apparent ease, using only one hand to steady the pot as she steps forward on her left foot. Delicately modeled with soft gradations of tone especially around her face and bosom, the present figure displays greater plasticity than found in the majority of the Gosol drawings.

35. *Head of a Young Man (Self Portrait)*
circa Autumn 1906

Quill pen and black ink on white laid paper

12⁹/₁₆ x 9³/₈ ins. (31.8 x 23.9 cms.) sheet

Signed in pencil at lower right: *Picasso*

Cone Collection, 50.12.485

EXHIBITIONS: New York, Wildenstein & Co., *Cone Collection*, March 29-May 4, 1974.

BIBLIOGRAPHY: A. D. Breeskin, "Early Picasso Drawings in the Cone Collection," *Magazine of Art*, March 1952, repr. p. 109; Christian Zervos, *Pablo Picasso*, Vol. VI, Paris: Cahiers d'Art, 1954, repr. no. VI.851; *Cone Collection*, 1955, repr. p. 50; Maurice Jardot, *Pablo Picasso Drawings*, New York: Harry N. Abrams, 1959, no. 19, repr.; *Cone Collection*, 1967, no. 315, repr. p. 57; Victor I. Carlson, *Picasso Drawings and Watercolors, 1899-1907*, Baltimore: Baltimore Museum of Art, 1976, no. 44, repr. p. 87.

As Victor Carlson has pointed out, the present drawing, traditionally called *Head of a Young Man*, is closely connected with a sheet of studies (Daix-Boudaille, Addenda, A.22) for Picasso's *Self Portrait with Palette* (Philadelphia Museum of Art, Zervos I.375). The model no doubt is the artist himself.

When compared with the oil portrait, both the Cone example and a closely related pen and ink drawing (also in the Philadelphia Museum of Art, Daix-Boudaille, D.XVI.22) further abstract the planar structure of the face by juxtaposing abruptly contrasting areas. For instance, the forehead and narrow strip down the nose as well as the curving shape under the man's left eye are white (bare paper), while the left side of his nose, the lower cheek and mouth, and the left eye with brow are covered with a dense mesh of hatchings in black ink. Due to the extensive elimination of details and reduction of the facial structure to a few planes in the present drawing, Carlson has suggested that the Baltimore *Self Portrait* may post-date the oil *Self Portrait with Palette*.

36. Reclining Nude Woman (Femme Nue Couchée)
circa Autumn 1906

Black chalk on white laid paper

18³/₈ x 24¹/₂ ins. (46.6 x 62.2 cms.) sheet

Signed in black chalk at upper left: *Picasso*

Cone Collection, 50.12.651

PROVENANCE: Collection of Michael and Sarah Stein.

EXHIBITIONS: New York, Museum of Modern Art, *Four Americans in Paris: The Collections of Gertrude Stein and Her Family*, December 18, 1970-March 1, 1971, p. 168, not repr. (also included in modified versions of this exhibition shown at Baltimore Museum of Art, April 4-June 13, 1971 and San Francisco Museum of Art, September 15-October 31, 1971).

BIBLIOGRAPHY: Waldemar George, *Picasso Dessins*, Paris: Editions des Quatre Chemins, 1926, repr. pl. 4; Etta Cone, *Cone Collection*, 1934, repr. pl. 103 bottom; A. D. Breeskin, "Early Picasso Drawings in the Cone Collection," *Magazine of Art*, Vol. XLV, no. 3 (March 1952), repr. p. 109; *Cone Collection*, 1967, no. 316, not repr.; Pierre Daix and Georges Boudaille, *Picasso, the Blue and Rose Periods. A Catalogue Raisonné, 1900-1906*, London: Evelyn, Adams and Mackay, 1967, repr. no. D.XVI.14; Christian Zervos, *Pablo Picasso*, Vol. XXII, Paris: Cahiers d'Art, 1970, repr. no. XXII.463; Rhode Island School of Design exhibition catalogue, *Selection V*, 1975, p. 130, not repr. (not in exhibition); Victor I. Carlson, *Picasso, Drawings and Watercolors, 1899-1907*, Baltimore: Baltimore Museum of Art, 1976, no. 43, repr. p. 85.

In the Autumn of 1906, Picasso began to work on a series of drawings of monumentally proportioned nude figures (Christian Zervos, *Pablo Picasso*, Vol. I, Paris: Cahiers d'Art, 1932, nos. 1.364, 1.365, 1.369, Vol. XXII, nos. XXII.465, XXII.467 and XXII.469; Daix-Boudaille, XVI.16 and XVI.19) which resulted in his canvas *Two Nudes* (The Museum of Modern Art, New York, Zervos 1.366; Daix-Boudaille, XVI.15). The grave composure and massive dignity of these Amazonian figures owe much to Picasso's admiration of Cézanne's nudes in addition to his study of Iberian sculpture from ca. 400-200 B.C. A group of newly discovered pieces was placed on display by the Louvre in the Spring of 1906; other Iberian examples had been on exhibition there for some time (James Johnson Sweeney, "Picasso and Iberian Sculpture," *The Art Bulletin*, Vol. XXIII, no. 3 (September 1941, pp. 191-198). Closest to the Baltimore Museum's drawing is a standing nude (Zervos, Vol. VI, Paris: Cahiers d'Art, 1954, no. VI.645) which can be seen as a vertical counterpart to this sheet (for an extensive and subtle analysis of the standing nude, see entry by Susan A. Denker for no. 56 in *Selection V: French Watercolors and Drawings from the Museum's Collection*, Providence: Museum of Art, Rhode Island School of Design, 1975).

In keeping with Picasso's concern for the plastic grandeur of these figures, his draughtsmanship becomes bolder and more schematic in its definition of the interaction of light with mass. Broad areas of transparent shadow, lightly rubbed across the paper's textured surface, are given further definition by an overlay of lines which more sharply focus the sculpturesque realization of the figures.

37. *Portrait of Léopold Zborowski* circa 1919

Pencil on off-white wove paper

14^5/$_{16}$ x 10^1/$_2$ ins. (36.4 x 26.6 cms.) sheet

Signed in pencil at lower right margin: *Picasso*

Cone Collection, 50.12.503

EXHIBITIONS: New York, M. Knoedler & Co., *Cone Collection*, January 24-February 12, 1955; Toronto, Art Gallery of Toronto, January 11-February 16, 1964 and Montreal Museum of Fine Arts, February 28-March 31, 1964, *Picasso and Man*, no. 68, repr. p. 80; New York, Wildenstein & Co., *Cone Collection*, March 29-May 4, 1974.

BIBLIOGRAPHY: Etta Cone, *Cone Collection*, 1934, repr. pl. 111; Douglas Cooper, "A Picasso Drawing Identified," *BMA News*, June 1958, pl., repr. as frontispiece; *Cone Collection*, 1967, no. 319, repr. p. 55.

REMARKS: Previously called *A Russian*.

Léopold Zborowski was a Polish exile poet, living in France during the early decades of the twentieth century. He became friends with Amedeo Modigliani, whose work he much admired. In 1917, Zborowski organized the first one-man show of the Italian artist's work at Berthe Weill Gallery in Paris. During the following years, he was responsible for subsequent Modigliani exhibitions. As in the present Picasso drawing, Modigliani's portrait of his dealer (repr. in Ambrogio Ceroni, *Amedeo Modigliani, Dessins et Sculptures*, Milan: Edizioni del Milione, 1965, no. 147) portrays a similarly serious looking bearded man with identical fluffs of hair overlapping his brow and somewhat rebelliously sticking out over his right ear.

Although executed during a period when some of Picasso's oils represented abstract compositions in synthetic cubist style, *Léopold Zborowski* reveals the Spanish-born artist portraying his sitter with great naturalism and attention to three dimensional modeling. Picasso describes Zborowski with exacting detail, subtly molding his high cheek bones and meticulously delineating his closely cropped beard. This emotionally charged interpretation of character is exceptional during this period when Picasso depicted others, such as Ambroise Vollard with classical detachment, which as Alfred Barr has noted, paid homage to Ingres.

38. *Portrait of Dr. Claribel Cone* 1922

Pencil on off-white wove paper

25³/₁₆ x 19⁷/₁₆ ins. (64 x 49.4 cms.) sheet

Signed and dated in pencil at lower right: *Picasso/14-7-22*

Cone Collection, 50.12.499

EXHIBITIONS: Baltimore, Baltimore Museum of Art, *A Century of Baltimore Collecting, 1840-1940*, June 6-September 1, 1941, p. 113, not repr.; New York, Museum of Modern Art, *20th Century Portraits*, 1942, p. 141, repr. p. 85; Richmond, Virginia Museum of Fine Arts, *Cone Collection*, 1953; New York, M. Knoedler & Co., *Cone Collection*, 1955; New York, Museum of Modern Art, May 22-September 8, 1957 and Art Institute of Chicago, October 29-December 8, 1957, *Picasso: 75th Anniversary*, repr. p. 54; Philadelphia, Philadelphia Museum of Art, *Picasso*, January 8-February 23, 1958, no. 104, repr.; Rotterdam, Museum Boymans-van Beuningen, August 2-September 28, 1958, Paris, Musée de l'Orangerie, October 2, 1958-January 2, 1959, and New York, Metropolitan Museum of Art, February 3-March 15, 1959, *French Drawings from American Collections: Clouet to Matisse*, no. 220, repr. pl. 203 in Dutch and English cat., repr. pl. 218 in French cat.; New York, Wildenstein & Co., *Cone Collection*, March 29-May 4, 1974; New York, Wildenstein & Co., *The Artist and His World*, October 21-November 27, 1976.

BIBLIOGRAPHY: Waldemar George, *Picasso Dessins*, Paris: Editions des Quatre Chemins, 1926, repr. pl. 16; Etta Cone, *Cone Collection*, 1934, repr. p. 22; *BMA News*, October 1949, repr. p. 2; "Dr. Claribel and Miss Etta, Collectors," *Art News*, January 1950, repr. p. 39; Doris Brian, "The Baltimore Museum's Cone Collection," *Art Digest*, January 15, 1950, repr. p. 7; Christian Zervos, *Pablo Picasso*, Vol. IV, Paris: Cahiers d'Art, 1951, repr. no. IV.362; Thomas B. Hess, "Ingres," *Art News Annual*, Christmas Edition, November 1952, repr. p. 172; Paul J. Sachs, *Modern Prints and Drawings*, New York: Alfred A. Knopf, 1954, repr. p. 5; *Cone Collection*, 1955, repr. p. 5; *Commemorative Portfolio of Masterpieces from the Cone Collection in the Baltimore Museum of Art*, New York, 1957, repr. on cover; Dale G. Cleaver, *Art, An Introduction*, New York: Harcourt, Brace, 1966, repr. pl. 84; *Cone Collection*, 1967, no. 322, repr. p. 15; Bernard Chaet, *The Art of Drawing*, New York: Holt, Rinehart & Winston, 1970, repr. fig. 269, discussed pp. 265-66.

Picasso's portrait of his Baltimore patron, Dr. Claribel Cone is composed with thin, unreinforced lines with no interior modeling. Details such as the sitter's brooch or lace collar are only vaguely indicated by short squibbly lines. Picasso's controlled, assured contours in this drawing contrast with the artist's technique in his *Portrait of Léopold Zborowski*, where he painstakingly described the plasticity and textures of the bearded man's face (see cat. no. 37).

The delicacy with which Picasso delineates Dr. Cone's slightly idealized features resembles the artist's rendering of his "classical" figures from the early 1920s. The monumental pose of Dr. Cone seated squarely in an armchair with her foot resting on a pillow implies her self-assured character. In sum, Picasso presents a graceful, yet majestic image of one of his earliest collectors.

HENRI MATISSE
French, 1869-1954

39. *Portrait of Mlle. Irène Vignier* circa 1914

Pencil on white wove paper

12⅞ x 10 ins. (32.7 x 25.4 cms.) uneven sheet

Signed in pencil at lower right: *Henri-Matisse*

Cone Collection, 50.12.39

EXHIBITIONS: Baltimore, Baltimore Museum of Art, *1914*, October 6-November 15, 1964, no. 155, not repr.; Baltimore, Baltimore Museum of Art, January 12-February 21, 1971, San Francisco, California Palace of the Legion of Honor, March 20-May 9, 1971, and Art Institute of Chicago, May 26-July 10, 1971, *Matisse as a Draughtsman*, no. 23, repr. p. 67; New York, Wildenstein & Co., *Cone Collection*, March 29-May 4, 1974.

BIBLIOGRAPHY: *Cone Collection*, 1967, no. 191, repr. p. 63.

Irène Vignier, the daughter of an antiques dealer and friend of the artist, was also the sitter for six etchings Henri Matisse executed in 1914 (see two versions repr. in William S. Lieberman, *Matisse, Fifty Years of his Graphic Work*, New York: George Braziller, 1956, p. 43). In the present work, Matisse used soft hatchings to indicate the gentle curves of the young girl's face; such modeling is absent in the linear design of the etched portraits of Irène. One senses Matisse's attraction for his charming wide-eyed model, whom he represents here from a close vantage point. Her face and flowing braids fill the sheet, keeping costume or accessories to a minimum in contrast to two other Cone drawings where the artist delights in detailing intricate patterns (see *The Plumed Hat*, cat. no. 40 and *The Rumanian Blouse*, cat. no 42).

40. *The Plumed Hat* circa 1919

Pencil on off-white wove paper

19⁵/₁₆ x 14⁹/₁₆ ins. (49 x 37 cms.) sheet

Signed in pencil at lower left: *Henri-Matisse*

Cone Collection, 50.12.58

PROVENANCE: Pierre Matisse Gallery, New York, 1932, Etta Cone.

EXHIBITIONS: New York, Pierre Matisse Gallery, *Henri Matisse, Exhibition of Fifty Drawings*, November 22-December 17, 1932, no. 30; New York, Museum of Modern Art, November 13, 1951-January 13, 1952, Cleveland Museum of Art, February 5-March 16, 1952, Art Institute of Chicago, April 1-May 4, 1952, and San Francisco Museum of Art, May 22-July 6, 1952, *Henri Matisse*, no. 120, not repr.; Richmond, Virginia Museum of Fine Arts, *Cone Collection*, 1953; New York, M. Knoedler & Co., *Cone Collection*, 1955; New York, Solomon R. Guggenheim Museum, November 6, 1963-January 5, 1964, Minneapolis, University of Minnesota, February 3-March 15, 1964, and Cambridge, Fogg Art Museum, April 6-May 24, 1964, *Twentieth Century Master Drawings*, no. 81, not repr.; Baltimore, Baltimore Museum of Art, January 12-February 21, 1971, San Francisco, California Palace of the Legion of Honor, March 20-May 9, 1971 and Art Institute of Chicago, May 26-July 10, 1971, *Matisse as a Draughtsman*, no. 34, repr. p. 89; New York, Wildenstein & Co., *Cone Collection*, March 29-May 4, 1974; Paris, Centre National d'art et de culture Georges Pompidou, *Henri Matisse, dessins et sculpture*, May 29-September 7, 1975, no. 61, repr. p. 105.

BIBLIOGRAPHY: Henri Matisse, *Cinquante dessins par Henri Matisse*, Paris: Bernheim-Jeune, 1920, repr. pl. XXXI; Adolphe Basler and Charles Kunstler, *Le Dessin et la gravure modernes en France*, Paris: Les Editions G. Crès & Cie, 1930, repr. p. 103; Etta Cone, *Cone Collection*, 1934, repr. pl. 83; *BMA News*, October 1949, repr. on cover; Alfred Barr, *Matisse, His Art and His Public*, New York: Museum of Modern Art, 1951, p. 206 and note 8, repr. p. 429; *A Picture Book*, Baltimore, 1955, repr. p. 61; Ira Moskowitz, *Great Drawings of All Time*, Vol. III, New York: Shorewood Publishers, 1962, no. 854, repr.; *Cone Collection*, 1967, no. 192, not repr.; Jean Guichard-Meili, *Henri Matisse*, New York & Washington: Frederick A. Praeger, 1967, repr. p. 90; Bernard Chaet, *The Art of Drawing*, New York: Holt, Rinehart & Winston, 1970, repr. p. 5.

In 1919 Matisse designed a fantastic hat of white feathers with ringlets of black ribbons hanging down on the two sides. He executed at least sixteen drawings and three oils showing his model Antoinette wearing this hat, but varied the pose, dress, and media employed (see Alfred Barr, *Matisse, His Art and His Public*, New York: Museum of Modern Art, 1951, pp. 225, 427-29; Victor Carlson, *Matisse as a Draughtsman*, Baltimore: Baltimore Museum of Art, 1971, nos. 35-37; and Aragon, *Henri Matisse, a Novel*, New York: Harcourt Brace Jovanovich, 1972, Vol. II, pls. XVII, XVIII, and figs. 99-102). In the present drawing and three related works, the flamboyant hat is counter-balanced by Antoinette's embroidered dress (see pl. 35 in Gallery of Modern Art, New York, exhibition catalogue, *Selections from the Collection of Dr. and Mrs. T. Edward Hanley;* pl. 32 in *Cinquante dessins par Henri-Matisse*, Paris: Bernheim-Jeune, 1920; and pl. 67 in Alexander Romm, *Matisse: A Social Critique*, New York: Lear, 1947). In contrast, Matisse sometimes allowed his fabulous plumed creation to dominate the composition in other drawings (see especially, Carlson, no. 36). Rendered with meticulous draughtsmanship, the artist's use of line in the present example contrasts with the seemingly spontaneous, free pen lines which describe the embroidery of the *Rumanian Blouse* executed nearly two decades later (see cat. no. 42).

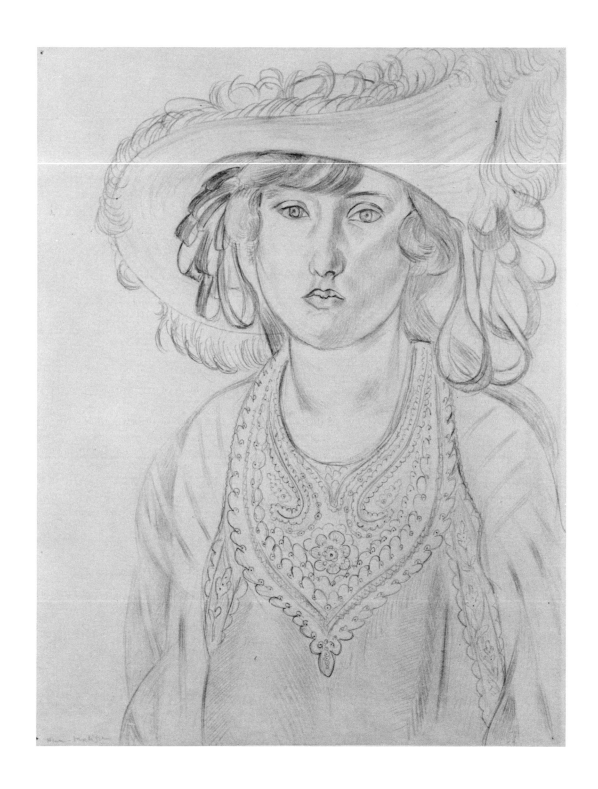

41. *Reclining Model with Flowered Robe*　circa 1923-24

Charcoal and estompe on white laid paper

18⅞ x 24¾ ins. (48 x 62.8 cms.) sheet

Signed in pencil at lower left: *Henri-Matisse*

Cone Collection, 50.12.52

PROVENANCE: Galerie Justin K. Thannhauser, Lucerne; Galerie Siegfried Rosengart, Lucerne; purchased by Etta Cone in August 1937.

EXHIBITIONS: Washington, D.C., National Gallery of Art, *19th and 20th Century European Drawings*, circulated by The American Federation of Arts, July 1965-July 1966, no. 36, repr.; Baltimore, Baltimore Museum of Art, January 12-February 21, 1971, San Francisco, California Palace of the Legion of Honor, March 20-May 9, 1971, and Art Institute of Chicago, May 26-July 10, 1971, *Matisse as a Draughtsman*, no. 43, repr. p. 107; New York, Wildenstein & Co., *Cone Collection*, March 29-May 4, 1974; Marseilles, Musée Cantini, *130 dessins de Matisse*, June-September 1974, no. 31, not repr.; Paris, Centre National d'art et de culture Georges Pompidou, *Henri Matisse, dessins et sculpture*, May 29-September 7, 1975, no. 69, repr. p. 113.

BIBLIOGRAPHY: Philippe Marcel, "Henri Matisse," *L'Art d'Aujourd'hui*, Summer 1924, repr. pl. XXVIII; *Cone Collection*, 1955, repr. p. 54; *Cone Collection*, 1967, no. 195, repr. p. 64; John Elderfield, "Matisse Drawings and Sculpture," *Art Forum*, September 1972, p. 80, repr. p. 83; Stephen Longstreet, *The Drawings of Matisse*, Alhambra, 1973, repr.

During the early 1920s Matisse frequently worked in charcoal and estompe to create three-dimensional images subtly modeled by the interplay between the artist's friable drawing medium and the grained surface of his paper. In the lovely *Reclining Model with Flowered Robe*, as in other Nice subjects from this period, the artist's model, portrayed in a relaxed pose, makes no direct contact with the viewer but appears lost in her thoughts. The juxtaposed patterns of the floral comforter and checkered fabric of the chaise display Matisse's fascination with decorative designs, so characteristic of his Nice paintings.

42. *The Rumanian Blouse* 1937

Pen and black ink on white wove paper

$24^{13}/_{16}$ x $19^{11}/_{16}$ ins. (63 x 50 cms.) sheet

Signed and dated in pen and black ink at lower left: *Henri Matisse 37*

Cone Collection, 50.12.57

PROVENANCE: Siegfried Rosengart Galerie, Lucerne; purchased by
Etta Cone in August 1937.

EXHIBITIONS: Lucerne, Galerie Rosengart, *Henri-Matisse*, 1937,
no. 2; Los Angeles, UCLA Art Galleries; Art Institute of Chicago,
and Boston, Museum of Fine arts, *Henri Matisse Retrospective*, 1966,
no. 183, repr. p. 154; Baltimore, Baltimore Museum of Art, January
12-February 21, 1971, San Francisco, California Palace of the Legion
of Honor, March 20-May 9, 1971 and Art Institute of Chicago, May
26-July 10, 1971, *Matisse as a Draughtsman*, no. 60, repr. p. 141; New
York, Wildenstein & Co., *Cone Collection*, March 29-May 4, 1974;
Marseilles, Musée Cantini, *130 dessins de Matisse*, June-September
1974, no. 49, repr.; Paris, Centre National d'art et de culture
Georges Pompidou, *Henri Matisse*, *dessins et sculpture*, May 29-
September 7, 1975, no. 98, repr. p. 139.

BIBLIOGRAPHY: *Cone Collection*, 1967, no. 285, not repr.

Matisse was fascinated by a Rumanian blouse embroidered with
richly colored threads. As early as 1935, two years prior to the
present work, he executed numerous large pen and ink drawings of a
model wearing this blouse. Two years following the Cone example,
Matisse painted the subject in oil, which Aragon photographed in
progress during 1939 and 1940 (see Aragon, Vol. I, pp. 18-21). In the
final painting, however, the artist has greatly simplified the blouse's
patterning (repr. in Aragon, Vol. I, p. 32).

The present *Rumanian Blouse* displays the virtuosity of the art-
ist's draughtsmanship, in which fine pen lines, seemingly spontane-
ous and free, create an elaborate design of lively patterns. Closely
related in style and composition to the present work is another
drawing, also dated 1937 (Collection James Kirkman, Ltd., Lon-
don). However, in the latter, Matisse has slightly altered the model's
pose (she turns her head towards her right, no longer facing the
viewer and clasps her hands across her lap), and thus, more nearly
anticipates the later oil composition.

43. *Self Portrait* 1937

Charcoal and estompe on white laid paper

18¹¹/₁₆ x 15³/₈ ins. (47.3 x 39 cms.) sheet

Initialed and dated in charcoal at lower left: *H M 37*

Cone Collection, 50.12.61

PROVENANCE: Purchased from the artist by Etta Cone in 1937.

EXHIBITIONS: Baltimore, Baltimore Museum of Art, *A Century of Baltimore Collecting, 1840-1940*, June 6-September 1, 1941, p. 113 not repr.; New York, Museum of Modern Art, *20th Century Portraits*, 1942, p. 140, not repr.; New York, M. Knoedler & Co., *Cone Collection*, 1955; Rotterdam, Museum Boymans-van Beuningen, August 2-September 28, 1958, Paris, Musée de l'Orangerie, October 2, 1958-January 2, 1959, and New York, Metropolitan Museum of Art, February 3-March 15, 1959, *French Drawings from American Collections: Clouet to Matisse*, no. 208, repr. pl. 187 in Dutch and English cat., pl. 202 in French cat.; Kassel, Alte Galerie, Museum Fridericianum and Orangerie, *Documenta III*, June 27-October 5, 1964, Matisse, no. 3, repr. p. 149; Baltimore, Baltimore Museum of Art, January 12-February 21, 1971, San Francisco, California Palace of the Legion of Honor, March 20-May 9, 1971, and Art Institute of Chicago, May 26-July 10, 1971, *Matisse as a Draughtsman*, no. 59, repr. p. 139: New York, Wildenstein & Co., *Cone Collection*, March 29-May 4, 1974.

BIBLIOGRAPHY: R. Escholier, *Henri Matisse*, Paris: Floury, 1937, repr. on cover; *Cone Collection*, 1955, repr. p. 55; *Cone Collection*, 1967, no. 287, repr. p. 59.

As Victor Carlson has noted, two other self-portrait drawings of 1937 are closely related to the present work but show the artist in a slightly different pose (see no. 181 in UCLA Art Galleries 1966 exhibition catalogue *Henri Matisse Retrospective* and no. 83, pl. 20 in the Solomon R. Guggenheim Museum 1963-64 exhibition catalogue, *20th Century Master Drawings*). Here, imposing, almost stern-looking, the artist directly confronts the viewer. As Carlson suggests, the erased shadow along Matisse's right profile implies movement, as if the artist just turned to face the viewer.

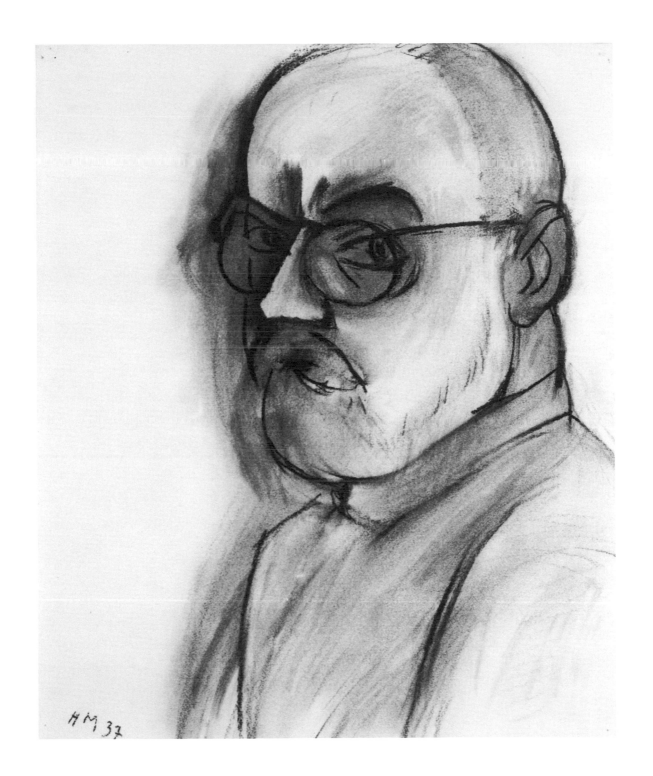

HM 37

AMEDEO MODIGLIANI
Italian, 1884-1920

44. *Seated Nude* circa 1909-1914

Turquoise blue pencil over tan and black chalk on off-white wove paper

22⅛ x 17⁹⁄₁₆ ins. (59.1 x 44.7 cms.) sheet

Signed in pencil at lower left: *modigliani*

Cone Collection, 51.12.43

PROVENANCE: Galerie Rosengart, Lucerne; Claribel and Etta Cone.

EXHIBITIONS: Baltimore, Baltimore Museum of Art, *A Century of Baltimore Collecting, 1840-1940*, June 6-September 1, 1941, p. 113, not repr.; Palm Beach, Society of the Four Arts and Coral Gables, Lowe Gallery, University of Miami, January-February 1954 and Houston, Contemporary Arts Association, April 15-May 23, 1954, *Amedeo Modigliani*, no. 28, not repr.; New York, M. Knoedler & Co., *Cone Collection*, January 24-February 19, 1955; Greensboro, University of North Carolina, *Cone Collection*, October 21-November 4, 1955; Boston, Museum of Fine Arts, and Los Angeles County Museum, *Modigliani, Paintings and Drawings*, 1961, no. 48, repr. p. 65; Baltimore, Baltimore Museum of Art, *1914*, October 6-November 15, 1964, no. 163, repr. p. 38.

BIBLIOGRAPHY: *A Picture Book*, Baltimore Museum of Art, 1955, repr. p. 67; *Cone Collection*, 1955, repr. p. 52; Alfred Werner, *Modigliani, the Sculptor*, New York: Arts, Inc., 1962, no. 72, repr.; *Cone Collection*, 1967, no. 288, repr. p. 62.

Seated Nude is closely related to nearly 100 drawing or watercolor studies for Amedeo Modigliani's grandiose sculptural project, a stone Temple of Beauty with caryatids supporting its entablature. This monument never came to fruition as Modigliani carved only one stone figure (Museum of Modern Art, repr. in Alfred Werner, *Modigliani, the Sculptor*, New York: Arts, Inc., 1962, pls. 14-17). However, the quantity of studies drawn over a period of years, from around 1908 until 1916, attest to the sculptor's intensive exploration of the subject. Unlike their Classical source, the standing, draped caryatids of the Erechtheum in Athens, Modigliani's stone model and the vast majority of related drawings portray a crouching nude, who uses her arms to help support the entablature. Her pose may derive from another well-known antique model, the Hellenistic *Crouching Aphrodite* (Terme Museum, Rome).

The more relaxed posture of the Baltimore nude, with her arms lowered and the implication that her left leg hangs down rather than is tucked under her, further deviates from standard caryatid representation and belies her function as a weight bearing column. In addition, no architectural member rests on her head. However, the manner in which her head is cut off coincides with Modigliani's caryatid studies (see especially two drawings repr. in Werner, pls. 69 and 77). Furthermore, one of the caryatid drawings in the Philadelphia Museum of Art (repr. in Werner, pl. 70) portrays a seated, not crouching, nude similar to the Cone figure. On the other hand, two related drawings of seated nudes (Collection Vanni Scheiwiller, Milan, repr. in Ambrogio Ceroni, *Amedeo Modigliani, Dessins et Sculptures*, Milan: Edizion del Milione, 1965, pl. 130; Private Collection, Milan, repr. in Osvaldo Patami, *Modigliani Disegni*, n.p.: Edizioni della Seggiola, 1976, pl. 16) in pose identical to the present drawing, are clearly not caryatids. Thus, though not strictly defined as a caryatid, the Baltimore *Seated Nude* represents one of several compositional variations Modigliani explored for his ambitious sculptural project.

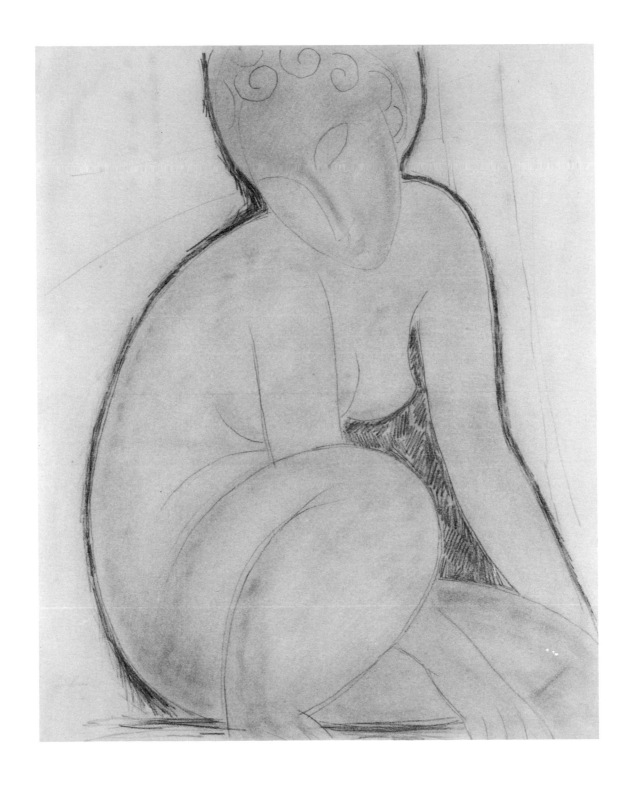

45. *Portrait of a Woman in a Large Hat*

Pencil on thin, tan wove paper from a spiral pad

15^{13}/16 x 10^{3}/16 ins. (42.7 x 26 cms.) sheet

Signed in pencil at lower left: *modigliani*

Gift of Blanche Adler, 30.42.1

EXHIBITIONS: Palm Beach, Society of the Four Arts, and Coral Gables, Lowe Gallery, University of Miami, *Amedeo Modigliani*, January-February 1954, no. 35, not repr.; San Antonio, Marion Koogler McNay Art Institute, *Amedeo Modigliani*, November-December 1957, no. 34, not repr.

Around 1915, Amedeo Modigliani abandoned sculpture to practice painting and drawing exclusively, focusing primary attention on portraiture. The present quick pencil sketch on spiral pad paper portrays a sophisticated lady with a large flamboyant hat. She is probably the same woman depicted in another drawing, *Passenger, Transatlantic Boat* (Collection Mr. and Mrs. J. W. Alsdorf, Chicago, repr. in Art Institute of Chicago, *Drawings by Amedeo Modigliani*, 1955, pl. 25). In both, delicate spontaneous lines, characteristic of drawings from the last years of the artist's short career, delineate the stylized "Modigliani" type: oval face, elongated nose, slanting eyes.

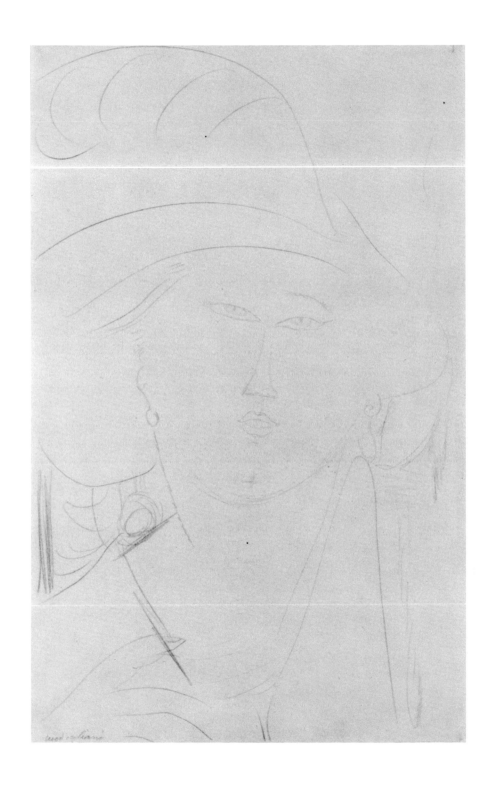

MAX WEBER
American, born Russia 1881-1961

46. *Interior in the Fourth Dimension*
1914 (?) / circa 1913

Brush and watercolor and gouache over black crayon on heavy watercolor paper

18½ x 24¼ ins. (47 x 61.8 cms.) sheet

Signed and dated in black ink at lower right: *Max Weber 14*

Purchase, Saidie A. May Fund, 70.42

PROVENANCE: Purchased from Bernard Danenberg Galleries, New York, in 1970.

EXHIBITIONS: Newark, Newark Museum, *Max Weber*, October 1-November 15, 1959, no. 77 (?), not repr.; New York, Bernard Danenberg Galleries, *Max Weber, the Years 1906-1916*, May 12-30, 1970, no. 64, repr. in color, p. 28.

BIBLIOGRAPHY: Phylis Burkley North, *Max Weber the Early Paintings (1905-1920)*, Ann Arbor: University microfilms, 1974, (unpublished dissertation written for the University of Delaware).

The gouache *Interior in the Fourth Dimension* is in all likelihood the final preparatory study for Max Weber's oil of the identical title (Collection Mr. and Mrs. Jerome Spingarn, Washington, D.C., repr. in 1959 Newark Museum exhibition catalogue, *Max Weber*, no. 16, p. 8). However, contradictory dates, which appear after the signature on both versions, muddle a chronology. The oil, signed and dated 1913, was purchased by Mr. and Mrs. Nathan Miller, early patrons of the artist, from his exhibition at the Montross Gallery in 1915. The picture was later lent to Weber's show at the Jones Gallery in Baltimore that same year. The present gouache, on the other hand, is signed and dated 1914. A gouache of the same dimensions, and at that time in the collection of the artist, was exhibited at the Weber retrospective in Newark in 1959 (no. 77), but unfortunately not reproduced in the catalogue. It seems probable

that the Baltimore gouache is one and the same with the work exhibited at Newark. The latter may still have been unsigned and undated at that time, as the catalogue gave 1913 as its date. Perhaps the artist mistakenly inscribed the wrong date (1914) when the work left his possession. One might also note that the signature on the Baltimore gouache is somewhat unusual in that it is in longhand rather than the block lettering Weber usually employed.

Although the compositions of the two works coincide, slight differences such as additional shading and crisper definition of various forms in the oil suggest that the painting is a development of the gouache. Certainly the present work is not a copy of the oil since the former includes specific elements (for example, three cone-shaped forms at the bottom center in place of two in the oil) not present in the painting.

As one of Weber's earliest and most abstract compositions, *Interior in the Fourth Dimension* reflects his understanding of both Cubist and Futurist paintings which he had seen in Paris during a three-year sojourn there from 1905 until 1908. A multitude of faceted small planes intersect at oblique angles indicating both spatial recession and movement. Individual linear motifs (lines with a half moon over them at the upper right; the curving cone-forms at the bottom center and the three arcs behind them) are repeated, producing a polyphony of rhythms. Similar in style to a series of semi-abstract compositions representing New York City (see for example, *Rush Hour*, repr. in Alfred Werner, *Max Weber*, New York: Harry N. Abrams, 1973, fig. 62), the present drawing's active tempo suggests the vitality and rapid motion of the city. During the teens, when Weber executed beautiful works such as *Interior in the Fourth Dimension*, he, with his co-exhibitors at Stieglitz's "291," was at the forefront of the modernist movement in America. Following around 1920, Weber concentrated on figural subjects, frequently emphasizing sociological themes.

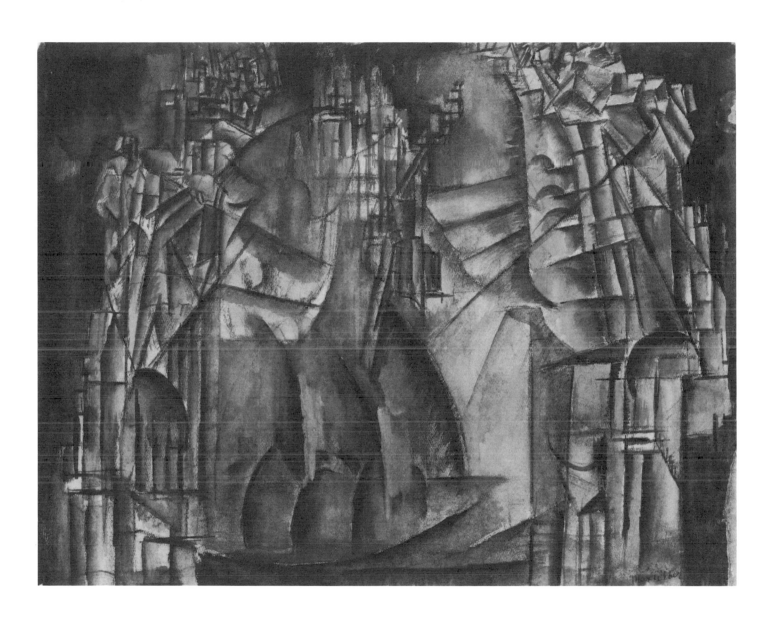

ELIE NADELMAN
American, born Warsaw, 1885-1946

47. *Horse* circa 1914

Brush and gray wash over pencil on off-white wove paper

7¹³/₁₆ x 10³/₈ ins. (19.8 x 26.4 cms.) sheet

Unsigned

Purchase, Blanche Adler Fund, 74.13

PROVENANCE: Nadelman Estate; Zabriskie Gallery, New York; acquired from Zabriskie Gallery in June 1974.

EXHIBITIONS: New York, Whitney Museum of American Art, and Washington, D.C., Hirshhorn Museum and Sculpture Garden, *The Sculpture and Drawings of Elie Nadelman*, 1975-76, no. 26, repr. p. 112.

Sculptor Elie Nadelman's drawing *Horse* consists of a few quick pencil lines heightened with graded wash along the contour to give the animal plasticity. Spontaneous rather than highly finished, the horse's head flows off the paper and its legs are very summarily indicated. Yet, one immediately senses the vitality and vivaciousness of the animal.

This drawing is closely related to Nadelman's bronze version of the same subject, cast posthumously. One cast is in the Baltimore Museum of Art collection; another is reproduced in the 1975 Whitney Museum of American Art exhibition catalogue, *The Sculpture and Drawings of Elie Nadelman*, plate 31. Although riderless, the horse in both sculpture and drawing appears in typical equestrian pose, standing proudly with foreleg raised and head drawn back sharply, as though reined in. The smooth, regularized volumes and willful distortions of proportions (the head is too small, for instance) recall the simplified, naive style of American "folk" sculpture, which Nadelman and his wife collected avidly. The Nadelman Museum on their estate in Riverdale, New York, once contained as many as 15,000 objects including numerous wooden figureheads. Following the Depression, most of the collection was dispersed; many works are now owned by the New-York Historical Society and the Abby Aldrich Rockefeller Folk Art Collection.

The stiff stance of the bronze horse is perhaps closer to "folk" art examples than the more active pose of the horse in the present drawing. The loosely applied wash of the latter gives a sense of potential movement not found in the more static sculpture. Nadelman's broad knowledge and appreciation of art is revealed in his admiration of Classical and Hellenistic art, paintings and sculptures of his contemporary Cubist friends, as well as the murals found in prehistoric caves such as those in Dordogne. The drawing *Horse*, in particular, echoes the freely painted, yet poetic animals found in these caves.

CHARLES DEMUTH
American, 1883-1935

48. *Bicycle Act, Vaudeville* 1916

Brush and watercolor over chalk and pencil on off-white laid paper

10¹⁵/₁₆ x 8 ins. (27.8 x 20.4 cms.) sheet

Signed and dated in pencil at lower left: *C. Demuth. 1916-*

Edward Joseph Gallagher III Memorial Collection, 59.13

PROVENANCE: Downtown Gallery, New York; E. J. Gallagher, Jr.,
1955; given to the museum in 1959.

EXHIBITIONS: Baltimore, Baltimore Museum of Art, *Modern Art
for Baltimore*, February 23-March 17, 1957; Harrisburg, William
Penn Memorial Museum, *Charles Demuth*, September 24-November 6, 1966, no. 29, not repr.; Akron, Ohio, Akron Art Institute,
Charles Demuth, April 16-May 12, 1968, no. 26, not repr.; Hagerstown, Washington County Museum of Fine Arts, *Gallagher
Collection*, January 4-31, 1970; Sarasota, Ringling Museum of Art
and Gainesville, University of Florida, *The Circus in Art*, January 20-April 20, 1077, repr.

BIBLIOGRAPHY: *BMA News*, April 1956, p. 10, not repr.; *Edward
Joseph Gallagher III Memorial Collection*, 1964, repr.

Charles Demuth, a master of watercolor, painted many episodes
of nightclub life, vaudeville, and the circus during the late teens.
Bicycle Act, Vaudeville, one of the earliest of this series, is dated 1916;
three years later Demuth reworked the identical composition in a
more detailed watercolor *In Vaudeville: Bicycle Rider* (Corcoran
Gallery of Art, repr. in William Penn Memorial Museum 1966
exhibition catalogue, *Charles Demuth*).

In the Gallagher drawing watercolor is beautifully applied with
much feeling for the liquidity of the medium. Yet the wash flow is
strongly controlled, especially in the background where dense blue
wash accents the rider's contour, but never crosses the edge of the
pencil drawing defining the figure. Bright yellows and brilliant
oranges together with playful curving lines are formal qualities
reflecting the high spirited mood of the circus performances and
vaudeville acts which Demuth attended in New York and at the
Colonial Theater in Lancaster, Pennsylvania. He captured animated movement through the teetering pose of the cyclist with one
leg precariously resting on the handle bar, and stabilized the compositon with the oval shape encircling the rider.

Concurrently with these anecdotal subjects, Demuth also
painted more abstract and two-dimensional works influenced by
Cubism used especially for his cityviews and landscapes of
Bermuda, Provincetown, and Gloucester. After 1920 he painted
most frequently in this flatter, non-illusionary style. Together with
his book illustrations for Zola, Poe, and others, the entertainers
series were his last works in the narrative idiom.

JOHN MARIN
American, 1870-1953

49. *Sun, Isles and Sea* 1921

Brush and watercolor on heavy off-white wove paper

16³/₈ x 19¹/₂ ins. (41.5 x 49.5 cms.) uneven sheet

Signed and dated in black ink at lower right: *Marin 21*

Edward Joseph Gallagher III Memorial Collection, 53.6

PROVENANCE: Downtown Gallery, New York, 1952; given to the museum by Edward J. Gallagher, Jr. in 1953.

EXHIBITIONS: Miami, University of Miami, *John Marin*, October 2-23, 1951, no. 10, not repr.; Utica, Munson-Williams-Proctor Institute, *John Marin*, December 2-30, 1951, no. 5; New York, Wildenstein, *XXth Century American Paintings*, February 21-March 22, 1952, no 67, not repr.; Baltimore, Baltimore Museum of Art, *Modern Art for Baltimore*, February 23-March 17, 1953; Los Angeles, University of California, Art Galleries, Cleveland Museum of Art, Minneapolis Institute of Art, Boston, Museum of Fine Arts, Washington, D.C., Phillips Collection, and San Francisco Museum of Art, *John Marin*, 1955-56, no. 14, repr. in color as frontispiece; Tucson, University of Arizona, *John Marin*, February 9-March 10, 1963, no. 28, repr. in color; Washington, D.C., National Collection of Fine Arts, *Roots of Abstract Art in America, 1910-1930*, December 1, 1965-January 16, 1966, no. 109, repr. in color on title page; La Jolla, La Jolla Museum, *Marsden Hartley-John Marin*, February 12-March 27, 1966, no 9, repr.; Hagerstown, Washington County Museum of Fine Arts, *Gallagher Collection*, January 4-31, 1970.

BIBLIOGRAPHY: *Time Magazine*, December 10, 1951, repr. in color p. 79; Adelyn D. Breeskin, "New Riches for the Museum," *BMA News*, December 1952/January 1953, repr. in color p. 5; "Living Memorial," *Art Digest*, January 15, 1953, p. 12, repr. in color on cover; Bernard Perlman, "The Baltimore Museum of Art: 25 Years of Growth," *Art Digest*, May 15, 1955, p. 19, repr. in color p. 17; *A Picture Book*, Baltimore Museum of Art, 1955, repr. p. 78; Alexander Eliot, *300 Years of American Painting*, New York: Time, Inc., 1957, p. 193, repr. p.190; "Object of the Week," Baltimore *Sunday Sun*, August 28, 1960, repr.; *BMA News*, Summer 1962, repr. p. 13; *Edward Joseph Gallagher III Memorial Collection*, Baltimore Museum of Art, 1964, repr.; Sheldon Reich, *John Marin, A Stylistic Analysis and Catalogue Raisonné*, Tucson: University of Arizona Press, Vol. I, p. 137, repr. in color fig. 106, Vol. 2, no. 21.58, repr. p. 491; Edmund Burke Feldman, *Art as Image and Idea*, Englewood Cliffs, New Jersey: Prentice Hall, 1967, p. 199, repr.; K. R. Greenfield, "The Museum: Its First Half Century," *Annual I*, Baltimore Museum of Art, 1966, repr. p. 60; Herbert D. White, Anthony G. Trisolini and Robert L. Wortman, *A Workbook for Comparative Arts*, Dubuque, Iowa, 1968, p. 62, repr. p. 67 (Sideways).

In *Sun, Isles and Sea*, John Marin presents an energetic interpretation of the rugged Maine coast. Bands of color shoot out from the sun. The seashore below is described with splashes of green, blue, or orange. Brushstrokes intersect, overlap, or abruptly end, creating active movement. Various forms representing the land or sea intermingle, not clearly distinguished from one another. Two years earlier, Marin painted an almost identical scene, *Sunset, Casco Bay* (1919, Wichita Museum of Art, repr. in Sheldon Reich, *John Marin, A Stylistic Analysis and Catalogue Raisonné*, Tucson: University of Arizona Press, 1970, no. 19.39). In contrast to the present representation, however, the sun's beams radiate as long, regularized, unbroken streams of light; ocean and shore exist as separate individually defined entities.

Close in formal terms to the present rustic seascape are Marin's watercolors depicting New York City. Reflecting the hustle bustle of urban life as well as demonstrating knowledge of Cubist compositions of intersecting planes, the artist's New York subjects (see especially *Lower Manhattan*, 1920, Museum of Modern Art, Reich 20.12, and *The Orange Sun, New York City*, undated, Reich 25.91) display lively movement as architectural forms tilt, turn, or twist. Such dynamism, appearing initially in Marin's cityviews, is transplanted to a rural setting in *Sun, Isles and Sea*.

Executed approximately mid-way in his career when Marin was at the height of his creativity, the Gallagher watercolor demonstrates that Marin was a master watercolorist. The heavy weight textured paper provides a coarse-grained surface that absorbs the fluid medium unevenly. Marin applies the transparent colors with great control, exploiting the fiber's grain and leaving much of the sheet white.

PIET MONDRIAN
Dutch, 1872-1944

50. *Trees at the Edge of a River*

Charcoal and estompe on buff laid paper

28⁵/₁₆ x 33½ ins. (71.9 x 85.1 cms.) sheet

Unsigned

Purchase, Nelson and Juanita Greif Gutman Fund, 64.106

PROVENANCE: Dr. Esser, Amsterdam; Miss Carla Esser, Paris (daughter of Dr. Esser); purchased from Allan Frumkin Gallery, New York, in 1964.

EXHIBITIONS: New York, Allan Frumkin Gallery, *Mondrian, The Early Years, 1905-1908*, April 27-May 23, 1964, no. 5, repr.; Toronto, Art Gallery of Toronto, February 12-March 20, 1966, Philadelphia Museum of Art, April 8-May 9, 1966, and The Hague, Gemeentemuseum, June 15-August 7, 1966, *Piet Mondrian*, no. 35, repr. p. 76.

BIBLIOGRAPHY: *The Baltimore Sun*, Sunday, June 14, 1964, repr. Section D, p. 4; Robert P. Welsh, *Piet Mondrian's Early Career, The "Naturalistic" Periods*, New York: Garland Publishing, 1977, (Outstanding dissertations in the fine arts, thesis written 1965), pp. 121-22, repr. pl. 208.

REMARKS: Also called *By the River, Trees Bordering a River*, and *River Landscape II*.

Trees at the Edge of a River is closely related to three oil studies of the same motif along the Rein or Amstel river near Amsterdam. Two of these canvases are signed and dated 1907 (Hart Nibbrig Collection, repr. in 1966 Toronto exhibition catalogue, *Piet Mondrian*, no. 36; Gemeentemuseum, repr. in Cor Blok, *Piet Mondriaan, Een*

catalogue van zijm werk in Nederlands openbaarbezit, Amsterdam: Neulenhoff, 1974, no. 113). The third (also in the Gemeentemusem, repr. in Blok, no. 112) was owned by Mondrian's friend Simon Maris, son of Willem Maris and nephew of Jacob Maris, painters of The Hague School.

Mondrian's early works also display a preference for the limited palette, picturesque motifs, and evocative moods created by nocturnal or twilight settings, found in paintings by the Maris brothers and other late nineteenth century Dutch artists. Such landscapes find their ultimate source in French Barbizon art, especially in the paintings of Daubigny, Diaz, and Corot. As Michel Seuphor has mentioned, Mondrian had direct knowledge of the Barbizon masters' works from visits to the Mesdag Collection in The Hague (see *Piet Mondrian, Life and Work*, New York: Harry N. Abrams, n.d., p. 69).

Although the charcoal drawing shows a dependence on nature found in Mondrian's early work, it already forecasts the more structural and abstract elements of his later style. In the Hart Nibbrig oil, for example, the tree reflections on the river are painted in naturalistic, curving shapes. In the charcoal, on the other hand, one sees the break-up of these reflections into flat, two-dimensional vertical and horizontal patterns. This lessened dependence on observation and greater attention to formal composition evidences Mondrian's experimentation during his early years, and suggests that the drawing may post-date the Hart Nibbrig oil, rather than be a preparatory cartoon. As Robert Welsh documents in his thesis on Mondrian, 1908 is the pivotal year in Mondrian's early stylistic development. *Trees at the Edge of a River* would seem to come at the conclusion of his "naturalistic" period.

GUSTAV KLIMT
Austrian, 1862-1918

51. *Reclining Nude (Study for Water Serpents)*
circa 1904-07

Pencil on tan wove paper

13³/₄ x 21⁵/₈ ins. (34.8 x 55 cms.) sheet

Estate stamp in purple on verso at lower right: *Gustav/Klimt/Nachlass* (Lugt 1575). Unidentified collector's stamp in green on verso at lower left: *M/A* (not in Lugt)

Purchase, 58.214

PROVENANCE: Johanna Zimpel, Klimt's sister (stamp); purchased from Gauss, Germany.

The exquisite pencil *Reclining Nude* presents Gustav Klimt's favorite and almost exclusive subject, the female nude. Among the thousands of drawings, for this fin-de-siècle Austrian painter was a prolific draughtsman, are several kindred works. The present representation of a nude stretched out in peaceful repose against a backdrop of scattered pillows nearly duplicates a drawing of a reclining woman, possibly the same model, in the Karlheinz Gabler Collection, Frankfurt (repr. in the 1970 Darmstadt catalogue *3. Internationale der Zeichnung, Gustav Klimt, Henri Matisse*, no. 84). In the former, however, the dozing woman's head, turned to her right, is drawn with greater detail. Further, a clump of rumbled sheets placed under the model's legs counterbalances the two pil-

lows used in lieu of the somewhat awkward long row of five pillows in the Frankfurt drawing. Another drawing in the Neue Galerie am Landesmuseum in Graz (repr. in Darmstadt catalogue, no. 99) extends the theme of sleeping nudes to include female friendship. There, a similar reclining figure approximates the pose of the Baltimore nude with the model's left arm stretched under her head and her other hand resting on her chest. However, in place of the pillows in the exhibited work, Klimt there added the torso of a second figure with her arm extended in embrace. Other pencil drawings, akin in style and theme, portray languorous women in embracement.

These related drawings are studies for the simplified flowing bodies of "water serpents," the subject of two paintings, also entitled *Women Friends*, which Klimt executed between 1904 and 1907 (nos. 139 and 140 in Fritz Novotny and Johannes Dobai, *Gustav Klimt with a catalogue raisonné of his paintings*, New York and Washington: Frederick A. Praeger, 1968). In the delicately delineated pencil sketches such as *Reclining Nude*, the artist carefully positioned the undulating slender stretched-out bodies on the upper half of the tan paper. Accessories and high finish are kept to a minimum. The controlled sparseness of these drawings provides a refined elegance that is somewhat overshadowed in the more decorative paintings of *Water Serpents*, which are filled with intricate jewel-like patterns of color.

EGON SCHIELE
Austrian, 1890-1918

52. *Reclining Woman with Blond Hair* 1914

Brush with watercolor and gouache over pencil on Japan-finish paper

19 x 12½ ins. (48.4 x 31.7 cms.) sheet

Signed and dated in pencil in square at bottom center: *Egon/Schiele/1914*

Purchase, Fanny B. Thalheimer Fund and Friends of Art Fund, 66.38

PROVENANCE: Purchased from Galerie St. Etienne, New York in 1966.

EXHIBITIONS: Darmstadt, Mathildenhohe, *Egon Schiele*, *2. Internationale der Zeichnungen*, July 16-September 9, 1967, no. 58, repr.; Des Moines Art Center, September 20-October 31, 1971, Columbus Gallery of Fine Arts, November 15-December 19, 1971, and the Art Institute of Chicago, January 3-February 13, 1972, *Egon Schiele and the Human Form*, no. 44, repr. (sideways).

BIBLIOGRAPHY: *Gazette des Beaux-Arts*, supp. February 1967, no. 384, repr. p. 108; *BMA News*, 1968, nos. 1-2, p. 30; Rudolf Leopold, *Egon Schiele, Paintings, Watercolours, Drawings*, London and New York: Phaidon, 1972, p. 596, not repr.

Rudolf Leopold has identified Egon Schiele's *Reclining Woman with Blond Hair* as one of four preliminary studies for the large oil, *Recumbent Woman* (L 287, Kallir 222, repr. in Rudolf Leopold, *Egon Schiele, Paintings, Watercolours, Drawings*, London: Phaidon, 1973, pl. 202). A related watercolor of a semi-nude figure, painted in 1916 (Private Collection, Vienna, repr. in Leopold, p. 502) serves as an intermediary between the clothed Baltimore figure and the 1917 nude.

Moveover, *Reclining Woman with Blond Hair* differs from the oil in both composition and mood. In the former Schiele employed a device he used frequently. By placement of his signature and date, he converted a horizontal composition to a vertical format. In its transformed state, the blond model seems to float in space without any contract with the ground. In contrast, when viewed sideways (and due to the ambiguity of the pose, reproductions have been printed sideways), one can logically interpret the figure as reclining on a floor, leaning on her left arm. Interestingly, the drawing works in both formats, and one wonders if the tension caused by the ambiguous placement of the figure and signature was deliberate. In *Recumbent Woman*, the artist returned to a horizontal format and surrounded his seductive dark-haired woman with rich yellow drapery. Walli, Schiele's mistress prior to his marriage to Edith in 1915, probably served as model for the Baltimore watercolor. Her pose is casual and mildly erotic, with clothing covering most of her body. In the oil, by contrast, woman appears as a blatant sexual image with breasts exposed, legs spread wide apart and arms raised almost defiantly with one fist clenched.

Erotic themes are prevalent in Schiele's œuvre. His choice of subject raised objections, and he was even imprisoned for 24 days in 1912 for pornography. Rather than depicting decadence, however, his bony, often nude figures express alienation and spiritual anguish, perhaps achieving their greatest poignancy in the watercolor medium.

ERICH HECKEL
German, 1883-1969

53. *Portrait of Mrs. Heckel* 1914

Brush and watercolor over pencil on off-white wove paper

20½ x 11½ ins. (52.3 x 29 cms.) uneven sheet

Signed and dated in pencil at lower left: *Erich Heckel 14*

Gift of Mrs. Nelson Gutman in Memory of Mr. Nelson Gutman's Birthday, 58.52

PROVENANCE: Ferdinand Roten Gallery, Baltimore.

EXHIBITIONS: Baltimore, Baltimore Museum of Art, *1914*, October 6-November 15, 1964, no. 87, repr. p. 33; Notre Dame, University of Notre Dame Art Gallery, *The German Expressionists and Their Contemporaries*, December 7, 1969-February 15, 1970, no. 37, repr.

BIBLIOGRAPHY: *BMA News*, December 1958, repr. p. 4.

In 1905 with Ernst Ludwig Kirchner, Fritz Bleyl, and Karl Schmidt-Rottluff, Erich Heckel founded the artist association "Die Brücke" (The Bridge). Influenced by the emotionally charged paintings of Vincent van Gogh and Edvard Munch for example, these German Expressionist artists produced paintings and prints which conveyed the anixiety and restlessness of contemporary Europe. Using brash unnatural colors, agitated lines, and distorted forms, they vividly yet brutally described the inhabitants of pre-World War I cities of Dresden and Berlin.

Executed nearly a year after "Die Brücke" had officially disbanded, *Portrait of Mrs. Heckel* presents an agonized image of sorrow and disillusionment. Dressed in black, the artist's wife gazes downward as she wrings her tense thin fingers. The exaggerated angularity of her facial features–pointed brows, jutting chin, and hallowed out cheeks–further contribute to the aura of desolation. Heckel's representation of his wife expresses psychological distress.

KATHE KOLLWITZ
German, 1867-1945

54. *Double Portrait* 1921

Black chalk on thin off-white wove paper

20⅜ x 26⅛ ins. (51.7 x 66.3 cms.) uneven sheet

Signed and dated in pencil at lower right: *Kathe Kollwitz 1921*

Gift of W. A. Dickey, Jr., 55.24

PROVENANCE: Franz Bader Gallery, Washington, D.C.; given to the museum by W. A. Dickey, Jr., in 1955.

EXHIBITIONS: Washington, D.C., National Gallery of Art, *19th and 20th Century European Drawings*, circulated by The American Federation of Arts, July 1965-July 1966, no. 31, repr.

BIBLIOGRAPHY: *A Picture Book*, Baltimore Museum of Art, 1955, repr. p. 70; Carl Zigrosser, "Drawings by Käthe Kollwitz," *BMA News*, February 1956, p. 4, repr. fig. 1; Herbert Bittner, *Käthe Kollwitz Drawings*, New York: T. Yoseloff, 1959, no. 85, repr.; Otto Nagel, *The Drawings of Käthe Kollwitz*, New York; Galerie St. Etienne, 1972, no. 901, repr. p. 371.

Double Portrait is part of a series of drawings and related lithographs of *Nachdenkender* (pensive or introspective) figures Käthe Kollwitz executed between 1920 and 1922. No lithographic version exists of *Double Portrait*, but such a print may have been destroyed when Kollwitz's house was bombed during World War II. Most of these portrait drawings from the early 1920s depict working class men and women of post-World War I Germany who suffered poverty, sickness, and hunger in the aftermath of defeat (see nos. 863-72 and 901-08 in Otto Nagel, *The Drawings of Käthe Kollwitz*, New York: Galerie St. Etienne, 1972). Their representations, with hands clasped over mouths or clenched over foreheads, and sorrowful eyes turned downwards, express profound grief or misery. The sitter of *Double Portrait*, however, appears more reflective and less agonized than other figures. Also, his facial features are more individualized. Otto Nagel has suggested that he may be the artist's brother, Dr. Konrad Schmidt. Indeed, he bears a familial resemblance to Kollwitz herself as portrayed in numerous self portraits. Frequently, as seen here, she uses the device of a hand placed against a face to reveal the introspective character of her models.

Raised in a family practicing strong social responsibility and later married to a doctor serving Berlin's slum poor, Kollwitz's art focuses on the plight of the common man affected by elemental forces of poverty, war, and death. In the best of her graphic works the social message compels the viewer's emotional response.

LOVIS CORINTH
German, 1858-1925

55. *Self Portrait* 1923

Black lithographic crayon on cream wove paper

19³/₄ x 13¹/₂ ins. (50.1 x 34 cms.) uneven sheet

Signed and dated in pencil at lower right: *Lovis Corinth/9 November 1923.*

Purchase, Nelson and Juanita Greif Gutman Fund, 64.144

PROVENANCE: Estate of the artist; Allan Frumkin Gallery, New York, 1963; purchased from Frumkin by the museum in 1964.

EXHIBITIONS: New York, Allan Frumkin Gallery, *Lovis Corinth: Self Portraits*, Autumn 1963, no. 17, not repr.; New York, Gallery of Modern Art, *Lovis Corinth*, September 22-November 1, 1964, no. 154, not repr.

BIBLIOGRAPHY: *Gazette des Beaux-Arts*, supp., February 1965, no. 263, repr. p. 66; *Lovis Corinth*, Mexico City: Instituto Nacional de Bellas Artes, 1967, repr. on cover of exhibition catalogue, but not in show.

Lovis Corinth frequently analyzed his own features as the subject of numerous pencil, crayon, or watercolor drawings and lithographs. Especially during the 1920s many self-portraits, including the Baltimore drawing, are precisely documented with exact date, as though the artist was keeping an on-going record of his appearance and feelings. The blurred image drawn with thick black crayon is informally placed off-center at the top left edge of the paper. Yet Corinth directly confronts the viewer with an unyielding, intense gaze. Executed two years before his death, *Self Portrait* emphasizes an emotional interpretation of the painter's personality rather than a visual rendering of his physical features. Like other late works, the present drawing bears a close relationship to the art of the younger German Expressionists, some of whom Corinth knew (see for example, Erich Heckel's *Portrait of Mrs. Heckel*, cat. no. 53).

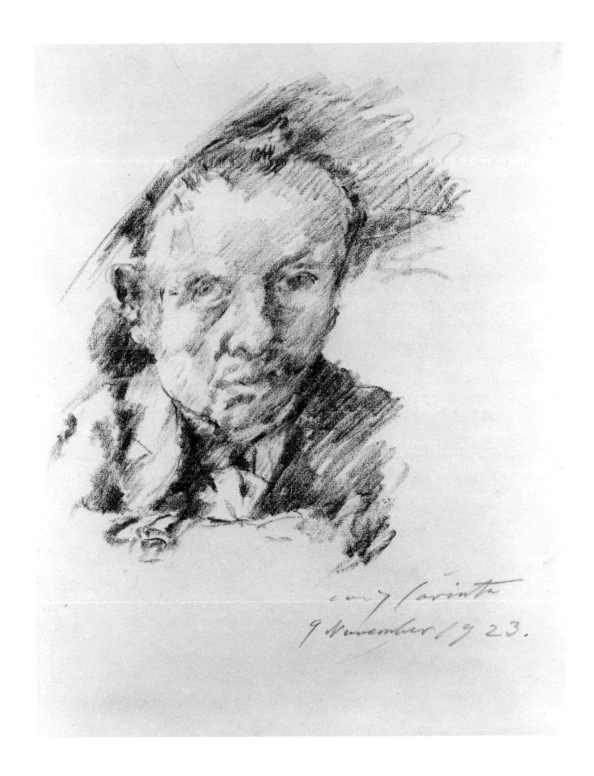

conz Corintu
9 November 1923.

MAX ERNST
German, 1891-1976

56. *Whip Lashes or Lava Threads (Les coups de fouet ou ficelles de lave)* circa 1925

Pencil frottage on off-white wove paper

10¼ x 16¹¹/₁₆ ins. (26 x 42.4 cms.) sheet

Signed in pencil at bottom, near right corner: *Max Ernst*

Gift of Mme. Helena Rubenstein, 53.91

PROVENANCE: Jeanne Bucher, Paris; Helena Rubenstein, New York.

EXHIBITIONS: Paris, Jeanne Bucher in Boutique Pierre Chareau, *Max Ernst, Histoire Naturelle*, 1926; Brussels, A la Vièrge Poupine, *Max Ernst, Histoire Naturelle*, October 1926, no. 11.

BIBLIOGRAPHY: Max Ernst, *Histoire Naturelle*, Paris: Jeanne Bucher, 1926, repr. no. 11; Ernst, *Oeuvres de 1919 à 1936*, Paris: Cahiers d'Art, 1937, p. 18, not repr.; Ernst, *Beyond Painting and other Writings by the Artist and his Friends*, New York: Wittenborn, 1948, repr. p. 136; *Max Ernst, Gemälde und Graphik 1920-1950*, Brühl: Schloss Augustusburg, 1951, no. 11, repr. p. 46; *Max Ernst, Histoire Naturelle*, Cologne: Galerie der Spiegel, 1964, no. 11, repr. p. 21; Werner Spies, *Max Ernst, Frottagen*, Stuttgart, 1968; Spies, *Max Ernst Werke 1925-1926*, Houston and Cologne: Menil Foundation, 1976, no. 800, repr. p. 5.

Whip Lashes or Lava Threads, number 11 of Max Ernst's "frottage" series *Histoire Naturelle*, was executed in 1925. Frottage, as employed by Ernst, is similar in technique to making brass rubbings. Paper is placed over an uneven surface, then rubbed with pencil. During the twenties under the inspiration of the Surrealists and their doctrine of "automatic" writing, Ernst had been experimenting with new ways to create paintings and drawings. Writing about frottage in 1937, the artist described his "discovery" of the medium on August 10, 1925, although four years earlier he made his first frottage *Animal* (Kunstmuseum, Basel, repr. in Solomon R. Guggenheim Museum, *Max Ernst, A Retrospective*, 1975, p. 97) by making a pencil rubbing from the back of a telegram. Ernst did not, however, systematically execute frottages until the Histoire Naturelle series.

Beginning with a memory of childhood in the course of which a panel of false mahogany, situated in front of my bed, had played the role of optical provocateur of a vision of half-sleep, and finding myself one rainy evening in a seaside inn, I was struck by the obsession that showed to my excited gaze the floor-boards upon which a thousand scrubbings had deepened the grooves. I decided then to investigate the symbolism of this obsession and, in order to aid my meditative and hallucinatory faculties, I made from the boards a series of drawings by placing on them, at random, sheets of paper which I undertook to rub with black lead. In gazing attentively at the drawings thus obtained, "the dark passages and those of a gently lighted penumbra," I was surprised by the sudden intensification of my visionary capacities and by the hallucinatory succession of contradictory images superimposed, one upon the other, with the persistence and rapidity characteristic of amorous memories.

My curiosity awakened and astonished, I began to experiment indifferently and to question, utilizing the same means, all sorts of materials to be found in my visual field: leaves and their veins, the ragged edges of a bit of linen, the brushstrokes of a "modern" painting, the unwound thread from a spool, etc. There my eyes discovered human heads, animals, a battle that ended with a kiss (the bride of the wind) rocks, the sea and the rain, earthquakes, the sphinx in her stable, the little tables around the earth, the palette of Caesar, false positions, a shawl of frost flowers, the pampas.

Blows of whips and threads of lava, fields of honor, inundations and seismic plants, fans, the plunge of the chestnut tree.

Under the title Natural History *I have brought together the first results obtained by the procedure of* frottage.

I insist on the fact that the drawings thus obtained lost more and more, through a series of suggestions and transmutations that offered themselves spontaneously—in the manner of that which passes for hypnagogic visions—the character of the material interrogated (the wood, for example) and took on the aspect of images of an unhoped-for precision, probably of a sort which revealed the first cause of the obsession, or produce a simulacrum of that cause.

(Originally published in French in *Cahiers d'Art*, 1937; English translation from Ernst, *Beyond Painting*, 1948, pp. 7-8.)

A duality exists between the object actually employed in making the frottage (flooring, leaf veins, etc.) and the resulting image. The latter appears as various biological forms: animals, birds, plants, and other more ambiguous organisms. In the present drawing, one does not initially identify the object rubbed. Only after reading Ernst's description of procedure does the viewer become conscious of wood graining texture in the Baltimore drawing; even then, it is not certain whether the freely moving lines forming lava threads were rubbed from leaves or scars on the floor. In contrast, Robert Rauschenberg's use of frottage (see cat. no. 79) results in exact, though reversed, reproduction of the original object (usually magazine photographs).

Closer in concept to Ernst's *Histoire Naturelle* is Victor Vasarely's *Denfert* series (see cat. no. 71). In both cases the drawn images are stimulated by intense observation of and fascination with patterns of inanimate objects: Ernst's worn floor boards or Vasarely's cracked tiles seen at a railway station. But neither work clearly reveals its source; instead, the artists' method of working prompts new, independent images.

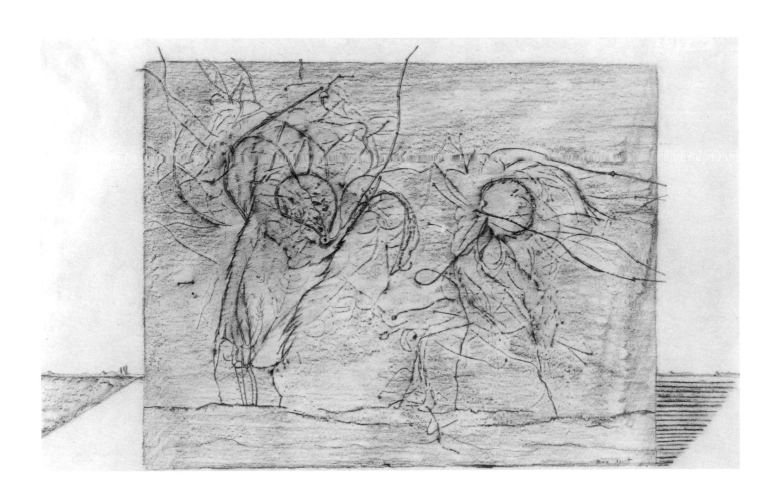

PAUL KLEE
Swiss, 1879-1940

57. *"Geringer Ausserordentlicher, Bildnis"* 1927

Brush and dark blue wash on off-white laid paper

18⅛ x 12 ins. (46.1 x 30.6 cms.) uneven sheet

Signed in pen and black ink at upper left: *Klee*
Inscribed and dated in pen and black ink on lower margin: *1927 geringer Ausserordentlicher, Bildnis*

Nelson and Juanita Greif Gutman Memorial Collection, 63.144

PROVENANCE: Purchased from Galerie Rosengart, Lucerne; Mrs. Nelson Gutman.

BIBLIOGRAPHY: G. di San Lazzaro, *Klee, A Study of his Life and Work*, New York: Praeger, 1957, repr. p. 70; Joseph Emile Muller, *Klee, Figures and Masks*, 1961, repr. second pl. in text; Thomas M. Messer, "Paul Klee at the Baltimore Museum of Art," *Annual IV*, Baltimore Museum of Art, 1972, p. 75, repr. p. 76.

Paul Klee's drawing inscribed "geringer Ausserordentlicher, Bildnis" is executed in the same technique and style as *Man Verging on Despair, Portrait* (repr. in *Paul Klee in the Collection of the Solomon R. Guggenheim Museum*, 1977, no. 40). Both works, drawn with brush and wash, appear superficially casual. However, their titles imply a more serious content. A few (only two or three) continuous lines, varying in width, delineate these caricatural personalities. These lines, not restricted to contours, weave in and out in maze-like movement.

The title of the present drawing eludes an exact translation into English. As Thomas Messer indicated in his essay on "Paul Klee at the Baltimore Museum of Art," the German inscription can be translated by any combination of words whose definitions supply a contradiction between "much and little." Messer suggests such titles as *The Extraordinary Nobody* or *His Minor Uniqueness*. Thus Klee's inscription implies his humorous intent based on paradox. Can one be both extraordinary and a nobody? Playful energetic lines describe a somewhat pompous, bald-headed figure as he comments on some unknown, though probably insignificant, subject. His chin juts out as he speaks and he raises his right hand to emphasize a point.

Klee, a prolific draughtsman, produced thousands of drawings during his lifetime. In 1927 alone, the year of the present work, he executed over 210 drawings.

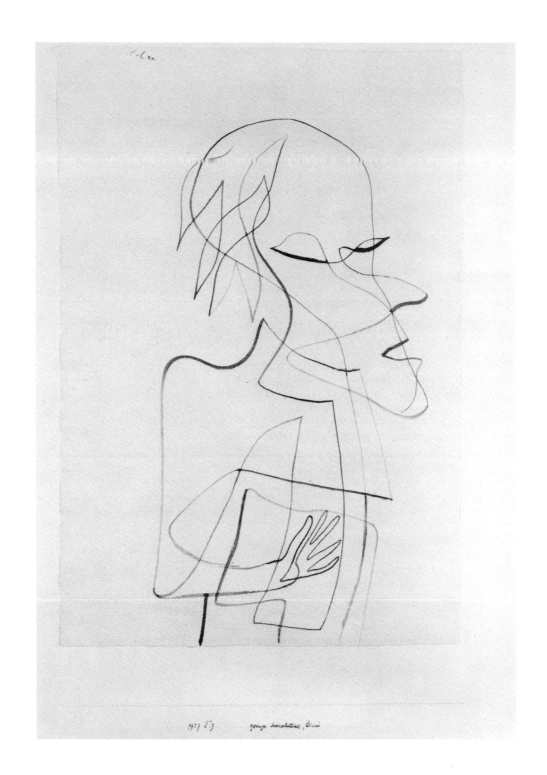

1927 J.9 geringes Ausrahterei, Blick

JOHN D. GRAHAM
American, born Russia, 1890-1961

58. *Portrait of Dr. Claribel Cone* 1927

Pencil on brown wove paper

14$\frac{1}{2}$ x 11$\frac{5}{16}$ ins. (36.9 x 28.8 cms.) sheet

Signed and dated in pencil at lower left: *'9 Graham 27*
Inscribed in pencil at upper left: *Claribel Cone*

Purchase, Cone Fund, 67.15

PROVENANCE: Noah Goldowsky Gallery, New York; purchased
from Goldowsky by Mrs. Kay Hillman, New York; purchased from
Mrs. Hillman by the museum in 1967.

BIBLIOGRAPHY: Carl Goldstein, "John Graham during the 1920s:
His Introduction to Modernism," *Arts*, March 1977, repr. fig. 7,
p. 99.

Dr. Claribel and Miss Etta Cone, John D. Graham's first patrons,
met the artist after he moved to Baltimore in 1925. Traditionally
Graham is considered a transitional figure who bridged the gap
between European moderns and Abstract Expressionist painters
such as Arshile Gorky and Willem de Kooning. Although the
Russian-born painter's own writings claimed knowledge of Picasso
and Matisse paintings in private collections in Moscow, Carl Gold-
stein has suggested that his understanding of modern French mas-
ters came later, after Graham studied the works in the Cone Collec-
tion in Baltimore (see "John Graham during the 1920s: His Intro-
duction to Modernism," *Arts*, March 1977, pp. 98-99). Graham's
own paintings, as Goldstein has noted, do not reflect influence from
Picasso or other European contemporaries until after 1925. A few
years later, perhaps under encouragement from the Cone sisters,
Graham visited Paris where he met Picasso, Gertrude Stein, and
other avant garde painters and writers.

 Certainly Graham's simplified linear drawing style, as exem-
plified by the present portrait, echoes Picasso's "classical" works,
and especially his pen and ink or pencil drawings such as *Portrait
of Dr. Claribel Cone* (see cat. no. 38), executed five years before
Graham's portrait. One wonders if Graham was not very familiar
with the former drawing from his many visits with the Cones. In the
Graham portrait, however, more jagged, broken lines and rein-
forced contours are in contrast to the delicate, almost continuous
outlines of Picasso's portrait. Graham's drawing, emphasizing the
strong profile of the sitter, portrays Dr. Cone as the firm, assertive
individual she was.

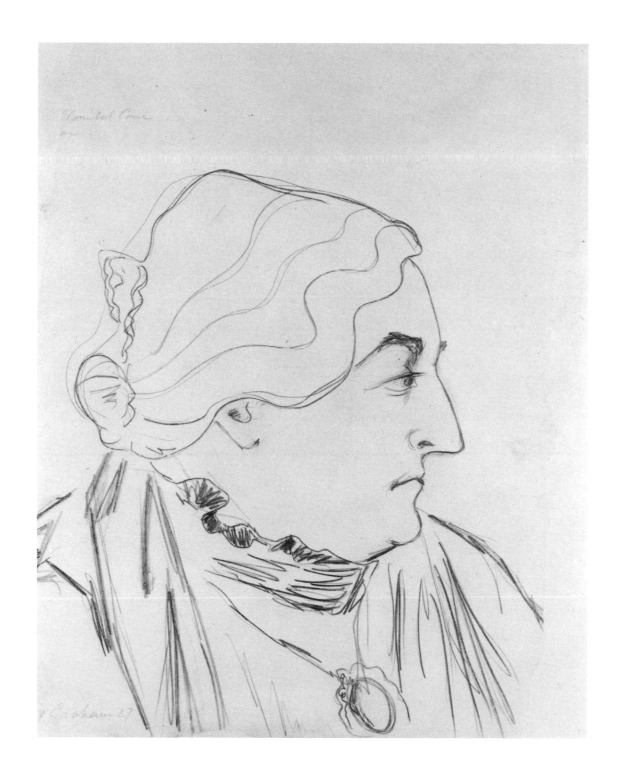

GASTON LACHAISE
American, born France, 1882-1935

59. *Seated Female Nude with Uplifted Leg*
circa 1930-34

Pen with blue-black ink, and brown ink, over pencil on off-white
wove paper

24³/₁₆ x 19 ins. (61.4 x 48.3 cms.) sheet

Signed in pencil at lower right: *G Lachaise*

Purchase, Friends of Art Fund, 66.28

PROVENANCE: Purchased from Robert Schoelkopf Gallery,
New York, in 1966.

BIBLIOGRAPHY: *BMA News*, 1967, nos. 1-2, p. 50, not repr.

Seated Female Nude with Uplifted Leg displays dynamic expressionis-
tic qualities characteristic of Gaston Lachaise's late work. Swirling,
undulating lines describe an exuberant woman, who in contrast to
Lachaise's monumental static figure called *Elevation* (repr. in Hilton
Kramer, *The Sculpture of Gaston Lachaise*, New York: Eakins Press,
1967, pl. 12), kicks up her leg, sways her hips, and flings out her arm
in exhilarated action. Gigantic sagging breasts and enlarged belly
imply her function as a fertility goddess in similar mode to prehis-
toric "Venus" figures.

Thematically related to many of his sculptural images of the
1930s, the present drawing contains specific compositional elements
which also appear in two bronzes the sculptor modeled during the
last three years of his life. *Acrobat Woman* of 1934 (repr. in Gerald
Nordland, *Gaston Lachaise: the Man and His Work*, New York: G.
Braziller, 1974, pl. 72) lifts her leg, pointing her toe, in the same way
as the nude in the drawing. *Dynomo Mother* (repr. in Nordland,
pl. 82), the sculpture Lachaise considered central in his "new"
development, portrays a seated woman with outstretched limbs in
pose very similar to the Baltimore nude.

Throughout his career, Lachaise was committed to depicting an
unabashedly sexual woman, inspired by his wife Isabel. In the
preface to a 1919 exhibition catalogue he stated his general aim: "The
obligation is to create a new Venus with no loss of vigor." (Quoted in
Nordland, p. 166.) Especially in the late work as exemplified by the
present drawing and the bronze *Dynomo Mother,* flamboyant forms
and energetic movement create an image of woman possessing
regenerative primeval power.

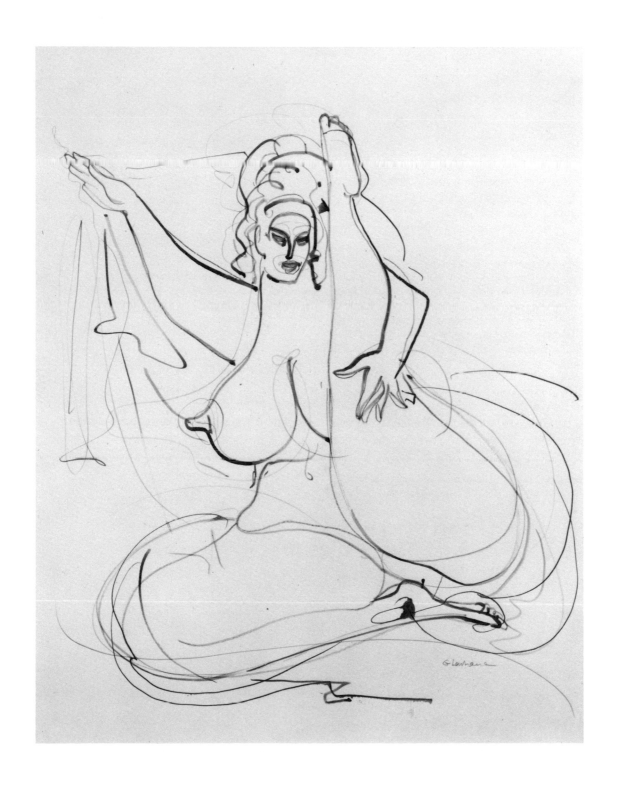

CHARLES DESPIAU
French, 1874-1946

60. *Reclining Nude* circa 1933

Brown chalk on off-white wove paper

10⅛ x 14¹/₁₆ ins. (25.9 x 35.7 cms.) sheet

Inscribed and signed in brown chalk at lower left: *Pour Saidie May/avec mes respecteux hommages/C. Despiau*

Saidie A. May Collection, 33.595

PROVENANCE: Acquired by Saidie May from the artist; given to the museum in 1933.

EXHIBITIONS: Baltimore, Baltimore Museum of Art, *A Century of Baltimore Collecting, 1840-1940*, June 6-September 1, 1941, p. 113, not repr.

BIBLIOGRAPHY: *Saidie A. May Collection*, 1977, repr. p. 57.

Charles Despiau, sculptor of portrait busts, genre figures, and monuments, was a prolific draughtsman. Saidie May, to whom the present drawing is inscribed, commissioned a portrait bust by the artist. A cast of her bronze portrait, completed in 1934 after 48 sittings, is now in the Baltimore Museum of Art as part of the May Collection (three plaster models and other bronze casts are in French collections). *Reclining Nude*, donated to the museum in 1933, probably was given to Mrs. May during the period she sat for the artist.

The May chalk drawing is characteristic of Despiau's many representations of female nudes, the favored subject of his drawings. Often faceless or with features only dimly indicated as in present example, Despiau's nudes, modeled with soft gradated shading, betray a sculptor's volumetric concerns. In contrast to the dynamic women of Gaston Lachaise's sculpture and drawings (see cat. no. 59), Despiau's figures, devoid of emotion, provide a motif for formalistic variations.

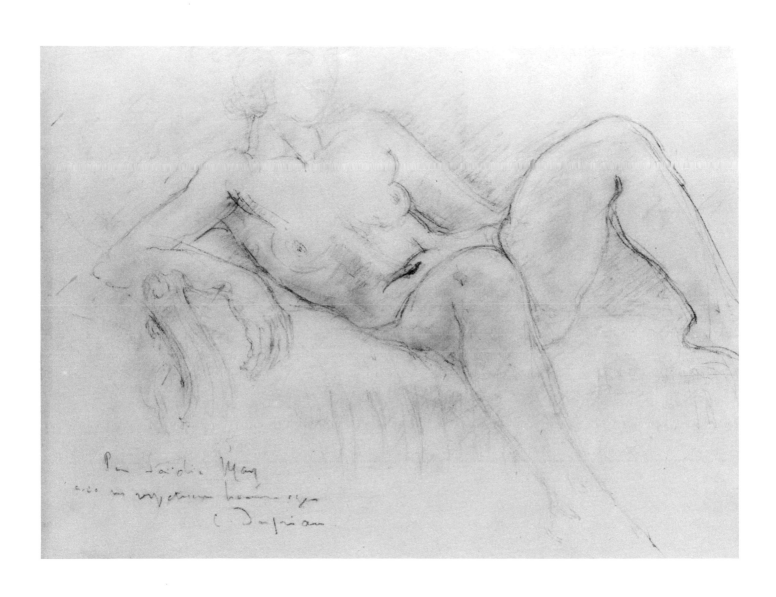

Pour Jacqueline May
avec un respectueux hommage
C. Despiau

EDOUARD VUILLARD
French, 1868-1940

61. *Study for the Lithograph "The Butler"*
 (Le Maître d'Hotel) circa 1934

Black crayon, brush and black ink on off-white wove paper

12³/₄ x 9³/₄ ins. (32.4 x 24.8 cms.) sheet

Vuillard stamp in black ink at lower right: *E. V.* (Lugt sup. 909c)

Purchase, Nelson and Juanita Greif Gutman Fund, 65.46

PROVENANCE: Purchased from Allan Frumkin Gallery, New York,
in 1965.

BIBLIOGRAPHY: *BMA News*, 1967, no. 1-2, p. 54, repr. p. 53.

Edouard Vuillard, together with Dunoyer de Segonzac and
Villeboeuf, executed lithographs and etchings as illustrations for
Cusine, a collection of Henri-Jean Laroche's recipes, published in
1935. *The Butler* is one of several preliminary studies for the litho-
graph (Claude Roger-Marx, *L'oeuvre gravé de Vuillard*, Monte-
Carlo: A. Sauret, 1948, no. 56) which depicts the *maître d'hotel*
displaying a basket of fish. The other five lithographs by Vuillard
for the cookbook include the frontispiece and four scenes related to
The Butler, each representing various aspects of a meal: 1) a couple
planning the menu; 2) a cook seasoning a dish on the range; 3) a cook
preparing a flambée; and 4) concluding with the serving of the meal.

The present drawing is practically identical to the finished
lithograph; in the latter, however, Vuillard added a more detailed
interior setting. In both works, the butler's attention is focused on
the basket of fish. As Roger-Marx has noted, he performs his task
with great solemnity.

The vast majority of Vuillard's lithographs date from the last
decade of the nineteenth century when together with Pierre
Bonnard and Henri Toulouse-Lautrec, he rejuvenated the litho-
graphic medium, producing many large color prints of contempo-
rary scenes. *The Butler*, small in format and introspective in mood,
comes nearly forty years later, and is one of Vuillard's last works.

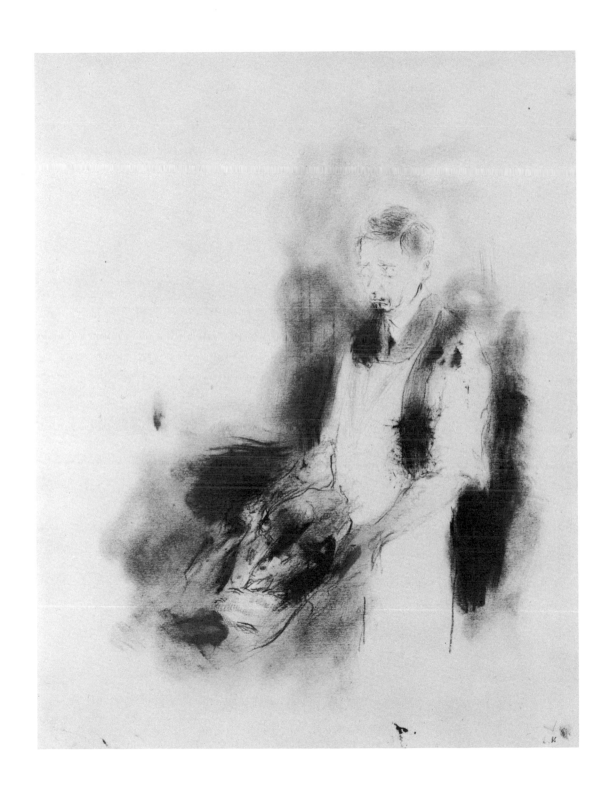

JOAN MIRO
Spanish, born 1893

62. *A Night Scene* 1937

Brush and tempera with collage of printed papers and thin wood
veneer over pencil indications on off-white wove watercolor paper
prepared with blue tempera

25³/₁₆ x 19³/₁₆ ins. (64 x 40.7 cms.) sheet

Signed in black tempera near center, left of male figure: *Miró*
Signed and dated in black ink on verso: *MIRÓ/4/12/37.*
Inscribed on verso in orange crayon: *ST 752/PM JM 272/Figures &
Collages on/blue background*

Bequest of Saidie A. May, 51.337

PROVENANCE: Purchased from Pierre Matisse Gallery by Mrs. May
in 1938; on extended loan to the museum from 1938 until bequest.

BIBLIOGRAPHY: *BMA News*, March 1950, no. 80, not repr.;
Saidie A. May Collection, 1977, repr.

Large and brightly colored, *A Night Scene* includes fanciful repre-
sentations of a man and a woman set against a rich blue background.
The character of other imaginary forms are more ambiguous. Joan
Miró designed this energetically composed collage combining
tempera, printed papers and thin strips of wood veneer, in De-
cember 1937, five months before Saidie May purchased it.

 1937 was a year which saw brutal Fascist victories in Spain,
including the use of Hilter's bombers to destroy the Basque town of
Guernica. Although usually apolitical, Miró, like his compatriot
Picasso, reacted strongly to the fierce agonies inflicted on his home-
land during the Spanish Civil War. Several paintings executed
during 1937 such as the powerful *Still Life with Old Shoe* (repr. in
Jacques Dupin, *Miró*, London: Thames and Hudson, 1962, no.
473, p. 267) and his mural decoration depicting a barbarous *Reaper*
(Dupin no. 474, repr. p. 329), which hung in the same building in
Paris as Picasso's *Guernica*, reflect Miró's anguish over these tumul-
tuous events. Despite *A Night Scene*'s light-hearted fantasy, a
slightly menacing quality lingers, and one wonders if the two
six-pointed stars, duplicating the Jewish star of David, have any
symbolic significance.

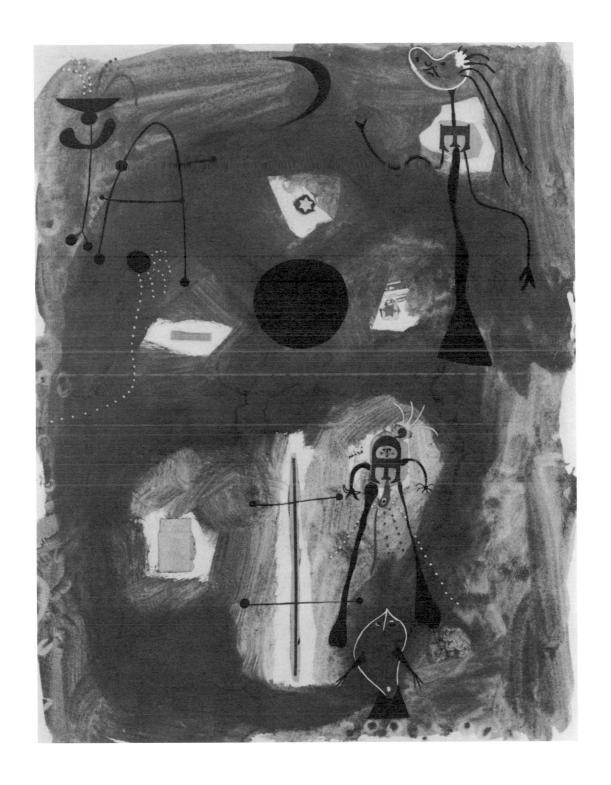

SEBASTIAN MATTA ECHAURREN
Chilean, born 1911

63. *Forms in a Landscape* 1937

Crayons and pencil on tan wove paper

19¹¹/₁₆ x 25⁹/₁₆ ins. (50.1 x 65 cms.) sheet

Dated in red crayon at lower left: *37*

Saidie A. May Collection, 38.819

PROVENANCE: Given to the museum in 1938 by Saidie A. May.

BIBLIOGRAPHY: *Saidie A. May Collection*, 1977, repr.

Forms in a Landscape depicts fantastic spiny objects set in front of floating amoebic forms and a brilliant yellow sky. The "outer space" terrain below recedes quickly to a distant horizon line. Executed in the year that Sebastian Matta Echaurren officially joined the Surrealist group in France, the large May drawing is one of Matta's initial essays as a draughtsman. The Chilean artist emigrated to Paris in 1934, where he studied architecture with Le Corbusier. Influenced by Surrealist art, especially the paintings of Salvador Dali, Yves Tanguy, and André Masson, Matta made his first drawings in 1937. A year later he began painting in oil; within a year or so he quickly established an independent style.

At the beginning of World War II, Matta along with other Surrealists, moved to New York. There he came in contact with many American painters. In particular, he became a close friend of Arshile Gorky, whom he influenced for a time (see cat. no. 65).

ARSHILE GORKY
American, born Armenia, 1904-1948

64. *Portrait of the Artist's Wife, "Mougouch"*
circa early months 1943

Pen and dark brown and black ink, brush and light brown and gray wash on off-white wove paper

13³/₄ x 9³/₈ ins. (35.3 x 23.8 cms.) uneven sheet

Signed in pencil at lower right: *A. Gorky*

Thomas E. Benesch Memorial Collection, Gift of Mr. and Mrs. I. W. Burnham II, 63.110

PROVENANCE: From a sketchbook which Gorky gave to a New Jersey framer in exchange for frames in the early 1940s (information from Robert Schoelkopf); purchased from Schoelkopf Gallery, New York, in 1963.

EXHIBITIONS: College Park, University of Maryland Art Gallery, *The Drawings of Arshile Gorky*, March 20-April 27, 1969, no. 1 under "Portrait and Figure Drawings," repr. pl. 8; Austin, University of Texas, October 12-November 23, 1975, San Francisco Museum of Art, December 4, 1975-January 12, 1976, Purchase, Neuberger Museum, SUNY, February 10-March 14, 1976, and Utica, Munson-Williams-Proctor Institute, April 4-May 9, 1976, *Arshile Gorky*, p. 105, repr. p. 77.

BIBLIOGRAPHY: *BMA News*, 1967, nos. 3-4, p. 11, not repr.; *Burlington Magazine* 107 (January 1965), p. 54, repr. fig. 70; Julien Levy, *Arshile Gorky*, New York: Harry N. Abrams, 1966, repr. pl. 32; Jim M. Jordan, *Gorky: Drawings*, New York: M. Knoedler & Co., 1969, no. 58, repr. p. 33; *Thomas Edward Benesch Memorial Collection*, 1970, repr.

Arshile Gorky first met Agnes Magruder, whom he affectionately nicknamed "Mougouch," in 1941. The couple married in the fall of that year. Since Agnes is portrayed pregnant, the Benesch drawing was probably executed in the early months of 1943 prior to the birth of their daughter Maro in April. A second daughter, Natasha, was born in August 1945.

The pose of Mougouch follows an earlier oil portrait by Gorky, *Portrait of Master Bill* (de Kooning) (repr. in Irving Sandler, *The Triumph of American Painting*, New York and Washington: Praeger, 1970, fig. 9-6). Both figures are placed on an oblique angle to the picture plane, and sit with their left hands held across their laps and their right arms extended from their side. Although the pen and ink sketch describes facial features more naturalistically than the simplified planes forming Master Bill's nose, forehead, and cheeks, both portraits emphasize the sharp contour of a long nose and large open eyes with prominent brows. In contrast to the unmodeled patches of color in the oil which flatten the image, the heavy use of hatching in the present drawing creates a very plastic figure existing in three-dimensional space.

Early in his career, Gorky was concerned with portraiture. His most famous portrait, *The Artist and His Mother* (Whitney Museum of American Art), painted over a decade from circa 1926 until 1936, depicts himself and his mother frontally as they confront the viewer. During the 1940s, when it is generally agreed he executed his greatest masterpieces, Gorky seldom painted portraits, but instead constructed abstractions composed of dynamic non-objective shapes (see cat. no. 65). However, in drawing media, he continued to sketch family or friends as seen in the exquisite Benesch portrait of Mougouch.

65. *Composition II* 1946

Pencil and colored crayons on off-white laid paper

18⅞ x 24¹³/₁₆ ins. (47.9 x 63 cms.) sheet

Signed and dated in pen and black ink at right of center: *A. Gorky/46*

Purchase, Nelson and Juanita Greif Gutman Fund, 67.20

PROVENANCE: Estate of the artist, 1961; purchased from Allan Frumkin Gallery, New York, in 1967.

EXHIBITIONS: College Park, University of Maryland Art Gallery, *The Drawings of Arshile Gorky*, March 30-April 27, 1969, no. 36 under "Drawings, Sketches and Gouaches," repr. pl. 34, p. 45; Chicago, Museum of Contemporary Art, *Drawings by Five Abstract Expressionist Painters*, January 10-February 29, 1976, not repr.

BIBLIOGRAPHY: Ethel Schwabacher, *Arshile Gorky*, New York: Macmillan, 1957, repr. pl. 55; *BMA News*, 1968, nos. 1-2, repr. p. 28; Robert F. Reiff, *A Stylistic Analysis of Arshile Gorky's Art from 1943-1948*, New York: Garland Publishing, 1977 (Outstanding dissertations in the fine arts; thesis written in 1961), pp. 106f, repr. pl. 80, with diagrams of composition, pp. 359-60.

Although 1946 began with several personal tragedies for Arshile Gorky (his barn burned down in January destroying many paintings; in February he underwent cancer surgery), the year from the summer of 1946 through the summer of 1947 was one of the most productive and creative of his life. He resided at the Virginia farm of his wife's family for prolonged periods, especially during the summer and fall of 1946. There he executed nearly 300 drawings, some after nature, albeit abstracted, and others, experimentations with automatic writing or compostional drawings to be executed in oil. *Composition II*, representing various dynamic forms, dates from this fertile period. Individual shapes may have been suggested to the artist from his intense observation of nature; for instance, his friend and biographer Ethel Schwabacher describes the narrow flat forms at the upper left as leaves. However, such images have been translated into an independent non-objective vocabulary which no longer represents a landscape per se. Some elements such as the shaded sharp-edged oval at the lower right appear as hard substances, perhaps metal. These animated machine-like objects remind one of the kinetic sculpture of Jean Tingely, as forms moving to and fro seemingly purely for their intrinsic appeal.

Earlier, during the 1930s, Gorky's abstract shapes derived from Surrealist images, especially those found in the paintings of Joan Miró. In the early forties, Gorky came into personal contact with the Surrealist expatriates in New York, and exhibited with them in 1945. André Breton praised Gorky's paintings, and wrote a preface for a catalogue of the latter's work. Gorky's closest friend among the Surrealists was the young Chilean, Sebastian Matta Echaurren. During the early to mid-1940s these two artists worked closely together providing mutual stimulation. Indeed, the biomorphic forms floating across the pictorial plane in *Composition II* resemble objects portrayed in Matta's drawings from the same date.

Gorky occupies a transitional, and somewhat ambiguous, place in the development of modern American art. By many, including William Rubin, he is categorized as the "last Surrealist." Others label him the forerunner of Abstract Expressionism.

EDWIN DICKINSON
American, 1891-1978

66. *Portrait of Mrs. B.*

Pencil with extensive use of stumping and erasure on white wove
paper

10^{15}/16 x 12^{15}/16 ins. (27.8. x 32.9 cms.) sheet

Signed and dated in pencil along left edge near top: *1937 EW
Dickinson*

Thomas E. Benesch Memorial Collection, 74.5

PROVENANCE: Purchased from the artist by David Daniels, New
York, in November 1960; purchased from Daniels by the museum
in 1974.

EXHIBITIONS: New York, Whitney Museum of American Art,
Edwin Dickinson, 1965, no. 123, repr. p. 13; Minneapolis Institute of
Art, February 22-April 21, 1968, Art Institute of Chicago, May 3-
June 23, 1968, Kansas City, Nelson Gallery-Atkins Museum,
July 11-September 29, 1968, and Cambridge, Fogg Art Museum,
October 16-November 25, 1968, *Drawings from the Daniels Collec-
tion*, no. 77, repr.; AFA circulating exhibition shown at Min-
neapolis Institute of Arts, New York, Whitney Museum of Ameri-
can Art, and the Fine Arts Museums of San Francisco, *American
Master Drawings and Watercolors*, 1976-77, repr. in book associated
with exhibition (see Stebbins below).

BIBLIOGRAPHY: Lloyd Goodrich, *The Drawings of Edwin Dickinson*,
New Haven: Yale University Press, 1963, repr. pl. 30; Theodore
E. Stebbins, Jr., *American Master Drawings and Watercolors*, New
York: Harper & Row, 1976, pp. 293-94, repr. fig. 253 (book asso-
ciated with AFA exhibition).

REMARKS: Previously called *Portrait* or *Portrait of a Woman*.

Edwin Dickinson's penetrating *Portrait of Mrs. B.* represents a
wistful woman, lost in introspection. A commissioned work, the
present drawing was rejected and remained in the artist's possession
for over two decades. In correspondence, however, Mrs. Dickinson,
the painter's wife, has identified the sitter as Mrs. Byrd, or Bird.

Characteristically Dickinson did not flatter or beautify his sit-
ters. Rather he seems to sympathetically analyze their pensive
moods. Here, he suggests a reflective mind probing interior feel-
ings, as expressed by her downward gaze. No visual communica-
tion takes place between Mrs. B. and the artist or viewer. Worry
lines between her brows and down from her nose accentuate her
brooding countenance.

For drawing, Dickinson preferred to use pencil. As in the present
case, he achieved subtle tonal harmonies by softening contour lines
and interior modeling with extensive erasures or stumping. Such
rubbings also produced a thin haze. Highlights coming from an
unknown source combined with the suggestive character of
Dickinson's drawing style create an aura which envelopes the
figure, separating her from our environment.

CHARLES SHEELER
American, 1883-1965

67. *Rocks at Steichen's* 1937

Conté crayon on off-white wove paper

16 x 13³/₄ ins. (40.6 x 34.9 cms.) uneven sheet

Signed and dated in conté crayon at lower right: *Sheeler—1937*

Purchase, Eleanor P. Spencer, Lilian Greif, and Nelson and Juanita Greif Gutman Funds, 77.27

PROVENANCE: Downtown Gallery, New York; Henry Ploch, New Jersey; purchased from Terry Dintenfass, Inc., New York, in 1977.

EXHIBITIONS: New York, Whitney Museum of American Art, February 1938; New York, Museum of Modern Art, *Charles Sheeler*, 1939, no. 102, repr.; Los Angeles, University of California Art Galleries; San Francisco, M. H. de Young Memorial Museum; Fort Worth Art Center; Utica, Munson-Williams-Proctor Institute; Philadelphia, Pennsylvania Academy of the Fine Arts and San Diego Fine Arts Gallery, *Sheeler Retrospective*, 1954-55, no. 52, repr. p. 29; San Francisco, San Francisco Museum of Art, *Master Drawings*, April 20-May 29, 1966; Washington, D.C., National Collection of Fine Arts, October 10-November 24, 1968, Philadelphia Museum of Art, January 10-February 16, 1969, and New York, Whitney Museum of American Art, March 11-April 27, 1969, *Charles Sheeler*, no. 82, repr. p. 127.

BIBLIOGRAPHY: Frederick S. Wight, "Charles Sheeler," *Art in America*, October 1954, repr. p. 200; Allan Gussow, *A Sense of Place, The Artist and the American Land*, New York: Friends of the Earth, 1971, p. 98, repr. p. 99; Martin Friedman, *Charles Sheeler*, New York: Watson-Guptill, 1975, repr. p. 110.

Charles Sheeler describes the rock formations at the country residence of his friend, the photographer Edward Steichen, with narrow crisp crayon lines forming pristine edges. He achieves subtle tonal gradations by varying the pressure with which he applies the crayon. Such veristic images rely to some degree on the artist's earlier photographic studies. Further, both the choice of subject and Sheeler's emphasis on the varying textures of natural forms coincide with the aesthetics espoused by his photographer-friends: Paul Strand, Edward Weston, and Steichen.

The present work like other conté drawings Sheeler executed during the 1930s is highly finished with great attention given to the rendering of details (see *Feline Felicity*, 1934, Fogg Art Museum, repr. in Martin Friedman, *Charles Sheeler*, New York: Watson-Guptill, 1975, pl. 102 or *Kitchen Williamsburg*, 1936, Private Collection, repr. in Friedman, p. 111). In *Rocks at Steichen's* light is used both to model three-dimensional forms and to suggest transience by its implied oscillation. In contrast, *Fissures* (Lane Collection, repr. in Friedman, p. 149), a watercolor representing a subject nearly identical to the present drawing but painted almost a decade later, is more two dimensional with stark juxtapositions of lights and darks.

A photographer and painter as well as draughtsman, Sheeler is perhaps best known for his precisionist representations of modern industrial architecture or uninhabited interior scenes, executed first in Doylestown, Pennsylvania and later in New England. Some of his paintings from the 1930s, however, are painted in a very three-dimensional realistic style similar to *Rocks at Steichen's*.

MILTON AVERY
American, 1893-1965

68. *Bubbly Sea* 1945

Scoring with stylus, brush and watercolor over black crayon on heavy white watercolor paper

$22^{13}/_{16}$ x $31^{3}/_{16}$ ins. (58 x 79.2 cms.) sheet

Signed and dated in pen and blue ink at lower left: *Milton Avery/ 1945*

Thomas E. Benesch Memorial Collection, Gift of Mr. and Mrs. Gustave Levy, 68.2

PROVENANCE: Grace Borgenicht Gallery, New York, 1966; given to the museum in 1968.

EXHIBITIONS: Lincoln, Nebraska, Sheldon Memorial Art Gallery, University of Nebraska, April 3-May 1, 1966 and Little Rock, Arkansas Art Center, May 6-June 26, 1966, *Milton Avery*, no. 50, not repr.; Greensboro, Weatherspoon Art Gallery, University of North Carolina, *Art on Paper Invitational '67*, 1967.

BIBLIOGRAPHY: *BMA News*, 1967, p. 6, not repr.; *Thomas Edward Benesch Memorial Collection*, 1970, repr.

The seacoast was a favorite theme for Milton Avery, as walking along the ocean's shore, he filled notebooks with closely observed studies. Later, employing such sketches as guides, he painted oils or large watercolors such as *Bubbly Sea*.

In the present work, nature's forms–rocks jutting out of water or the curving ragged coastline–have been simplified into board areas of unmodulated color. The texture and density of the medium varies. With a stylus or similar instrument Avery made scratches through the densely applied burnt orange patch at the lower right to indicate the sharp edges of stone, while the sandy beach in foreground is represented by thin overlapping tan watercolors. With a partially dry brush the artist drew the rolling action of the sea, allowing white, where the paper remains bare, to describe the foam of the waves and splashes across the brown rocks near the left edge. The very high horizon under a narrow band of deep yellow sky as well as the close-up point of view limits spacial recession, thereby emphasizing the disposition of forms and colors across the paper's surface.

LYONEL FEININGER
American, 1871-1956

69. *Manhattan Canyon* 1948

Pen and black ink, bursh and watercolor on heavy white laid paper

18⁷/₈ x 14³/₄ ins. (47.9 x 37.5 cms.) sheet

Signed and dated at lower left: *Feininger./1948*

Purchase, Frederic Cone Contemporary Art Fund, 50.153

PROVENANCE: Purchased from Buchholz Gallery, New York, in 1950.

EXHIBITIONS: Cleveland, Cleveland Museum of Art and the Print Club of Cleveland, *The Work of Lyonel Feininger*, November 2-December 9, 1951, no. 101, repr. pl. XIII; Pasadena, Pasadena Art Museum, April 26-May 29, 1966, Milwaukee Art Center, July 10-August 11, 1966, and Baltimore Museum of Art, September 7-October 23, 1966, *Lyonel Feininger*, no. 115, not repr.

Manhattan Canyon, a vista down a narrow street between two rows of skyscrapers which rapidly recede along the central axis, resembles earlier cityscapes Lyonel Feininger painted of Paris or Germany before World War II. Although born in New York, Feininger did not depict its towering skyline until the last two decades of his life.

Typically not emphasizing the descriptive aspects of specific locales, Feininger's paintings and numerous watercolors characterize architectural motifs as segmented Cubist-like planes visualized from multi-viewpoints. In works of the artist's last twenty years, architectural structures appear skeletal, as Feininger describes buildings with abrupt, broken lines. Representative of his late work, *Manhattan Canyon* is essentially a pen and ink drawing in which watercolor, unconfined by a building's boundary and not functioning as an element in the construction of the architectural forms, is added for its mood evocative character.

Frequently discussed as a German artist, Feininger moved there in 1887. He exhibited with the Blaue Reiter in 1913, later painting and teaching at the Bauhaus from its inception in 1919 until it closed in 1933. He returned to the United States in 1935, settling permanently in New York a year later.

ALBERTO GIACOMETTI
Swiss, 1901-1966

70. *Sketch for Man Pointing*

Pencil on off-white wove paper

21 ³/₁₆ x 14¹/₂ ins. (53.9 x 36.8 cms.) sheet

Signed and dated in pencil at lower right: *Alberto Giacometti/1947*
Inscribed in pencil at lower left: *6*

Verso: Pencil sketch of a man's head

Gift of Pierre Matisse, 49.32

PROVENANCE: Pierre Matisse Gallery, New York.

According to oral tradition, the Baltimore Museum's Alberto
Giacometti drawing is a sketch for the bronze sculpture, *Man
Pointing*, one cast of which is now part of the Saidie A. May
Collection at the museum. Giacometti's dealer, Pierre Matisse,
gave the drawing to the museum in the same year as Mrs. May
purchased the sculpture from him.

This drawing is also related to several oil portraits of the sculp-
tor's brother Diego, whom Giacometti painted during the late 1940s
and early 1950s. In particular, his brother wearing an identical
wide-collared jacket appears in *Diego Seated* 1948 (Mr. and Mrs. R. J.
Sainsbury, London, repr. in Arts Council of Great Britain 1965
Alberto Giacometti catalogue, no. 103) and in *Seated Man* 1949 (Mr.
and Mrs. Morton G. Neumann, repr. in Museum of Modern Art,
New York, *Alberto Giacometti* catalogue, 1965, p. 78), where the
studio wall behind the sitter is described with more detail.

Giacometti's bronzes and oils are interrelated, portraying similar
figure types. He also used his sculpture as the subject matter of his
paintings. Works in both media depict the stylized Giacometti type:
a thin, elongated, solitary figure. Specific features are usually ob-
scured by repeated swirls and hatchings across the faces in paint-
ings, or by unevenly modeled surfaces in his sculptures. His sitters,
frequently his brother Diego or his mother, serve as artist's models
posed in a sculptor's studio, rather than as specific individuals.
According to James Lord, Giacometti did not develop formal prepa-
ratory drawings for his sculpture. His drawings, rather, are initial
studies of details for expansion in clay or oil. Thus, a sketch of Diego
probably drawn from life, such as the present drawing, could be
employed as a working study for either bronze (*Man Pointing*) or oil
(*Seated Diego*).

Giacometti uses empty or negative space as a symbol of modern
man's isolation, or even alienation. In the present example, the
Swiss artist placed Diego's bust in the middle of a large sheet,
leaving bare a good deal of paper around the centralized image. That
Giacometti meant this negative area to affect the viewer's experience
of the drawing is implied by the placement of his signature at the
bottom of the page at considerable distance from the pencil portrait.

VICTOR VASARELY
French, born Hungary 1908

71. *Denfert* circa 1952

Pen and India ink over scoring with stylus on prepared cardboard

20½ x 19⅝ ins. (52.1 x 50 cms.) sheet

Initialed in black ink at bottom center: *V.*
Numbered in pencil below initial: *XVII/XVII*
Inscribed in pencil at top center: *HAUT*

Thomas E. Benesch Memorial Collection, 63.66

PROVENANCE: Given to the museum in 1963.

BIBLIOGRAPHY: *BMA News*, 1967, nos. 3-4, p. 15, not repr.; *Thomas Edward Benesch Memorial Collection*, 1970, repr., Werner Spies, *Victor Vasarely*, New York: Harry N. Abrams, 1971, repr. p. 44.

Artist statement about Denfert:

The little train of Arpajon, once it was electrified, was connected to the Paris metro in 1936 under the name of the Ligne de Sceaux; it passes through Arcueil where I lived for more than thirty years. The walls that enclose the endless platforms contiguous to the Denfert-Rochereau station are lined with finely crackled white tiles. While waiting for the connecting train I would gaze at these tiles, each of which had a simple, but individual crackle-design. Was it really chance that had so perfectly "framed" them? I had the impression of curious landscapes when the crackles were horizontal, of bizarre cities or phantoms when they ran vertically. Already I had an adumbration of the myth of the infallible human scale of the Renaissance and of the reference to named things; these outcroppings came from every source and were of all dimensions.

These "great landscapes," to be sure, being still macrocosmic reminiscences, were as many metamorphoses: the tiny crackle due to a break on the level of the molecular structure became identified with great geosynclinals and went even beyond, in my imagination. . . . The incubation of the plastic theme was a lengthy one, and it was only in about 1948 that I made my first "Denfert" drawings from memory, which later served me for a certain number of large compositions.

(from Marcel Joray and Victor Vasarely, *Varsarely*, Vol. I, Neuchâtel: Editions du Griffon, 1965, p. 10)

The Benesch drawing, numbered XVII of XVII, comes at the conclusion of Victor Vasarely's "Denfert" period in 1952. Denfert drawings, avoiding optical illusion and spacial recession usually associated with the "Op" master, are somewhat an anomaly in Vasarely's œuvre. In the present example, pristine black lines set against a veil of pale colors exist in one plane, identical to the support surface. Swirling scratches across a misty color-coated background are particularly unusual for an artist of highly ordered geometric compositions. Similar thin, exacting lines are also found in the "Photographics" series of about the same date (repr. in Werner Spies, *Victor Vasarely*, New York: Harry N. Abrams, 1971, p. 65). In contrast to the two-dimensional space of the Denfert drawing, however, the linear patterns of "Photographics" break up the surface plane into fluctuating three-dimensional forms, forecasting the kinetic energy found in Vasarely's mature work.

As discussed under the entry for Max Ernst's *Lava Threads* (cat. no. 56), Vasarely's Denfert drawings are very close in concept to Ernst's *Histoire Naturelle*. This similarity may be more than accidental. The younger painter advised and exhibited with Denise René in Paris, who gave Ernst a major retrospective in 1945. In addition to his familiarity with Ernst's art, as Werner Spies has noted, Vasarely owned the 1937 issue of *Cahiers d'Art* containing the description of *Histoire Naturelle* quoted earlier. The Hungarian artist's description (quoted above) of the process whereby while observing concrete images (the cracked tiles) he visualized hallucinatory or fantasy landscapes closely parallels Ernst's written account of the creation of his frottage images (see cat. no. 56), and was no doubt influenced by the latter.

Vasarely has divided his paintings and drawings done between circa 1948 and 1952 into three main groups: Denfert, Belle-Isle, and Gordes. All three result from intensive, visual observations of the specific locales for which they are named. Though seemingly abstract to the viewer, the linear patterns of Denfert and organic shapes of Belle-Isle and Gordes bear some resemblance to their respective sources. The Denfert drawings also reflect the forms of the hallucinatory "landscapes" envisioned by the artist as he gazed at the cracked tiles of the Metro station. Vasarely's semi-abstract works mark a turning point in his early development as he rejects recognizable images in favor of abstract vocabulary. Prior to 1948, Vasarely had worked primarily as a commercial artist and poster maker, turning to serious painting after World War II. Following the exploratory periods of Denfert, Belle-Isle and Gordes, Vasarely developed his mature "op art" style.

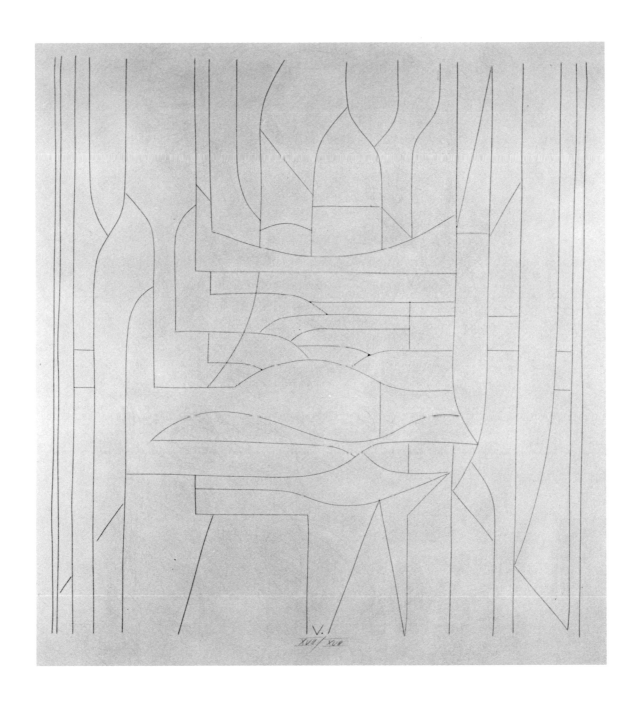

V.
XLII/XLIV

MARK TOBEY
American, 1890-1976

72. *Little Forest* circa March/April 1957

Brush and sumi ink on white wove paper

19³/₈ x 24 ins. (49.3 x 61 cms.) sheet

Unsigned

Thomas E. Benesch Memorial Collection, Gift of Mr. and Mrs. Gustave Levy, 64.168

PROVENANCE: Willard Gallery, 1957; sold to Mrs. Blaine Kolden, 1958; given to the museum in 1964.

EXHIBITIONS: New York, Willard Gallery, *Mark Tobey*, November 12-December 7, 1957.

BIBLIOGRAPHY: *Thomas Edward Benesch Memorial Collection*, 1970, repr.

During the spring of 1957 Mark Tobey made a series of drawings including *Little Forest* in Oriental sumi ink technique, which were exhibited at the Willard Gallery later that year. This technique, which originated in China, was brought to Japan in the sixth century by Buddhist monks. Sumi ink, made from compressed fine black soot, is molded into sticks. The artist rubs these sticks against a stone with a small amount of water, producing a thick wash of cream-like consistency. For tonal variations the thick wash is further diluted with additional water. Because of the restrictions of the medium (black is the sole color in three gradations), sumi paintings have frequently been likened to calligraphy, with the addition of tonal ink washes. Tobey first studied sumi painting in the early 1930s in Japan. During his residency in a Zen monastery there, a sumi ink painting was given to him for meditation.

In a letter to Katharine Kuh in 1961 the artist discussed his sumi paintings and how they came into existence:

As to the sumi paintings—you ask how I came to do them. Well, if I look back over my life I often wonder how I came to do this or that. Of course, there are signposts, hints, that one can talk about. It seems to me that questions are asked and answered as though there were no growth periods—or rather, as though nature had stopped functioning. Offhand, I don't know really how I began this period—it happened one day, a suggestion from a brown-black painting which I felt could be carried on in blacks. How long I had these Sumi paintings in cold storage or had the delayed-unrealized desire to paint them I don't know. It was a kind of fever, like the earth in spring or a hurricane. Of course I can give many reasons, that they were a natural growth from my experience with the brush and Sumi ink in Japan and China, but why did I wait some twenty years before doing them? There are so many suggestions on this question I could fill a book.

Perhaps painting that way I freed myself or thought I did. Perhaps I wanted to paint without too much thought. I don't think I was in the Void, that rather popular place today. But then maybe I wanted to be—it's difficult to be faster than thought. Which screen of ourselves comes first—the inner when one wants to state an inner condition, knowing it has to take flesh to be understood and knowing also that, because of the outer covering, it will be side-tracked and sit there for eons understood as a symbol without reality? Already I have gone too far, but I feel I have kept the problem in view.

How can I state in an understanding way why I did the Sumi paintings? Then, too, why after white writing should I turn to black ink? Well, the other side of the coin can be just as interesting, but to make myself simple I should remain a coin with only one side showing the imprint of man. It wouldn't be necessary to turn me over then—no need to wonder nor compare. Ibsen expressed it very well when he said, "Where I was ten years ago, you are now there but I am not with you."

(from Katharine Kuh, *The Artist's Voice*, New York: Harper & Row, 1962, pp. 244-45)

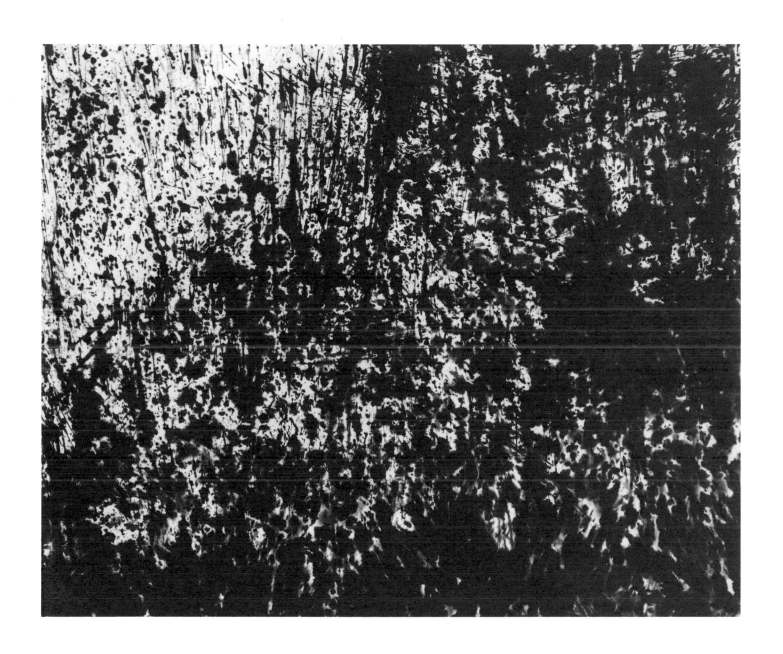

FRANZ KLINE
American, 1910-1962

73. *Study* circa 1956

Brush and black ink wash, heightened with white gouache or casein on off-white wove paper

8⁷/16 x 10¹¹/16 ins. (21.6 x 27.8 cms.) sheet

Signed in pencil at upper right: *KLINE*
Signed in pencil, then erased at lower left: *Kline*

Gift of Dr. and Mrs. Winston H. Price, 64.20

PROVENANCE: Acquired from the artist by Dr. and Mrs. Price; given to the museum in 1964.

Artist statement:

You know that people have been drawing and painting in black and white for centuries. The only real difference between my work and theirs is that they use a kind of metaphor growing out of subject matter. I don't paint objectively as they did in their period; I don't paint a given object—a figure or a table. I paint an organization that becomes a painting . . . I make preliminary drawings, other times I paint directly, other times I start a painting and then paint it out so that it becomes another painting or nothing at all. If a painting doesn't work, throw it out. When I work from preliminary sketches, I don't just enlarge these drawings, but plan my areas in a large painting by using small drawings for separate areas. I combine them in a final painting, often adding to or subtracting from the original sketches . . . I think the presence of a large painting is quite different from that of a small one. A small one can have as much scale, vigor, space, but I like to paint the large ones.

(from Katharine Kuh, *The Artist's Voice*, New York: Harper & Row, 1962, pp. 144-45, 152)

Study's small dimensions seem at first to contradict the importance of size for the artist of monumental black and white images. However, as described above, Franz Kline's drawings are not merely miniature compositions for enlargement, but often depict only a portion of the whole and function as aids in creating his larger oils.

Kline first turned to non-objective painting around 1950 after viewing a blow up of one of his figural works. The drastically changed effect produced by enlargement, which also obscured the subject, fascinated him.

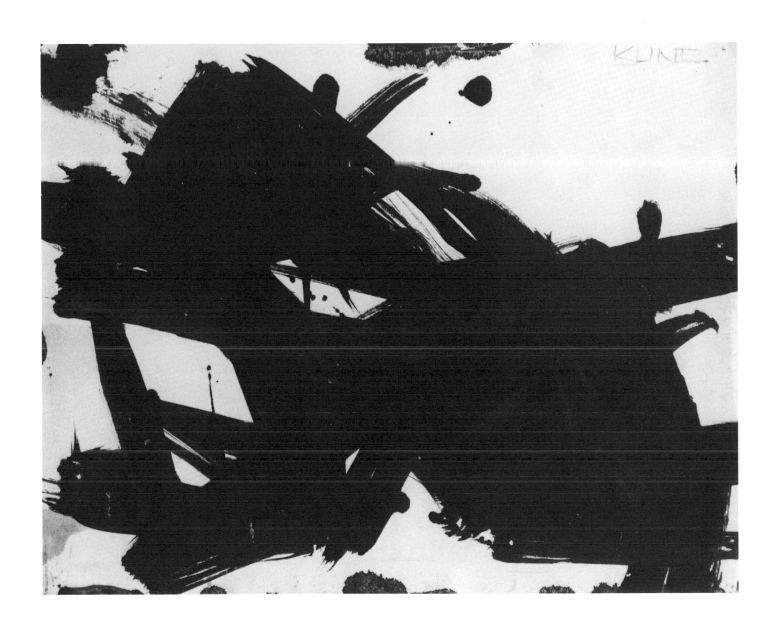

JEAN DUBUFFET
French, born 1901

74. *Untitled* 1960

Pen and India ink on heavy white wove paper

9⅝ x 12⅞ ins. (24.5 x 32.7 cms.) uneven sheet

Initialed and dated in India ink at bottom edge near right corner:
D aôut 60

Thomas E. Benesch Memorial Collection, 63.59

PROVENANCE: Daniel Cordier, Paris; given to the museum in 1963.

BIBLIOGRAPHY: *BMA News*, 1967, nos. 3-4, p. 9, not repr.; Max
Loreau, *Catalogue des travaux de Jean Dubuffet*, Vol. XVIII, *Dessins
(1960)*, n.p. (Switzerland); Weber, 1969, no. 185, repr. p. 109;
Thomas Edward Benesch Memorial Collection, 1970, repr.

Jean Dubuffet's untitled drawing is one of approximately 150 pen
and ink compositions that the artist executed for Daniel Cordier
during the summer of 1960. That year Cordier became the French
artist's dealer in both the United States and Europe. In addition
to mounting exhibitions, Cordier published a book on Dubuffet's
drawings (see *Drawings of Jean Dubuffet*, New York: G. Braziller,
1960).

Drawings in this series are semi-abstract arrangements of lines,
dots, swirls, or blots that cover an entire sheet. Some include
scribbled, expressive figures; others, such as the present drawing,
bring to mind fanciful landscapes made up of nooks and crannies.
Not topographical and without horizon lines, such landscapes chal-
lenge the viewer's imagination. As images suggestive of fantasy
landscape, Dubuffet's Cordier drawings bear comparison with two
other drawings in the Benesch Collection also executed in black ink:
Victor Vasarely's *Denfert* (cat. no. 71) and Mark Tobey's *Little Forest*
(cat. no. 72). However, in contrast to the former's pristine lines,
Dubuffet's free, spontaneous draughtsmanship uses varied textures
to create biomorphic forms. The active movement, staccato in
rhythm, of the latter's drawing differs from the tranquil environ-
ment contemplated in Tobey's *little Forest*.

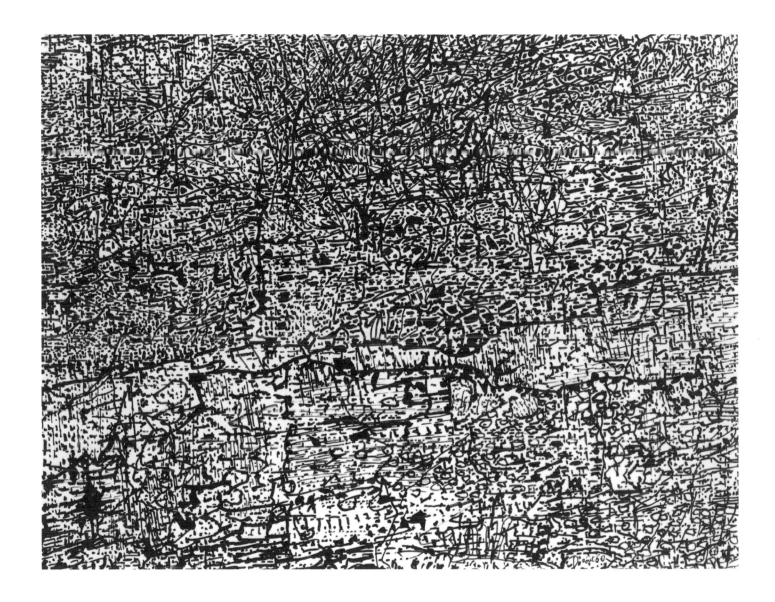

ELLSWORTH KELLY
American, born 1923

75. *Sweet Pea* 1960

Pencil on heavy white wove paper

22⁹/₁₆ x 28¹/₂ ins. (57.4 x 72.5 cms.) sheet

Signed in pencil at lower right: *Kelly*
Inscribed and dated in pencil, then erased at lower right under
signature: *Sweet Pea/20 March 60*
Signed in pencil on verso at lower right: *Kelly*
Inscribed and dated in pencil on verso at lower left: *Sweet Pea/20
March 1960*

Thomas E. Benesch Memorial Collection, 70.4.20

PROVENANCE: Sidney Janis Gallery, New York, 1969; purchased
from Janis Gallery and given to the museum in 1970.

EXHIBITIONS: New York, Metropolitan Museum of Art, *New York
Painting and Sculpture*, 1969, no. 190, not repr.

BIBLIOGRAPHY: *Thomas Edward Benesch Memorial Collection*, 1970,
repr.

Sweet Pea is one of many large pencil studies of plant forms that
Ellsworth Kelly drew during the late 1950s and 1960s. The present
work is somewhat unusual in two ways: two plants are depicted in a
horizontal format. More typically, Kelly drew single plants in a
vertical composition. Examination of the drawing, however, shows
a crease in the center of the sheet midway between the two sweet
peas. Thus, at one time, the sheet was folded in half, as if the artist
considered it to be two separate smaller drawings of single plants.

Interestingly, Kelly painted brightly colored abstract hard-edge
canvases concurrently with the plant drawings. Barbara Knowles
Debs (see "Ellsworth Kelly's Drawings," *Print Collector's Newsletter*
III, September/October 1972, pp. 73-77) and Eugene Goosen (see
Ellsworth Kelly, New York: Museum of Modern Art, 1973) have
suggested that the latter served as foils, or "surrogates" to use
Goosen's term, for the increasing abstraction of his paintings. In
aesthetic terms, the plant drawings have been interpreted by Debs
as explorations of formal problems of Kelly's sculpture, and stylisti-
cally said to be influenced by the precise, light lines in some of
Matisse's drawings (see, for example, the *Rumanian Blouse*, cat.
no. 42). However, these exquisite drawings exist on their own as
delightful naturalistic images, vigorous yet delicate. In particular,
the present work juxtaposing two separate viewpoints of a sweet
pea, has a sense of vitality and movement.

LARRY RIVERS
American, born 1923

76. *The Last Civil War Veteran* 1961

Pencil, black crayon, and paper collage heightened with white gouache on spiral sketch pad sheet

9¹⁵/₁₆ x 8 ins. (25.2 x 20.3 cms.) sheet

Signed and dated in pencil at lower right: *Rivers '61*

Thomas E. Benesch Memorial Collection, 61.261

PROVENANCE: Purchased from Tibor de Nagy Gallery, New York, and given to museum in 1961.

EXHIBITIONS: Waltham, Massachusetts, Rose Art Museum, Brandeis University, April 10-May 9, 1965, Pasadena Art Museum, August 10-September 5, 1965, New York, Jewish Museum, September 23-October 31, 1965, Detroit Institute of Arts, November 17-December 26, 1965, and Minneapolis Institute of Arts, January 20-February 20, 1966, *Larry Rivers*, no. 126, not repr.

BIBLIOGRAPHY: *BMA News*, 1967, nos. 3-4, p. 14, repr. p. 17; Sam Hunter, *Larry Rivers*, New York: Harry N. Abrams, 1970, pp. 32-33, repr. pl. 15; *Thomas Edward Benesch Memorial Collection*, 1970, repr.

The source for Larry Rivers' portrayal of the *Last Civil War Veteran* is found in two photographic articles from *Life* magazine. John Salling of Virginia died during the spring of 1959, leaving Texan Walter Williams as the last surviving soldier from the Civil War. In the May 11, 1959 issue *Life* published a photograph of the 116 year old vetern as he lay ill in bed surrounded by his collection of Civil War paraphernalia (pp. 45-46). A few months later Williams died. *Life* followed up the story with a photograph of the deceased veteran lying in state, with an accompanying nostalgic essay by Bruce Catton on the passing of the Confederate Army soldier (January 11, 1960 issue, pp. 65 plus).

Between 1959 and 1961, Rivers made at least nine paintings or collages and a lithograph inspired by the *Life* photographs. The earliest, *Next to Last Confederate* (Collection Mr. and Mrs. Guy A. Weill, repr. in Sam Hunter, *Larry Rivers*, New York: Harry N. Abrams, 1970, pl. 106) depicts Salling, although the anonymous face is without detailed features. Rivers painted three oils based on the photograph of the bed-ridden Williams, including one where the artist actually painted over the photograph (Collection of the artist, repr. in Hunter, pl. 107). In addition to the Baltimore collage, Rivers made two paintings and one other collage showing the dead Confederate lying in state, and one larger painting, *Dying and Dead Veteran* (Collection Mr. and Mrs. Max Wasserman, repr. in Hunter, pl. 112). Of these, the Benesch drawing, a quick pencil sketch with collage, follows the photograph most closely. However, as in all related works, the individual characteristics or physiognomy of the Rebel soldier is of little interest to Rivers. Instead, the artist emphasizes the "period" trappings from a bygone age: the Confederate uniform and flags hanging in the background and draping the coffin. Nearly a decade later, Rivers returned to this subject in large mixed media construction (Collection, F.T.D., repr. in Hunter, *Supplement to the First Edition*, New York: Harry N. Abrams, 1971, pl. 245), where he substituted a mask of his own face for the deceased.

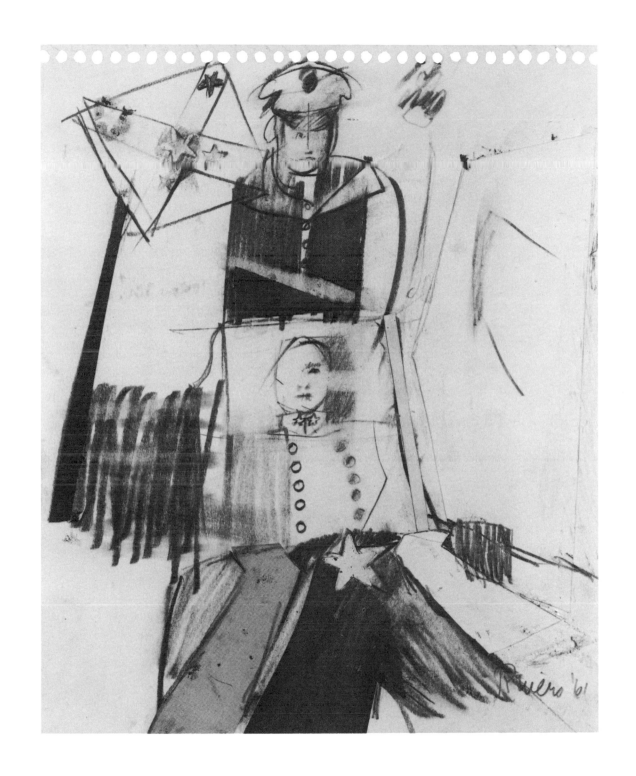

RICHARD LINDNER
American, born Germany, 1901-1978

77. *Charlotte* 1963

Colored crayons, brush and watercolor and gouache over pencil on heavy white wove paper

21 3/4 x 22 3/4 ins. (55.3 x 57.8 cms.) sheet

Signed and dated in pencil at lower left: *R Lindner/1963*

Thomas E. Benesch Memorial Collection, Gift of Mr. and Mrs. I. W. Burnham II and Friends, 68.18

PROVENANCE: Cordier and Ekstrom Gallery, New York; purchased in 1968.

EXHIBITIONS: Museum of Modern Art Circulating Exhibition, *Richard Lindner, Works on Paper*, 1967, no. 16, repr.; Leverkusen, Städtisches Museum Schloss Morsbroich, Hannover, Kestner Gesellschaft, Baden-Baden, Staatliche Kunsthall, Berlin, Haus am Waldsee, and Berkeley, University of California, *Richard Lindner*, 1968-69 (Leverkusen and Baden-Baden, no. 89, repr. pl. 47; Hannover, no. 89, repr. p. 101; Berkeley, no. 85, not repr.); Chicago, Museum of Contemporary Art, *Richard Lindner*, May 7-July 3, 1977, not repr.

BIBLIOGRAPHY: *BMA News*, 1967, nos. 3-4, p. 12, repr. p. 13; *Gazette des Beaux-Arts*, supp., February 1969, p. 90, no. 363; *Thomas Edward Benesch Collection*, 1970, repr.; Dore Ashton, *Richard Lindner*, New York: Harry N. Abrams, 1970, repr. pl. 116.

Richard Lindner, born in Germany, emigrated to the United States in 1941. For a decade he worked in commercial art as an illustrator for magazines such as *Fortune* and *Vogue*, turning to painting exclusively only in 1952. His early paintings and watercolors portray heavy set figure types from his native Bavaria, among them the *Ceremoniemeister* (Master of Ceremonies), who appears frequently, lending a theatrical or carnival flavor to the scenes. As Dore Ashton has pointed out this moustached male bears a striking resemblance to Lindner's uncle, a variety hall artist. However, beginning in the late 1950s, Lindner chose New York City as his major theme and the domicile of his new stereotypes: gangsters, hookers, and other anonymous citydwellers. At the same time, his painting style gradually evolved from the more traditional tonal use of subdued colors for plastically modeled figures to a brash new style depicting figures composed of mechanized shapes painted in bright, sometimes garish, colors with less tonal variations.

Charlotte, combining the iconographies and styles of both periods, is a transitional work in Lindner's evolution. The made-up face with bright red lips and cheeks and a twinkle of a grin recalls the "master of ceremonies" type found in earlier paintings such as *The Visitor* of 1953 (repr. in Dore Ashton, *Richard Lindner*, New York: Harry N. Abrams, 1970, pl. 2). One can interpret the moustached male in the Baltimore drawing, painted in muted colors with soft curving forms and delicate linear rhythms, as a magician performing an escape trick from handcuffs. A year later, however, a closely related man in identical pose and clothing appears in the watercolor/collage *The City* (Cordier & Ekstrom, repr. in Ashton, pl. 147). The face, no longer moustached, is blank and dehumanized, and his hands struggle more violently with the handcuffs. This latter watercolor clearly refers to crime and imprisonment, although the artist leaves somewhat ambiguous whether the man is a victimized citydweller or a captured crook. Lindner's art characteristically contains both the sinister and the comic. In *Charlotte*, which is lighter in spirit than many of his New York subjects, this duality of spoof and social comment is particularly evident.

CLAES OLDENBURG
American, born 1929

78. *Proposed Colossal Monument for Grand Army Plaza,
New York City: Baked Potato (Thrown Version)*
1965

Brush and gray wash over black crayon on white paper

22^{13}/$_{16}$ x 28^{15}/$_{16}$ ins. (57.9 x 73.6 cms.) sheet

Initialed and dated in black crayon at lower right: *C.O./65*
Inscribed in black crayon at lower left: *N.Y.*

Thomas E. Benesch Memorial Collection, 65.31

PROVENANCE: Purchased from Sidney Janis Gallery in 1965.

EXHIBITIONS: New York, Sidney Janis Gallery, *Recent Work by
Arman, Dine, Fahlstrom, Marisol, Oldenburg, Segal*, May 5-31, 1965;
Pasadena, Pasadena Art Museum, December 7, 1971-February 6,
1972, and tour February 1972-February 1973, *Claes Oldenburg:
Object into Monument*, no. 68, repr. p. 15.

BIBLIOGRAPHY: *BMA News*, 1967, nos. 1-2, p. 51, not repr.; *BMA
News*, 1967, nos. 3-4, p. 13, repr. p. 15; Claes Oldenburg, *Proposals
for Monuments and Buildings 1965-69*, Chicago: Big Table Publishing
Co., 1969, no. 5, pp. 156, 179, repr. pl. 4 (in reverse); Gene Baro and
Claes Oldenburg, *Claes Oldenburg, Drawings and Prints*, London
and New York: Chelsea House, 1969, no. 210, not repr.; *Thomas
Edward Benesch Memorial Collection*, 1970, repr.

Artist statement:

*The first suggestion of a monument came some years ago as I was riding in
from the airport. I thought: how nice it would be to have a large rabbit
about the size of a skyscraper in midtown. It would cheer people up seeing
its ears from the suburbs. The spot I had in mind was the space in front
of the Plaza Hotel (where there is already a fountain). However, the
Playboy Club later made its headquarters nearby which made construc-
tion of the giant rabbit at that particular spot impossible. I substituted
the baked potato, in either of two versions: upright or thrown against the
wall of the hotel.*

*The thrown versions of the monuments originated in my disgust with
the subject, the way one would kick over or throw down a piece of
sculpture that hadnt turned out well. Instead of destruction, I accepted
as result a variation of form and position (the effect of destruction labo-
riously constructed, as the workmen carefully shape the cannonholes in
fortresswalls for films).*

(from Stockholm, Moderna Museet exhibition catalogue, *Claes
Oldenburg: Skulpturer och techningar*, September 17-October 30,
1966)

The baked potato first appears as an Oldenburg subject in his
1963 *Baked Potato I*, constructed of burlap and plaster. After the
artist first conceived the potato as a colossal monument for New
York City, however, he returned repeatedly to the motif, in both
"hard" and "soft" sculptures. In the Baltimore drawing which is the
second of two proposals for the Grand Army Plaza on Fifth Avenue,
the potato is viewed as though thrown or smashed against the Plaza
Hotel.

n-y.

e, d.
65

ROBERT RAUSCHENBERG
American, born 1925

79. *Witness* 1966

Pencil, brush and white gouache, over frottage on heavy white wove paper

29¹/₁₆ x 23 ins. (73.7 x 58.3 cms.) sheet

Inscribed, signed, and dated in pencil on verso: *Witness/Rauschenberg/Dec '66*

Thomas E. Benesch Memorial Collection, Gift of Mr. and Mrs. I. W. Burnham II, 67.6

PROVENANCE: Purchased from Leo Castelli, Inc., New York in 1967.

BIBLIOGRAPHY: *BMA News*, 1967, nos. 3-4, p. 14, repr. p. 5; *BMA News*, 1968, nos. 1-2, p. 29, not repr.; *Thomas Edward Benesch Memorial Collection*, 1970, repr.

Using the frottage technique earlier employed by Max Ernst (see cat. no. 56), Robert Rauschenberg produces drawings consisting of scattered details transferred from printed sources. Such works are also called "transfer drawings" or "combine drawings." Rauschenberg's actual technical process somewhat differs from that used by Ernst. First, Rauschenberg wets drawing paper with hydrocarbon solvent or lighter fluid; then he places printed pages or reproductions, often from popular magazines such as *Time* or *Life*, face down on top of the drawing paper. With a pencil, he rubs back and forth across the back of the reproduction, thus transferring the printed image to the drawing paper. Such frottages almost duplicate their sources, except in reverse, but because of bare areas in between individual pencil rubbings, one is conscious of the drawing process.

Frequently, as in *Witness*, Rauschenberg combines a motley of frottages with other media–pencil, pen or gouache. The juxtapositions and overlaps of disconnected photographic images, printed words, and pencil drawing, differing in textures, distantly recall the collages by Dadaist Kurt Schwitters, whom Rauschenberg much admires.

Rauschenberg first made frottages for a series of drawings, *Dante's Inferno* in 1959. Later he extended his use of the medium to both mixed media paintings (see his *Hoarfrost* series of the 1970s) and lithography. In lithographs such as *Drizzle* of 1967, he transferred magazine images onto a lithographic stone that had been brushed with solvent.

BRIDGET RILEY
English, born 1931

80. *Study for "Deny"* 1966

Brush and gouache on heavy white wove paper

19⁷/₈ x 26⁵/₁₆ ins. (50.6 x 66.8 cms.) sheet

Signed and dated in pencil at lower left: *Bridget Riley/'66*
Signed, inscribed, and dated in pencil on verso:
Riley/'66/Gouache/27 x 20 ins.

VERSO: pencil sketch

Thomas E. Benesch Memorial Collection, 70.4.13

PROVENANCE: Acquired from the artist by Richard L. Feigen &
Co., in 1966; purchased from Feigen by the New School for Social
Research, New York in November 1969; purchased from the New
School and given to the museum in 1970.

EXHIBITIONS: Hannover, Bern, Düsseldorf, and Turin, *Bridget
Riley*, 1970-71, no. 107; London, Hayward Gallery, *Bridget Riley*
(expanded version of above exhibition), 1971, no. 115, not repr.

BIBLIOGRAPHY: *Thomas Edward Benesch Memorial Collection*, 1970,
repr.

Study for "Deny" is one of the preparatory drawings for Bridget
Riley's larger emulsion painting *Deny* (Chase Manhattan Bank,
New York, repr. in *Studio International*, March 1967, p. 135).
Characteristically, Riley makes a series of trial sketches on paper in
order to work out the "problems" and "potentials" of her conceived
"unit." Her mature drawings do not exist as independent works of
art; rather, they are always drawn with the idea of creating paint-
ings.

During an interview with David Sylvester (published in *Studio
International*, March 1967, pp. 132-35) Riley defined the intention
of *Deny* as follows:

*To oppose a structural movement with a tonal movement, to release
increased colour through reducing the tonal contrast. In the color rela-
tionship of the darkest oval with the ground, the change of colour is far
more pronounced than it is between the lightest oval and the ground,
where you get a tonal contrast—almost a black and white relationship—
happening instead, which knocks the colour down.*

In contrast to many of Riley's stark, vibrating black and white
images, both the gouache study and the emulsion painting *Deny*
have subtle color variations. In place of rapid, optical movement
found in the black and white examples, *Deny* provides slower,
fluctuating changes in hue. The silver ovals near the edges of the
gouache, for instance, gently evolve to teal blue near the center of
the composition. The tonal background, in part reacting to the color
change of the oval disks, becomes more intense and blacker in the
central "V" shape. (This "V" form, however, appears overly pro-
nounced in black and white reproductions.) The subjects of Riley's
art—movement, rhythm, tonal variation—appear as visual fugues
and suggest musical comparisons.

RICHARD DIEBENKORN
American, born 1922

81. *Sink* 1967

Brush and gray wash over charcoal on white laid paper

24³/₄ x 18⁷/₈ ins. (63 x 47.8 cms.) sheet

Initialed and dated in pencil at lower left: *RD67*

VERSO: Charcoal sketch of a female nude

Thomas E. Benesch Memorial Collection, 69.2

PROVENANCE: Purchased from the Poindexter Gallery, New York, and given to the museum in 1969.

EXHIBITIONS: New York, Poindexter Gallery, *Diebenkorn Drawings*, December 21, 1968-January 30, 1969, no. 28.

BIBLIOGRAPHY: *BMA News*, 1967, p. 9, repr. p. 10; *Thomas Edward Benesch Memorial Collection*, 1970, repr.

In the Benesch drawing, California painter Richard Diebenkorn depicts a sink in a corner of his studio, one of several interior scenes he executed during the 1960s. Four years earlier, in 1963, he painted a nearly identical subject (see *Corner of Studio–Sink*, Private Collection, repr., fig. 63 in the 1976-77 *Richard Diebenkorn* exhibition catalogue published by Albright-Knox Art Gallery, Buffalo). The more complex earlier canvas includes a cluttered row of soap, bottles and other articles on the shelf over the sink and describes the glistening effects of light as it reflects off shiny surfaces of the sink and metal pipes. In contrast, the content of *Sink* has been simplified, omitting the jumbled objects which imply recent human presence in the former painting. Light, rather than highlighting a particular motif or surface, is uniformly diffused. Diebenkorn has further refined his formal vocabulary, in which negative space, such as the background walls and the foreground vertical stripe at the left edge, play a fundamental role in the structure of the composition.

Diebenkorn's early paintings are in the Abstract Expressionist style. By the late 1950s, however, the California artist rejected non-objective themes, and painted numerous figures, landscapes, and still lifes. The restrained simplicity of *Sink*, one of his last representations of a recognizable object, anticipates the total abstraction of the artist's recent Ocean Park series, first begun in 1967.

EVA HESSE
American, 1936-1970

82. *Untitled* 1967-68

Brush and gray wash over pencil on heavy white wove paper

9 x 9⅛ ins. (22.9 x 23.3 cms.) sheet

Signed, dated in pencil at lower right: *Eva Hesse 1967-68*
Signed, dated, and numbered in pencil on verso at lower right:
#160 Eva Hesse 1967-68.
Inscribed on verso by unknown hand in pencil near upper left:
S 6383

Purchase, in honor of Tom L. Freudenheim, Director, The
Baltimore Museum of Art, 1971-1978, with funds contributed by
his friends, 78.133

BIBLIOGRAPHY: Lucy Lippard, *Eva Hesse*, New York: New York
University Press, 1976; fig. 228, p. 190.

*It was also on this visit (to Loveladies, New Jersey) that she began to
make the profoundly beautiful wash and ink circle drawings which
continued through 1968. They provided another outlet for her energies,
less frustrating than the sculpture, and important since drawing had
always been crucial to her. . . . When she arrived at the circles, a motif
already present in the three-dimensional work, she may have missed the
freedom of the more automatic imagery she had always used, but this
could not have lasted long, since she extracted from this very simple
formula—primarily rows of circles with or without centers—an endless
internal vitality that made each one different.*

*The drawings can be divided into two predominant types: the first
consisting of rows of usually concentric circles contained in a visible or
invisible grid; the second, larger or "target" circles, one or few to the
page, also contained in rectangular compartments. There also are the
mavericks—those in which all the grids are not filled by circles, or the
circles cover four of the grid squares, or pale diagonal lines cross the grid;
some are almost (but never quite) mechanical in execution; some are
centered by pin pricks, presumably to add threads or strings later, and so
on. They exclude no shade of feeling and formal diversity. Some are open,
light-filled fields of little dark-or-light centered circles. Some are dark,
ominous, almost invisible, the precise delineation of the circles absorbed
into the cloud of wash until the drawing is carefully perused. These come
into focus almost like Ad Reinhardt paintings—a possible influence, since
the "black monk" was a friend of Ruth Vollmer's and much admired by
LeWitt, Smithson, myself, and by Joseph Kosuth, also a friend of Hesse's
at that time.*

(Quotation from: Lucy Lippard, *Eva Hesse*, 1976, pp. 71-72)

SAUL STEINBERG
American, born Romania 1914

83. *Art History II* 1968

Pen and black ink, brush and watercolor and acrylic paint with stamped seals on heavy white wove paper

29¾ x 39½ ins. (75.6 x 100.4 cms.) sheet

Signed and dated in black ink at lower right: *Steinberg/1968*

Thomas E. Benesch Memorial Collection, 69.44.8

EXHIBITIONS: New York, Whitney Museum of American Art, April 14-July 9, 1978 and Washington, D.C., Hirshhorn Museum and Sculpture Garden, October 13-November 26, 1978, *Saul Steinberg*, repr. p. 145.

BIBLIOGRAPHY: *Thomas Edward Benesch Memorial Collection*, 1970, not repr.

To some degree spoofing the enshrined character of museum art in *Art History II*, Saul Steinberg represents four sets of imitations of paintings executed in watercolor or acrylic juxtaposed with authoritative looking printed seals. The hazy images of the third row personnages resemble varnish-darkened oil portraits of a type popularly thought to be typical of past masters. In the other three rows, expansive landscapes dominated by a pervasive misty light may refer to luminist landscapes of nineteenth century America. *Art History II*'s mini landscapes also forecast Steinberg's watercolor "postcards" of the early 1970s, executed in part as souvenirs of his world-wide travels (see for instance, *Anatolia* and *Kisumer*, repr. in Harold Rosenberg, *Saul Steinberg*, New York: Alfred A. Knopf in association with Whitney Museum of American Art, 1978, pp. 136, 142). In both the artist includes small anonymous figures who appear overwhelmed by the immensity of their unspecified environments. Left purposefully ambiguous in the present drawing, fuzzy imprints seemingly inked from some sort of official rubber stamp and accompanied by impressive, though illegible handwriting, either cynically symbolize verification of authenticity for the paintings surveyed, or perhaps imitate passport customs stamps recording Steinberg's excursions.

Steinberg is undoubtedly best known for his humorous cartoons appearing in magazines such as *The New Yorker*. He also creates masterful drawings such as *Art History II* which comment on the artist's situation.

JIM DINE
American, born 1935

84. *Flo-Master Hearts* 1969

Spray varnish over pen and India ink and brush and watercolor over black crayon on imitation vellum

13 3/8 x 12 1/4 ins. (34 x 31.2 cms.) sheet

Signed and dated in crayon along bottom edge: *Jim Dine 1969*

Thomas E. Benesch Memorial Collection, 70.21.5

BIBLIOGRAPHY: *Thomas Edward Benesch Collection*, 1970, repr.

Jim Dine uses the image of a heart as a symbol for his wife Nancy. This metaphor first appeared in the large mixed media construction, *Nancy and I at Ithaca*, executed at Cornell University in 1967. The latter has since been divided into three separate works (see for instance, *Straw Heart*, repr. in Whitney Museum of American Art, *Jim Dine* exhibition catalogue, 1970, fig. 99). In the years following, Dine painted a series of watercolors including *Rome Hearts* (1968) and *March without You* (1969) at times when he and Nancy were separated. *Flo-Master Hearts*, rather than a study for a larger painting or sculpture, is a further variation on this theme. The four hearts are painted in glowing translucent colors, lusciously spray varnished so that they glisten like jewels to delight the eye. The artist's creative technique as much as the visual object represented is the subject of this beautiful drawing.

WILLEM DE KOONING
American, born Holland 1904

85. *Untitled* circa 1969

Charcoal and estompe on thin off-white wove paper

18³/₄ x 23¹⁵/₁₆ ins. (47.8 x 60.9 cms.) sheet

Signed in charcoal at lower left: *de Kooning*

Thomas E. Benesch Memorial Collection, 73.37

PROVENANCE: M. Knoedler & Co., New York, 1969; purchased from Fourcade Droll, Inc., in 1973.

EXHIBITIONS: New York, M. Knoedler & Co., March 4-22, 1969; AFA circulating exhibition, *The Drawing Society National Exhibition*, 1970-71, opened at the Corcoran Gallery of Art, no. 16, repr. p. 41; New York, Solomon R. Guggenheim Museum, *Willem de Kooning in East Hampton*, February 10-March 23, 1978, no. 75, repr. p. 105.

The untitled Willem de Kooning drawing combines the artist's two major themes: woman and landscape. A briskly drawn doll-like creature stands out against a neutral landscape design. The artist exaggerates her caricatured face, heavily made-up with large fluttering eyelashes, and her nonchalant pose with skirt pulled up above crossed knobby knees. The setting, in contrast, functions as a patterned backdrop composed of individual forms that are difficult to identify.

During the late 1960s de Kooning produced under experimental conditions the present drawing together with other similar charcoals. He drew landscapes or female images while watching television, with his eyes closed, or using his left hand. In an almost Dadaist fashion, the artist thus exploited the results of automatic or accidental occurences. However, de Kooning consciously determined the subject matter of his pictures, unlike Max Ernst's experiments with frottage where biomorphic images form automatically from his rubbing over grains or ruts in wooden floorboards (see cat. no. 56).

In 1961 de Kooning moved his studio from New York City to the Springs, East Hampton, on Long Island. Created in this semi-rural environment, the present drawing belongs to the artist's late body of work which Diane Waldman has called "Impressionist" as distinct from his earlier Abstract Expressionist style (see 1978 Guggenheim Museum catalogue, *Willem de Kooning in East Hampton*). Although not closely duplicating visual observation, the Baltimore drawing nonetheless depicts a less emotional, more naturalistically proportioned woman than the brutalized images found in his series of Women from the 1950s.

JASPER JOHNS
American, born 1930

86. *Study According to What?* 1969

Pencil and brush and tempera on off-white wove paper

34³/₄ x 26 ins. (88.3 x 66.1 cms.) uneven sheet

Signed and dated in pencil at lower right: *J Johns/'69*
Inscribed in pencil at lower left: *According to What*

Thomas E. Benesch Memorial Collection, 70.4.18

PROVENANCE: Leo Castelli Gallery, New York.

BIBLIOGRAPHY: *Connoisseur,* February 1971, repr. p. 135; *Thomas Edward Benesch Memorial Collection,* 1970, repr.

Jasper Johns' drawing *Study According to What* is based on the lower right hand fragment of the artist's large canvas, *According to What* (repr. in Michael Crichton, *Jasper Johns,* New York: Harry N. Abrams in association with the Whitney Museum of American Art, 1977, pl. 115). The latter, painted five years before Johns executed the present work, combined oil with various objects glued to the canvas. In turn, the Benesch drawing served as the model for the artist's 1971 lithograph entitled *Coathanger and Spoon* (repr. in Richard S. Field, *Jasper Johns: Prints 1970-77,* Middletown: Wesleyan University, 1978, p. 73). The print, however, differs somewhat from the Benesch study by slight alterations Johns made in the placement of specific elements (for instance, the line with two arrows and the cord wrapped around the coathanger). Further, both lithograph and painting display more vigorous brushwork than present in the intermediary drawing.

As in the present case, Johns' drawings and prints frequently depict motifs which first appeared in his oils. However, in both the Benesch Collection work and its related lithograph, Johns has radically changed the composition by selecting objects which played only a minor role in the original oil. By eliminating the brash colors of the latter in favor of subtle grays, *Study According to What* displays Johns' pure delight in creating a variety of surface textures.

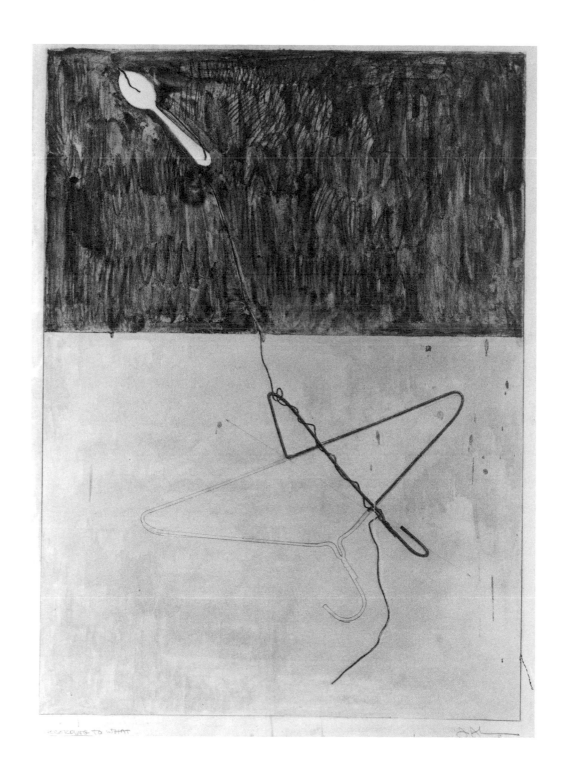

BELONGS TO WHAT

DAVID HOCKNEY
British, born 1937

87. *Armchair* 1969

Pen and black ink on heavy white paper

17 x 13⅞ ins. (43.1 x 35.3 cms.) sheet

Inscribed, signed and dated in pen and ink at lower right: *Clandeboye. DH '69*

Thomas E. Benesch Memorial Collection, 69.44.5

BIBLIOGRAPHY: *Thomas Edward Benesch Memorial Collection*, 1970, repr.; Nikos Stangos (ed.), *David Hockney by David Hockney*, New York: Harry N. Abrams, 1977, no. 274, repr. p. 212.

Armchair by the contemporary British artist David Hockney, is a preliminary study for the etching *Home;* the print introduced the story "The boy who left home to learn fear" from *Six Fairy Tales from the Brothers Grimm* published by Petersburg Press. Hockney spent nearly a year selecting the stories to be illustrated and executing the etchings for the limited edition publication, which he considers one of his major works. Each page of text includes an etching. In total, six tales were illustrated with 39 etchings. A small inexpensive photo-reproduced version of the book was also published in 60,000 copies.

The story which *Home* illustrates concerns a rather dumb boy who wants to learn to "shudder" or to be afraid. He leaves the security of home to spend several nights in scary towers supposedly inhabited by ghosts or in abandoned castles frequented by various monsters that reasonably might frighten the young protagonist. Rather than portraying a dramatic occurrence, the present drawing depicts the comforts of "home"–a cozy room with an overstuffed chair and pleasant view out of the window onto a serene landscape.

As noted in *David Hockney by David Hockney*, the artist usually composed the images for the Grimm tales directly on an etching plate. *Armchair* is one of few working drawings for this project. The related etching *Home*, however, closely follows the Benesch work, only lengthening the sheet to provide more space above and below the chair, and adding textural embellishments such as the fur fluff on the chair and the woodgraining of the floor.

Claude berge

EDWARD RUSCHA
American, born 1937

88. *Soup* 1970

Gunpowder on heavy white wove paper

14½ x 23¹/₁₆ ins. (37 x 58.6 cms.) sheet

Signed and dated in pencil at lower left: *E. Ruscha 1970*

Purchase, Friends of Art Fund, 72.5

PROVENANCE: Purchased from Stephen Mazoh, New York, in 1972.

Beginning in 1967, Los Angeles artist Edward Ruscha executed over 300 drawings using gunpowder in place of charcoal. He applied this substance by hand or with cotton pads, and placed masking tape along borders to ensure sharp edges. With this finely ground medium, the artist was able to achieve subtle tonal gradations by which he created highly illusionistic images often as ribbon-like forms which spelled out short (three or four letter) words. The actual dictionary definition of these words is of little interest to the artist. Rather he is attracted to specific words for their formal potentials.

Closely related to the Baltimore ribbon drawing is a pastel version of the same subject (1969, Collection of David Whitney, New York, repr. in *Art International*, November 1971, p. 27). Not identical, Ruscha has varied the placement of the ribbon-word, so that in the present example, SOUP flows downhill across the sheet while the letters move uphill in the earlier pastel.

Primarily a graphic artist and book-maker, Ruscha is fascinated with both typography and optical effects. Because he depicts rather everyday simple objects or words as subjects in a trompe l'oeil style Ruscha has been labeled a combination Surrealist-Pop artist.

PHILIP GUSTON
American, born 1912

89. *Untitled* 1970

Black crayon on off-white wove paper

17³/₈ x 22⁷/₈ ins. (44 x 58.1 cms.) sheet

Signed and dated in crayon at lower right: *Philip Guston '70*

Thomas E. Benesch Memorial Collection, 70.27.4

PROVENANCE: Purchased from Marlborough Gallery, New York, in 1970.

BIBLIOGRAPHY: *Thomas Edward Benesch Memorial Collection*, 1970, repr.

Philip Guston's untitled drawing depicts a cigar smoking hooded figure and his side-kick, who points out something ahead, riding in a black convertible with wooden crosses and an upside-down body stuffed into the backseat. Like other drawings and paintings of this series, which Guston first exhibited at the Marlborough Gallery, New York, in 1970, this drawing urges the spectator to compose a story. The characters and settings portrayed in Guston's untitled drawings also appear in his larger oils such as *Bad Times*, *Caught*, and *Evidence*. The provocative titles of the latter provide clues that enable the viewer to interpret this series as social commentary. Viewed as a group, a scenario, directed by a painter who compares himself to a movie director, unfolds involving white-hooded hooligans plotting conspiracies in rooms lit by naked light bulbs or driving around desolate landscapes collecting broken crosses and lifeless bodies. Finally, they are caught in these criminal acts and tried in court.

The source for Guston's narrative subjects is found in the paint-er's own work, done in California during the 1930s Depression . The prototypes for the hooded figures with their allusions to the Ku Klux Klan appear in the large oil, *Conspirators* of 1930 (repr. in Dore Ashton, *Yes, but . . .* , *A Critical Study of Philip Guston*, New York: Viking Press, 1976). These early paintings, however, directly reflect Guston's childhood and youthful memories of Klan activities in the Los Angeles area, and specifically recall KKK harassment of striking workers. The allegorical *Conspirators*, painted in a realist WPA mural style, shows influence from de Chirico through its disturbing mood created by an unnatural setting formed of fragmented architecture. In contrast, the figurative paintings and drawing after 1968 are humorous caricatures spoofing Guston's earlier subjects, and stylistically ape American comic strips. Yet there remain overtones of social comment with references to destructive forces in the world. Guston compares his images to Biblical Babel: "Like Babel with his (sic) Cossacks, I feel as if I have been living with the Klan, riding around empty streets, sitting in their rooms, smoking, looking at light bulbs." (from Ashton, p. 164).

During his career, Guston's subject matter and style has changed radically. His early works from the 1930s and 1940s were painted in a figurative mural style. In the late 1940s he developed an Abstract Expressionist style, perhaps reflecting influence from his friend Jackson Pollock. Two decades later, he has come full circle, rejecting non-objective painting for narrative images such as we see in the present drawing. Significantly, Guston, one of the major Abstract Expressionists during the 1950s and up until 1969, was not included in the recent exhibition, *The Great Decade of American Abstraction, Modernist Art 1960 to 1970*.

ANTONIO LOPEZ GARCIA
Spanish, born 1936

90. *Remainders from a Meal (Restos di Comida)* 1971

Pencil and erasure on white mat board mounted on plywood

16⅝ x 21⅜ ins. (42.2 x 54.3 cms.) board

Signed in pencil at lower right: *Antonio López García-1971.*

Thomas E. Benesch Memorial Collection, Gift of the Apple Hill Foundation, 72.2

BIBLIOGRAPHY: Antonio Bonet Correa, "Antonio López García," *Goya* 17 (July/August 1973), repr. p. 98.

The subject of Antonio López García's *Remainders from a Meal* is an old one, conceived in the traditon of seventeenth century still lifes painted by Spanish artists as well as by their Dutch contemporaries. Without references to the succulent food and luxurious vessels of precious metals represented in the Baroque prototypes, López García's more austere drawing nonetheless expresses the same theme: Vanitas. While the earlier paintings focused on the richness of worldly goods which we lose at death, López García's still life suggests both the ephemeral nature of life as well as the banality of modern times. As with many seventeenth century examples, one senses the "unseen presence" of a person who has just left the table. López García has suggested a similar situation by placing the silver spoon upside down against a dish. As a metaphor for fleeting time, the spartan remains from a meal are made contemporary by the bottle of prescription drugs set next to a partially full waterglass on the stained white tablecloth.

In the Benesch drawing, details are meticulously rendered, while strong light, somewhat mysteriously coming from the left, glistens on the reflective surfaces of silverware and water in the glass, casting shadows in the hollows of the rumpled napkin and the creases of the tablecloth. The pristine verism of *Remainders from a Meal*, executed in pencil, displays López García's technical brilliance.

Born in Tomelloso, a small town in La Mancha south of Madrid, López García has lived in the Spanish capital since 1949. Painter and sculptor as well as draughtsman, he has worked and exhibited with a group of Spanish artists called the "Magic Realists."

PHILIP PEARLSTEIN
American, born 1924

91. *Female Model Lying on a Bed, Feet on Floor* 1975

Brush and brown wash on heavy white paper

29¾ x 22⁷/₁₆ ins. (75.5 x 56.7 cms.) uneven sheet

Signed and dated in pencil at lower right: *Philip Pearlstein 1975 o*

Purchase, Women's Committee Fund, 75.23

PROVENANCE: Purchase from Allan Frumkin Gallery, New York, in 1975.

The large wash drawing, *Female Model Lying on a Bed* portrays Philip Pearlstein's favorite subject, the nude. Trained in the non-objective style of Abstract Expressionism, Pearlstein has concentrated on the human form since the late 1950s. His close-up radically cropped images are variations on a theme.

Two statements by the artist:

It seems madness on the part of any painters educated in the twentieth century modes of picture-making to take as his subject the naked human figure, conceived as a self-contained entity possessed of its own dignity, existing in an inhabitable space, viewed from a single vantage point. For as artists we are too ambitious and conscious of too many levels of meaning. The description of the surface of things seems unworthy. Most of us would rather be Freudian, Jungian, Joycean and portray the human by implication rather than imitation.

(from "Figure Paintings Today are not made in Heaven," *Art News* 61 (Summer 1962, p. 39)

The kind of subject I did have in mind when I decided not to make an Expressionist painting of a figure was a reaction against the Museum of Modern Art's "New Images of Man" show . . . People were painting the figure burnt, shredded, mangled, tortured, and I wanted to paint the human figure as it is—naturally, not glamorized, not as a study in perfect form, but just as a natural phenomenon.

(from Ellen Schwartz, "A Conversation with Philip Pearlstein," *Art in America* 59 (September/October 1971), p. 55)

INDEX